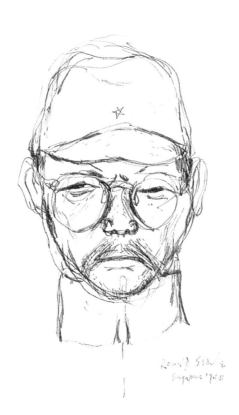

Ronald Sila &
Singapore '94.5

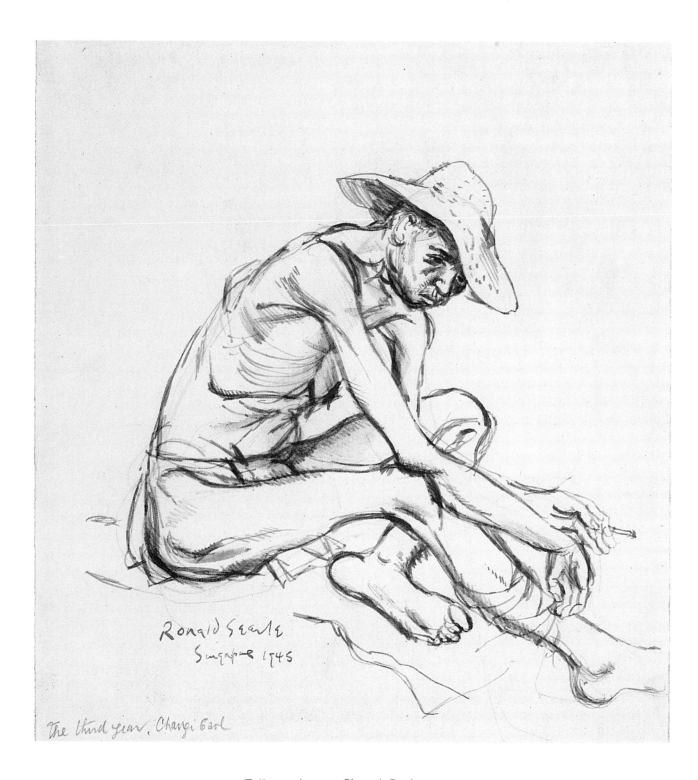

Ronald Searle
Singapore 1945

The third year, Changi Gaol

Fellow prisoner, Changi Gaol, 1945

RONALD SEARLE
To the Kwai
-and Back

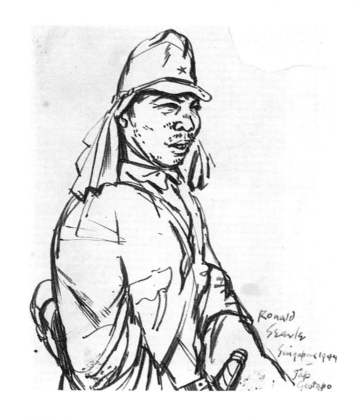

WAR DRAWINGS
1939-1945

SOUVENIR PRESS

First published in Great Britain by
William Collins Sons & Co Ltd, 1986

This edition published in 2006 by Souvenir Press Ltd
43 Great Russell Street, London WC1B 3 PD

Reprinted 2006

ISBN 0285637452

Origination by M.R.M Graphics Ltd.

Printed and bound in Singapore under the supervision of
M.R.M Graphics Ltd.

Contents

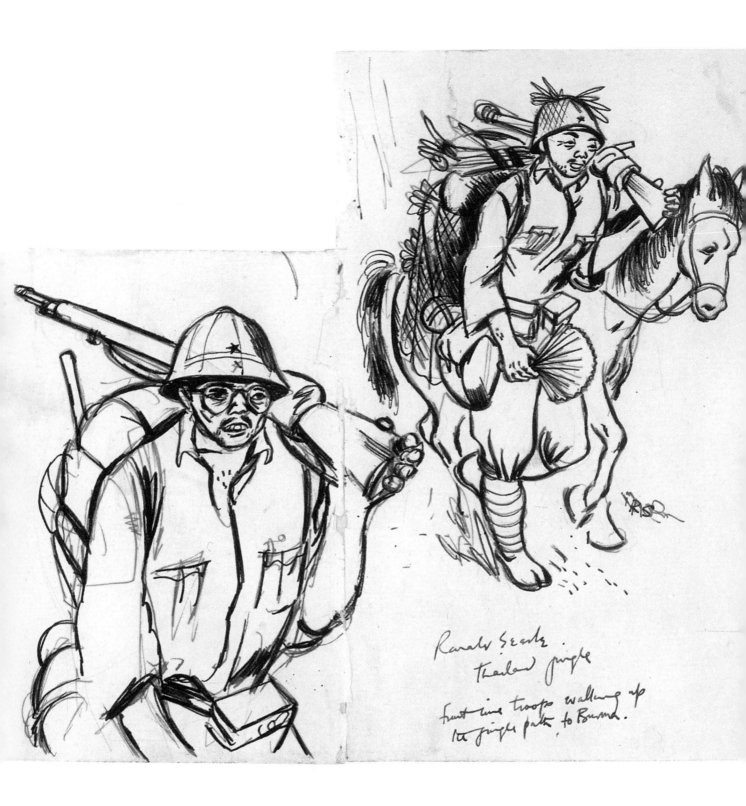

Siam 1943. Happy Japanese front-line
troops heading for Burma.

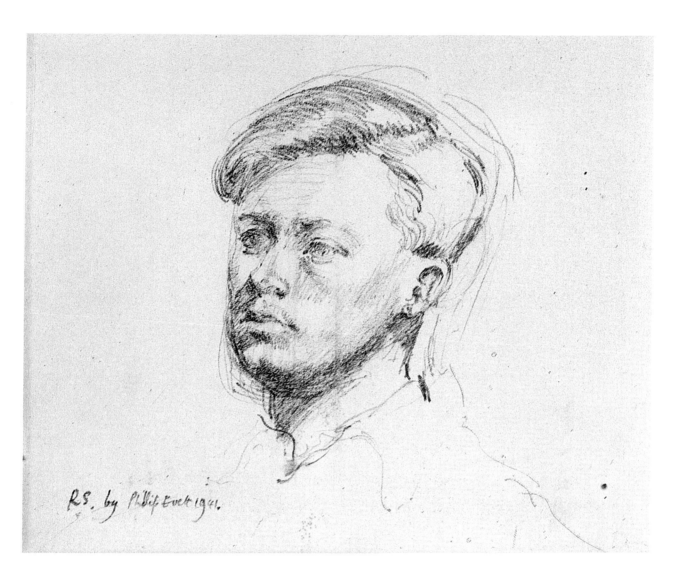

RS. by Philip Evett 1941.

A Word From the Artist

These pictures were not drawn with brushes made from human hair nor with blood replacing ink, as has been occasionally recounted. But they were made with sweat, fear and, at the outset at least, wide-eyed noble intent.

I was twenty-one years old when I was taken prisoner by the Japanese at the capitulation of Singapore in February 1942, and a repellently diseased twenty-five-year-old when I was released from Changi Gaol on that same island, in August 1945, with the remaining survivors of a wickedly inept political sacrifice.

As a somewhat weedy scholarship student from the Cambridge School of Art, unconvinced by Neville Chamberlain's piece of paper, I had volunteered to join the Army in April 1939 and, with some neat

Aged 21. Sapper Searle, R., No. 2072249, 287 Field Company, Royal Engineers, drawn by a fellow art student shortly before leaving for the Far East, October 1941

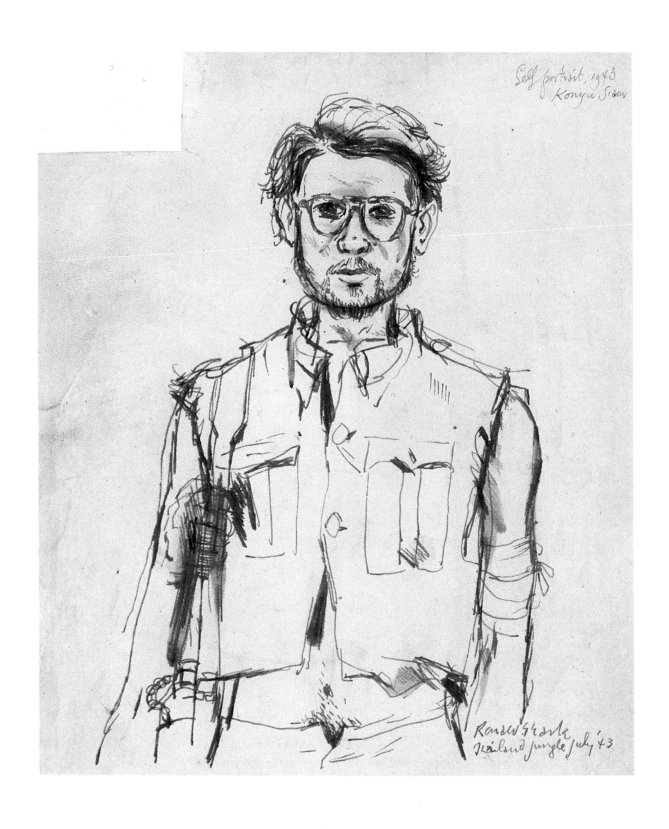

Self-portrait (handwritten annotations on drawing): *Self portrait, 1943 Konyu, Siam* ; *Ronald Searle Thailand jungle July '43*

Self-portrait, aged 23

effacement and a great deal of East Anglian cunning, managed to remain Sapper Searle, R., 2072249, until I was demobbed seven years later. By then I was a weedy but experienced neurotic, extremely nimble with a pen and unmatched in the manipulation of a survival kit. During my captivity I had, in a somewhat unimaginative and already ambitious way, convinced myself that my mission was to emerge from the various camps, the jungle and finally prison, with a 'significant' pictorial record that would reveal to the world something of what happened during those lost and more or less unphotographed years.

I was very fortunate. Unlike the majority of my friends, I did return and with a pictorial record. Much of it is in this book.

The story begins in England with sketches by a mildly talented nineteen-year-old and ends in the Far East with drawings by a sharper and certainly more tolerant adult. The line may frequently be immature and occasionally somewhat approximate. But many of these technical deficiencies can be overlooked in the light of a visible determination to get the experiences on paper as dispassionately, as authentically, not to mention as rapidly, as possible.

Obviously there are gaps in the narrative. From the early and demoralizing days of captivity on Singapore Island, passing by the mad saga of forced labour in the Siamese jungle, to the final years in prison, physically it was almost impossible to do much more than try to survive until something resolved our fate one way or another. It is worth recalling that these drawings were not made by an observer-reporter with time to reflect and digest before pronouncing. They were made by an unwilling (albeit self-appointed) participator-recorder, involved in an intimate drama more appropriate to the Dark Ages than to the surrounding global warfare. But, unlike the medieval warriors in the *jidai-geki* (period drama) of Kurosawa, there were no heroes. Merely killers and survivors.

If the dossier is incomplete it is because determination – and the human body – has its limits. Much of the time I was either too tired, too ill, or too cowardly to take the risk of being seen drawing. Towards the end I really did not dare and I almost did not care to imagine that there might be a chance of getting out alive with what, by then, amounted to some three or four hundred drawings and several note-books, much of it compromising. Chances were against it. The climate alone was capable of rotting anything, men included, and what did not disintegrate naturally was likely to be turned over at some point by the Japanese who, even deep in the jungle, continued to search our rags and filthy belongings – belongings to which

normally only the local snakes and scorpions would turn for solace. The Japanese were right, of course. We were all hiding something. In my case it was frequently due to the selfless aid of men sick or dying of cholera that this bulky record remained finally undetected by the Japanese. They were terrified of cholera.

These drawings were not a means of catharsis. Circumstances were too basic for that. But they did at times act as a mental life-belt. Now, with the perspective and detachment that a gap of forty years or so can achieve, they can be looked on as the *graffiti* of a condemned man, intending to leave rough witness of his passing through, but who found himself – to his surprise and delight – among the reprieved.

This book – these drawings for what they are – belong to those who were not.

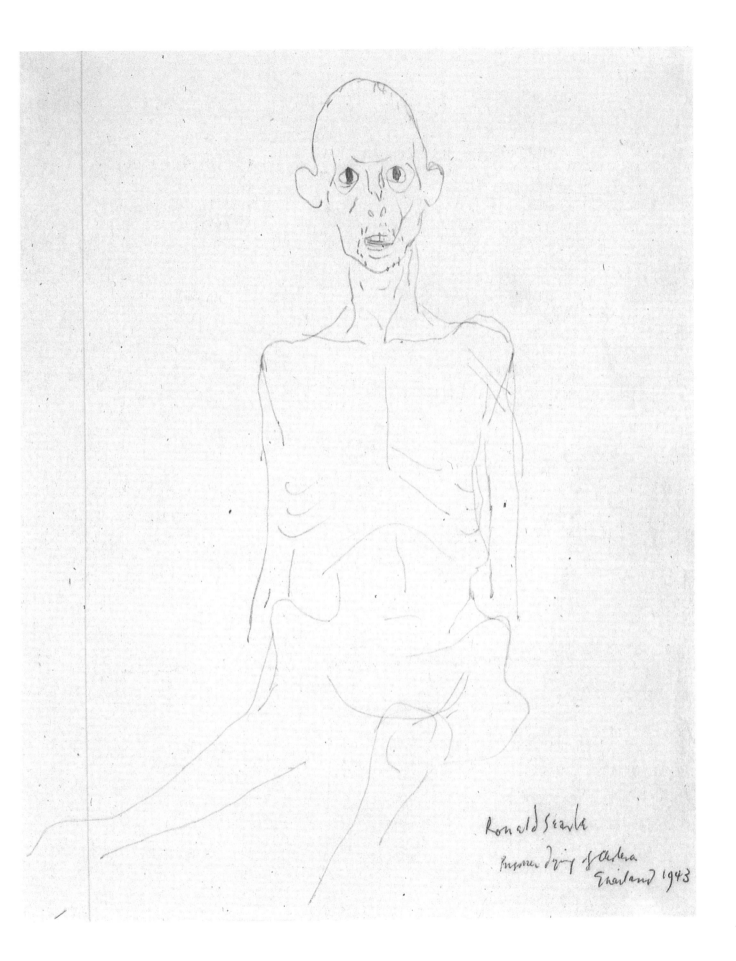

Siamese jungle, 1943.
Prisoner dying of cholera.

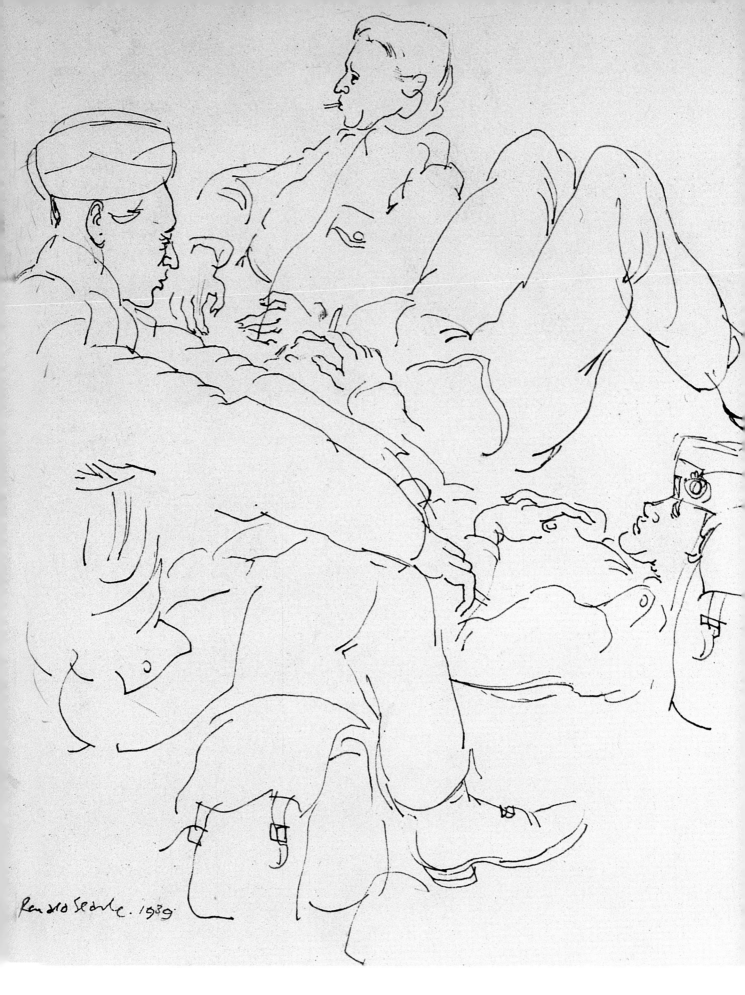

The early days. Miserable civilian soldiery
regretting that it ever left home. (1939)

I

Soldiering

1939–1941
(Some Snapshots)

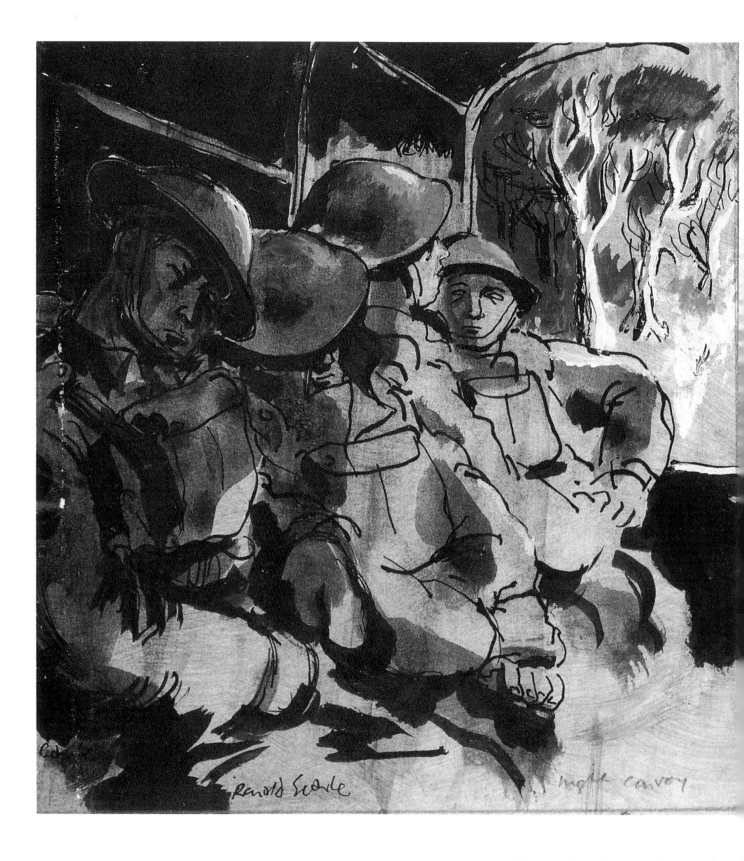

The 287 Field Company R.E. on night manoeuvres 'somewhere in Scotland'.

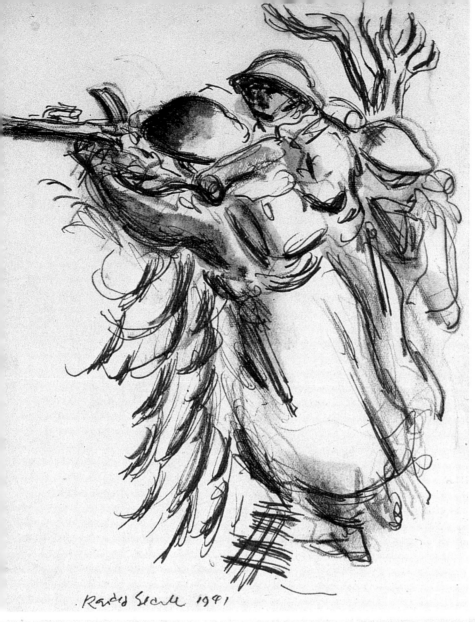

Bren gun post

Spud bashing, Norfolk

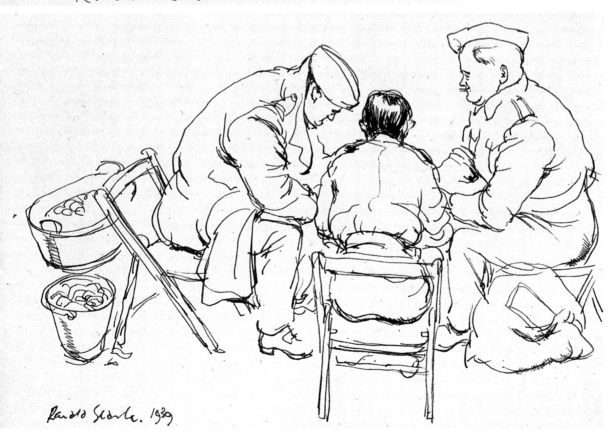

15

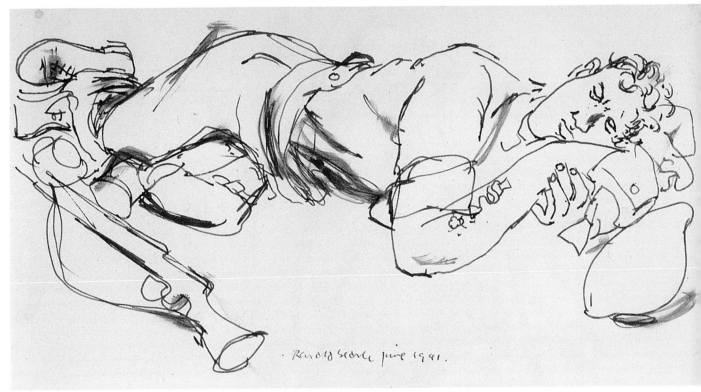

Exhausted military

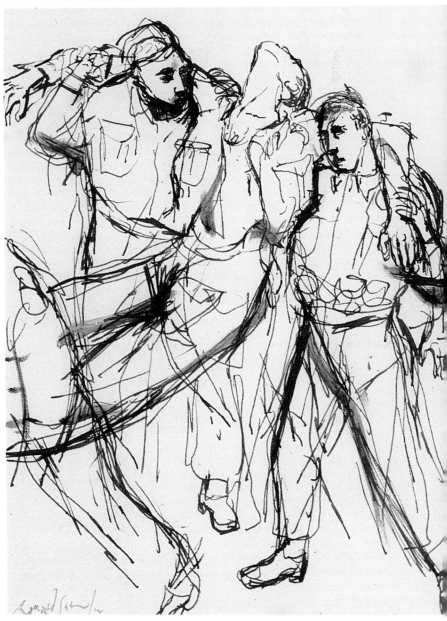

Shooting accident

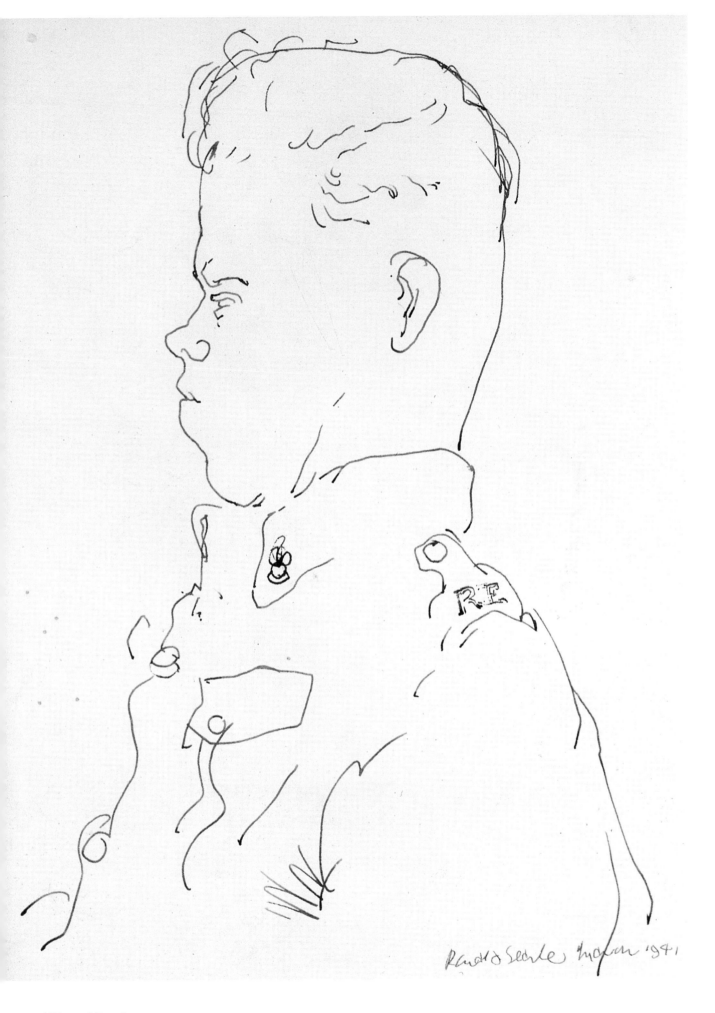

'Ginger' Lewis

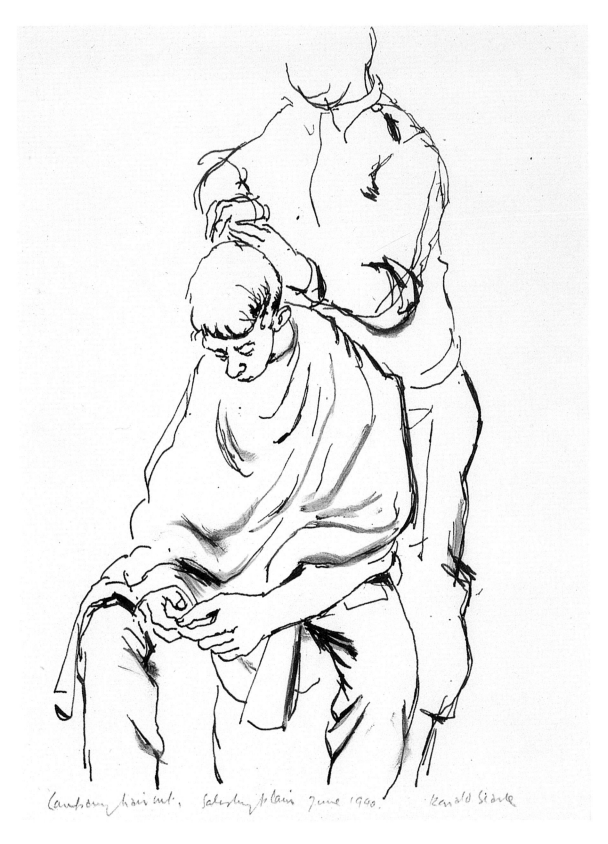

Canterbury haircut, Salisbury plain June 1940. Ronald Searle

Regulation haircut

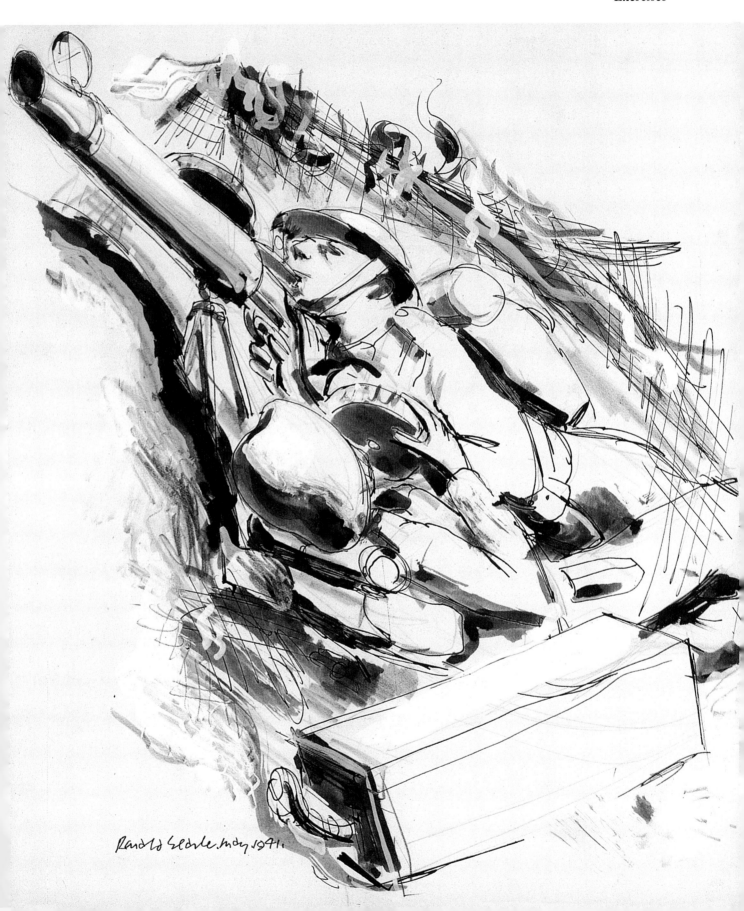

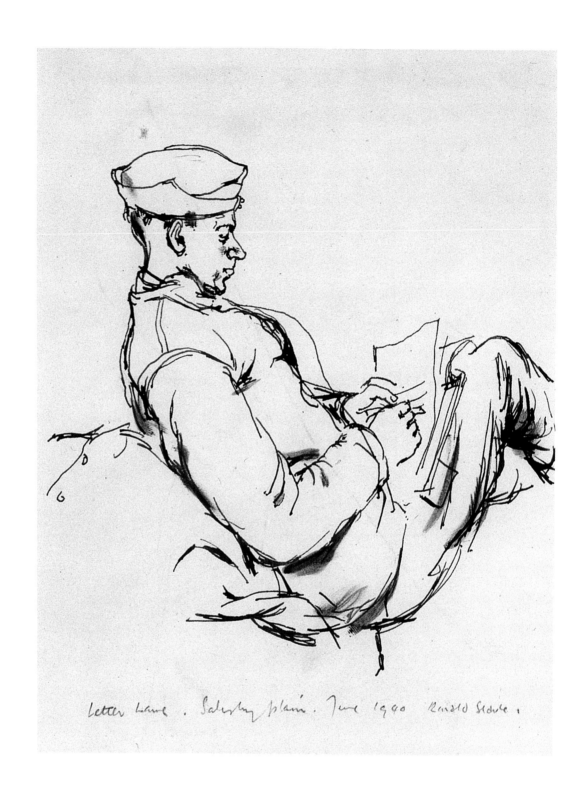

Letter home

2

The Journey to the East
October 1941–January 1942

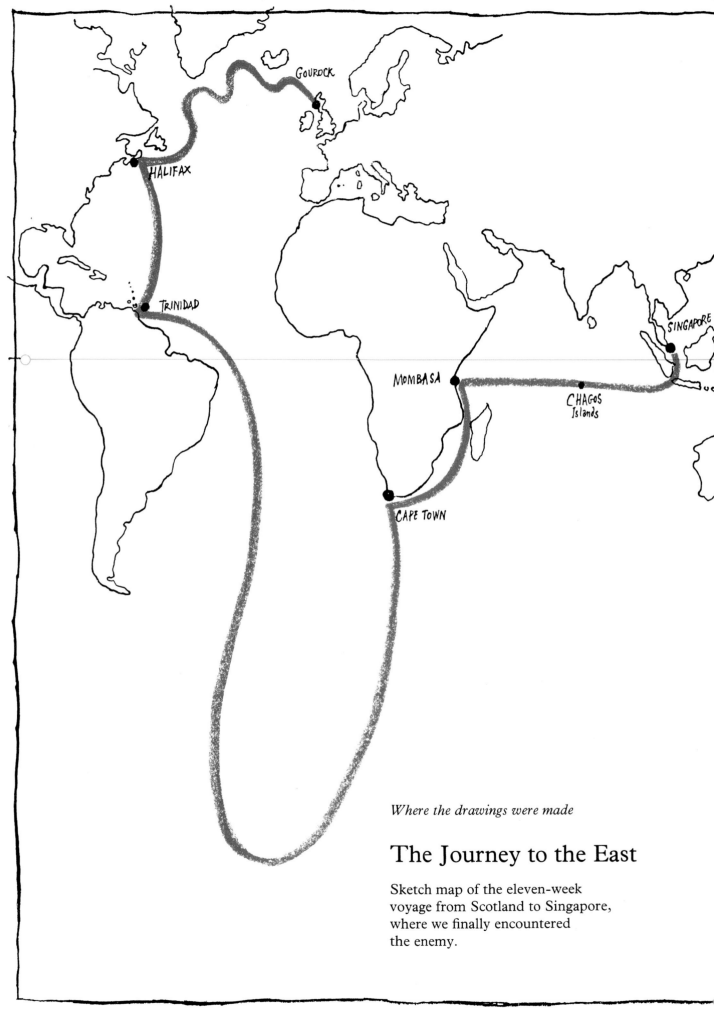

GOURDOCK

HALIFAX

TRINIDAD

MOMBASA

CHAGOS
Islands

SINGAPORE

CAPE TOWN

Where the drawings were made

The Journey to the East

Sketch map of the eleven-week
voyage from Scotland to Singapore,
where we finally encountered
the enemy.

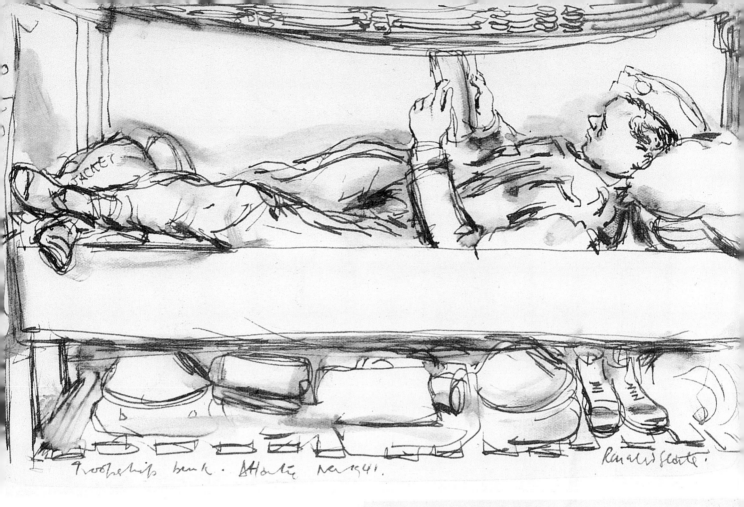

Troopship bunk. Atlantic Nov 1941. Ronald Searle

ABOVE Soldier on back in bunk

RIGHT Soldier approximately in life-jacket

On 29 October 1941 the 53rd Brigade (18th Division) embarked on the Polish troop-carrier *Sobieski* at Gourock in Scotland, to sail for an unknown destination (Egypt). It arrived at Halifax, Nova Scotia, on 8 November. All troops were then transferred to the 'neutral' American ship, USS *Mount Vernon*.

The *Sobieski* was a rather tight fit and we were more or less forced to cross the Atlantic on our backs. After eleven sweaty, seasick days below the water-line, the atmosphere was, to say the least, over-charged and claustrophobic. At the end of them, even fishy Halifax smelt like an exotic Spice Island.

Ronald Searle
1941 Soldier in life-jacket.

Some of the *Sobieski*'s crew

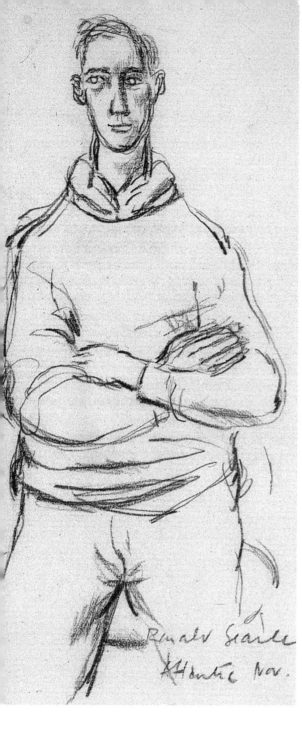

Ronald Searle
Atlantic Nov.

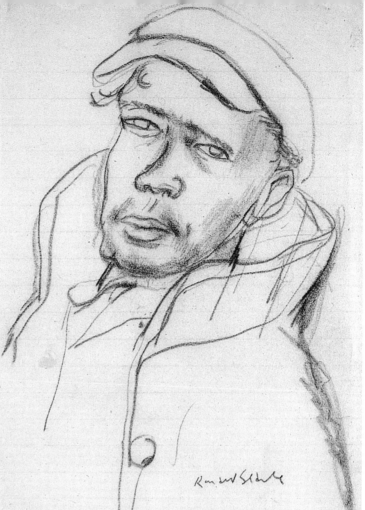

Ronald Searle

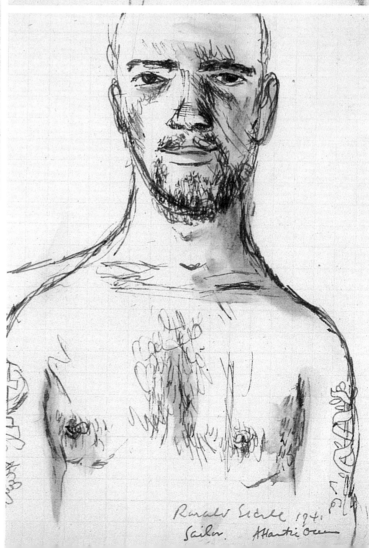

Ronald Searle 1941.
Sailor. Atlantic Ocean

25

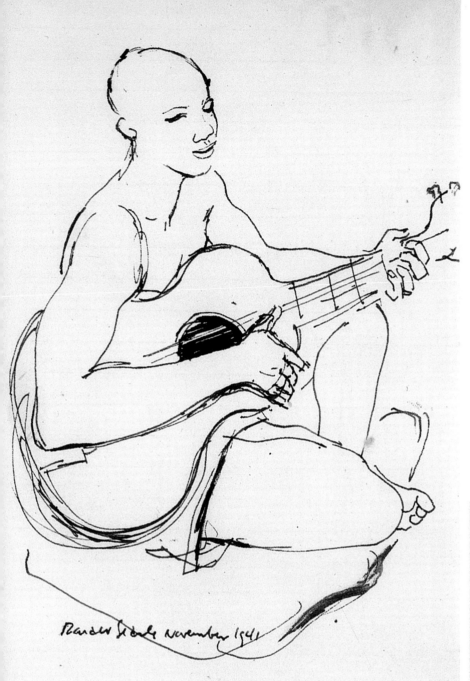

Randle Sodale November 1941

On the *USS Mount Vernon*

More sailors . . .

On 9 November 1941 the USS *Mount Vernon*, as yet not in the war, left Halifax with a casual air of innocence and, a week later, after taking on fuel and water at Trinidad, headed very positively south.

By late November we were practically among the ice-floes and rumour had it that we were to be dressed as penguins and quietly distributed about the Antarctic on secret missions that would be revealed only when Roosevelt and Churchill signalled that the seals on the

envelopes could be broken. Our lives took on the sort of fantasy that comes with interminable suspense between sea and sky.

On 7 December, against the rules, the Japanese bombed Pearl Harbor naval base and destroyed a fair slice of the American Pacific fleet. America and Britain declared war on Japan and the USS *Mount Vernon* headed rapidly for Cape Town. Meanwhile, back on deck, we continued to idle around in the few square inches available to each man, inhaling our free Camels and reeling under gargantuan helpings of American peacetime navy food. Sometimes, as a diversion, we hung over the side of the ship to watch the flotilla of strange fish that trailed behind us picking up the swill.

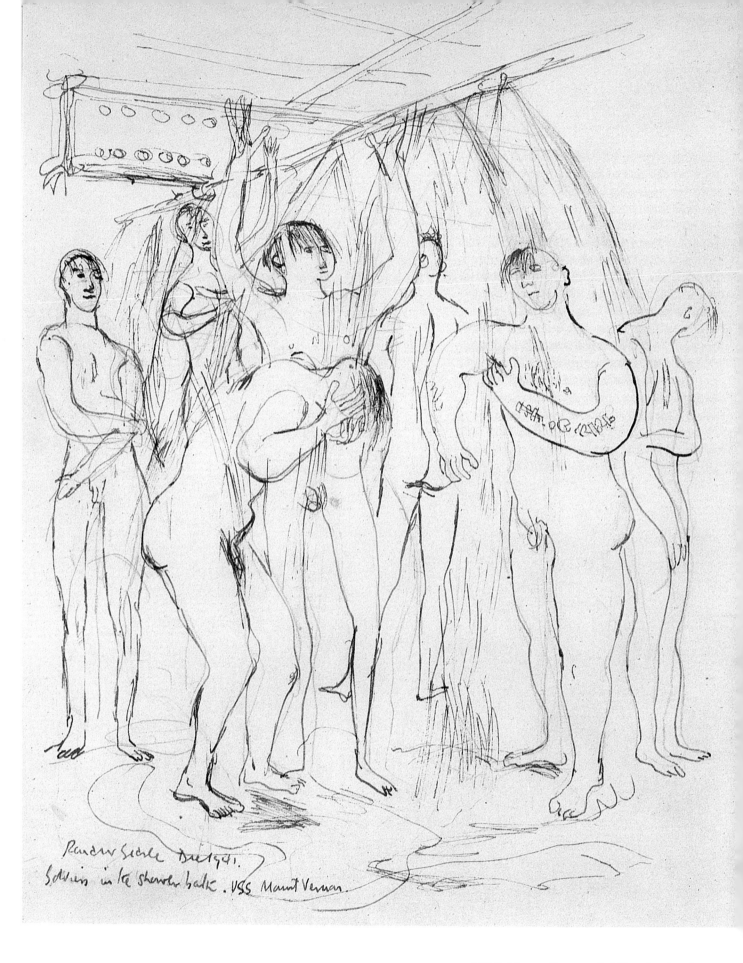

Ronald Searle Dec 1941.
Soldiers in the shower bath. USS Mount Vernon.

USS Mount Vernon: Soldiers in the shower

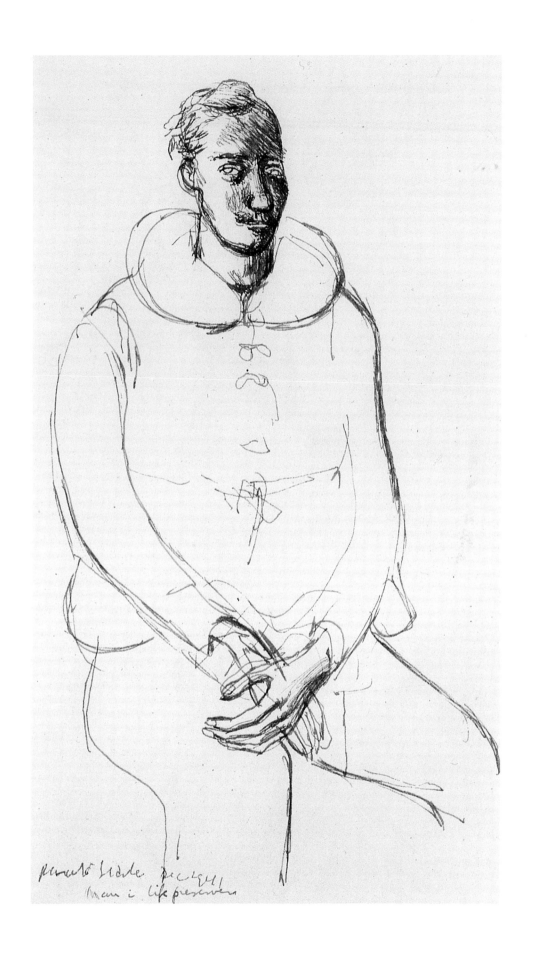

Soldier sitting out life-boat drill

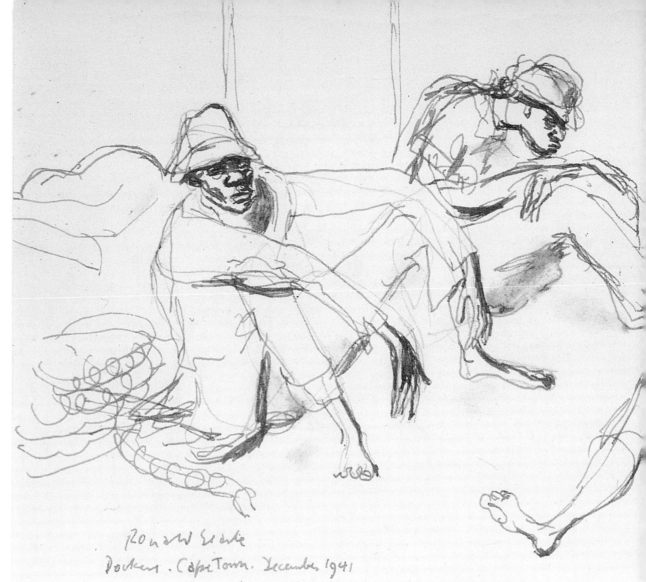

Ronald Seale
Dockers. Cape Town. December 1941

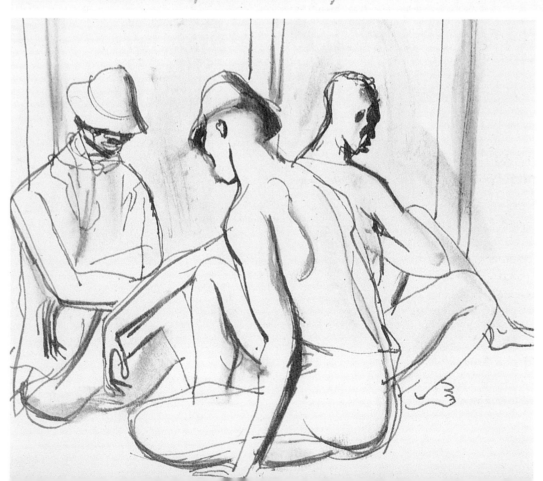

I was finally unable to get under the skin of the subject at any point. I forgot about the necessity to seek the human being behind the material and scribbled on regardless. By the time I was being less breathless about it and narrowing my eyes a little, it was too late, and we had sailed on.

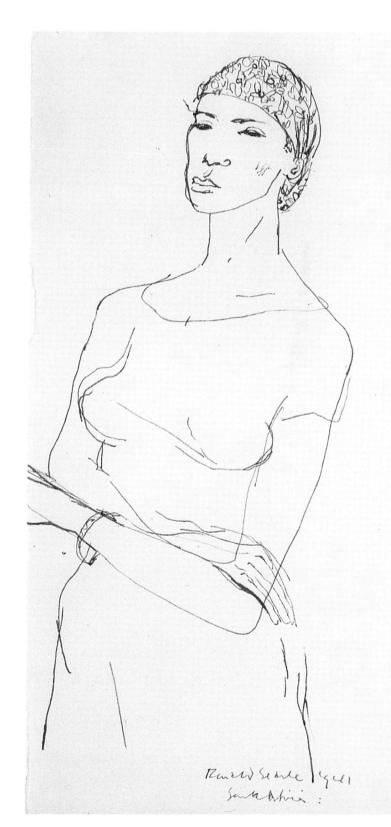

etches from the deck of the
SS *Mount Vernon* soon after
cking

ape Town, South Africa
13 December 1941

ving arrived at Cape Town without
ident, we were allowed ashore for three
ys during daylight hours. After thirty
ys of unbroken seascapes, I could barely
ntrol my pen – not only because of the
citement of actually putting a foot on
rica, but also because of the sudden and
zzling reversal of subject-matter. Torn
ween wanting to drool visually and
nting to convert the lot into drawings,

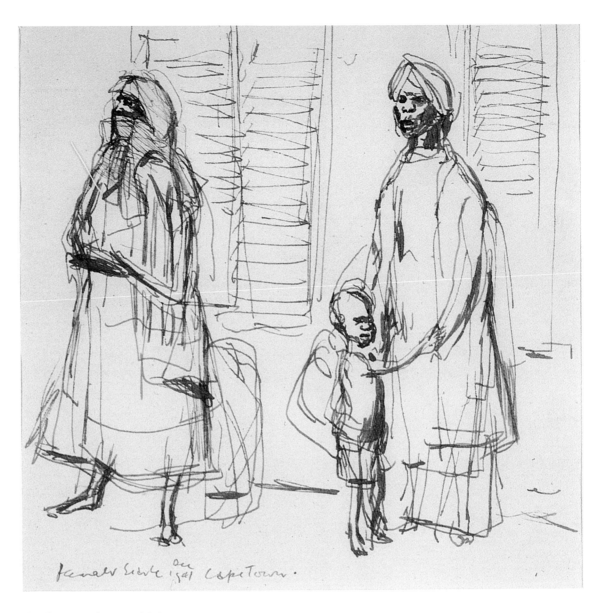

Indian couple and child

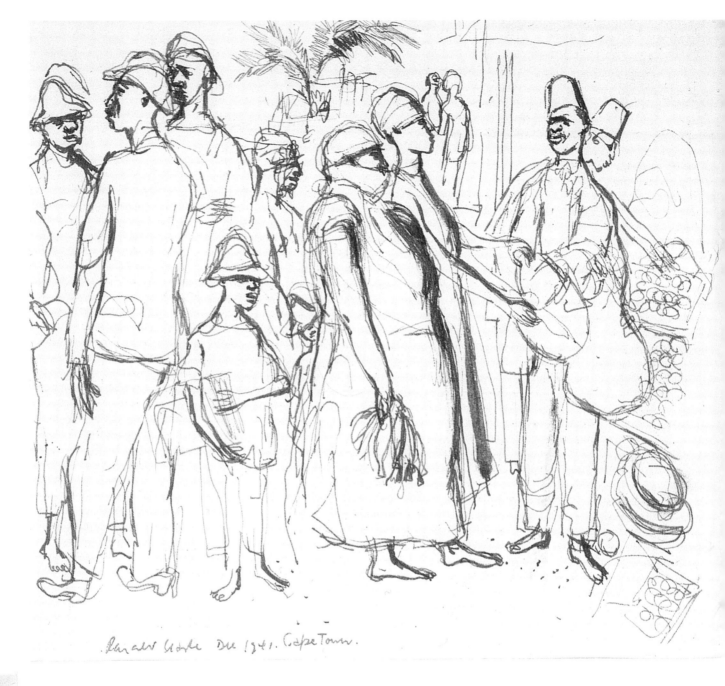

Ronald Searle Dec 1941. Cape Town.

In the Green Market

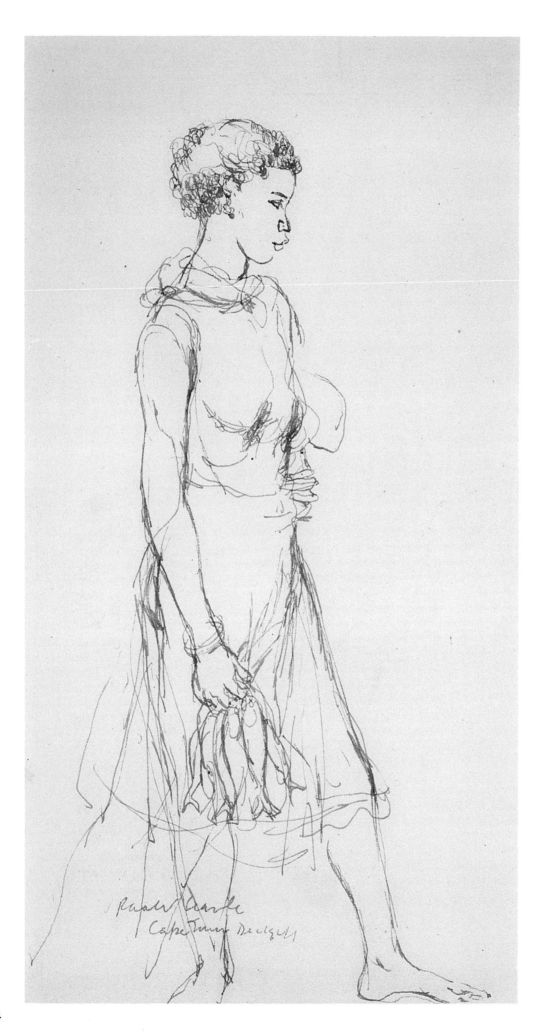

Girl with fishes

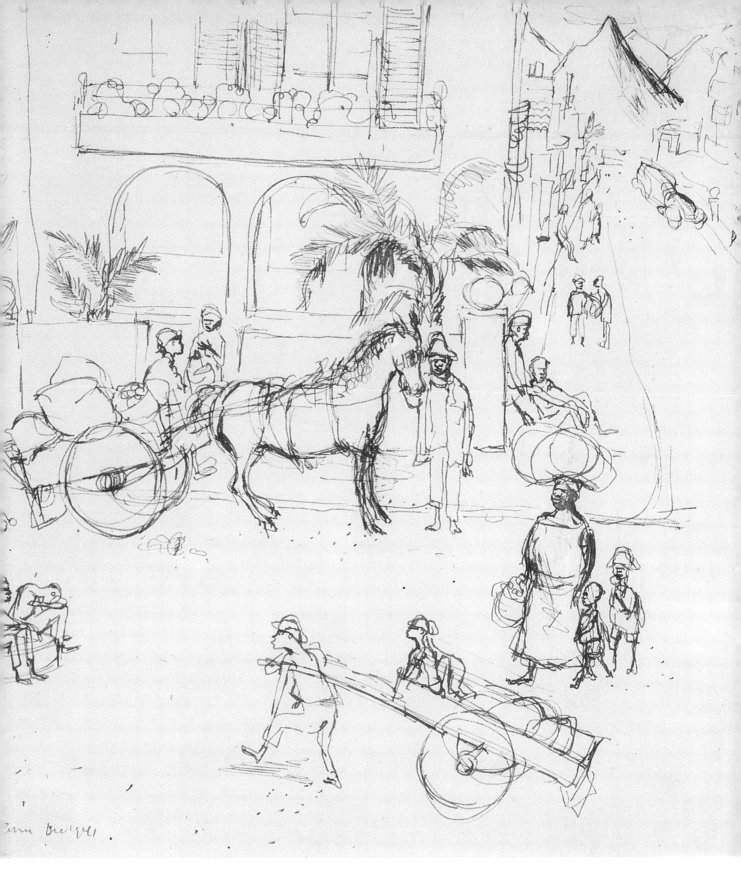

Street scene with fruit cart

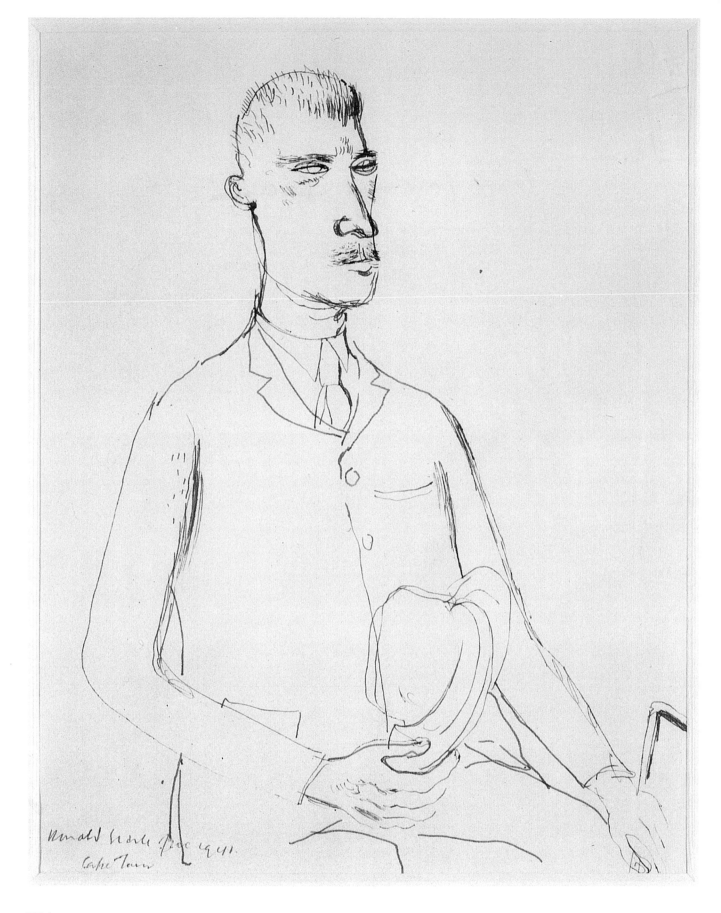

White

Black

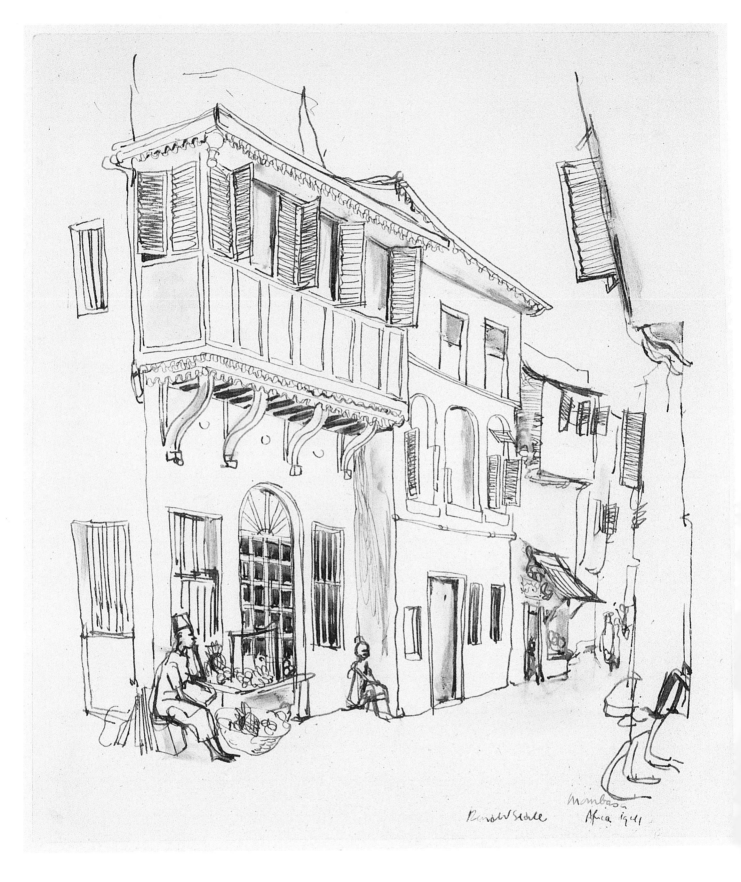

Mombasa, East Africa
25–29 December 1941

We reached Mombasa on Christmas Day. The turkey having 'gone off' and been thrown to passing sharks, we were almost too excited to toy with the corned beef and angel cake that replaced it. It appeared that there had been a change of priorities. We were no longer required to restore order to North Africa. Instead, we were to be diverted to the Far East, where we were to shove some (by now rapidly advancing) Jap dwarfs out of Malaya and back onto their own rotten rice patch where they belonged. OK?

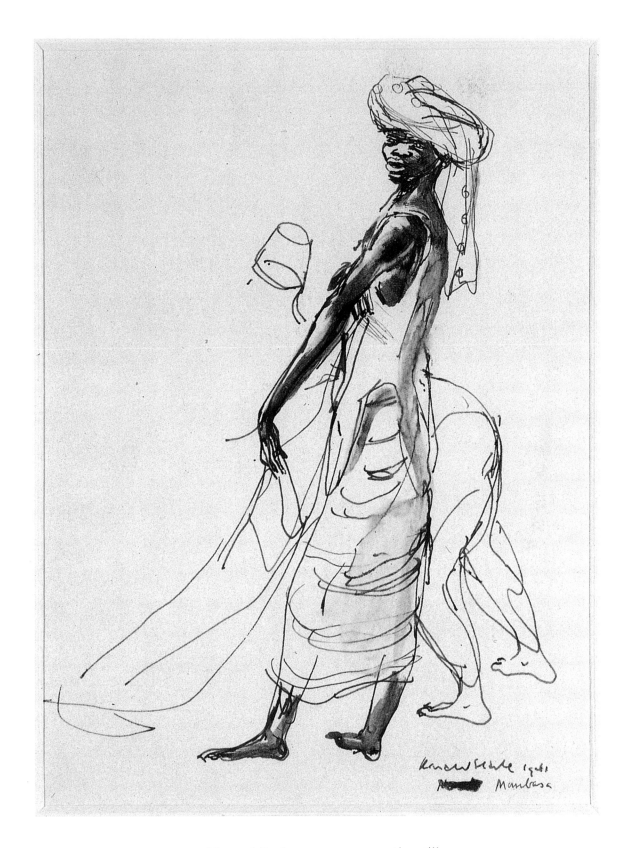

Meanwhile there was, apparently, still
time to fit in three more days of exotic
sketching . . .

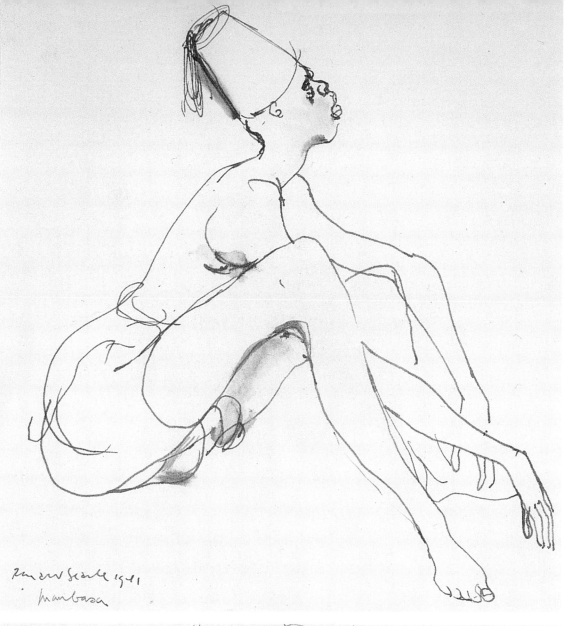

Ronald Searle 1941
Mombasa

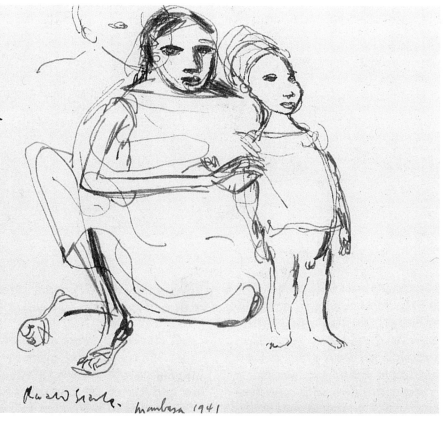

Ronald Searle. Mombasa 1941

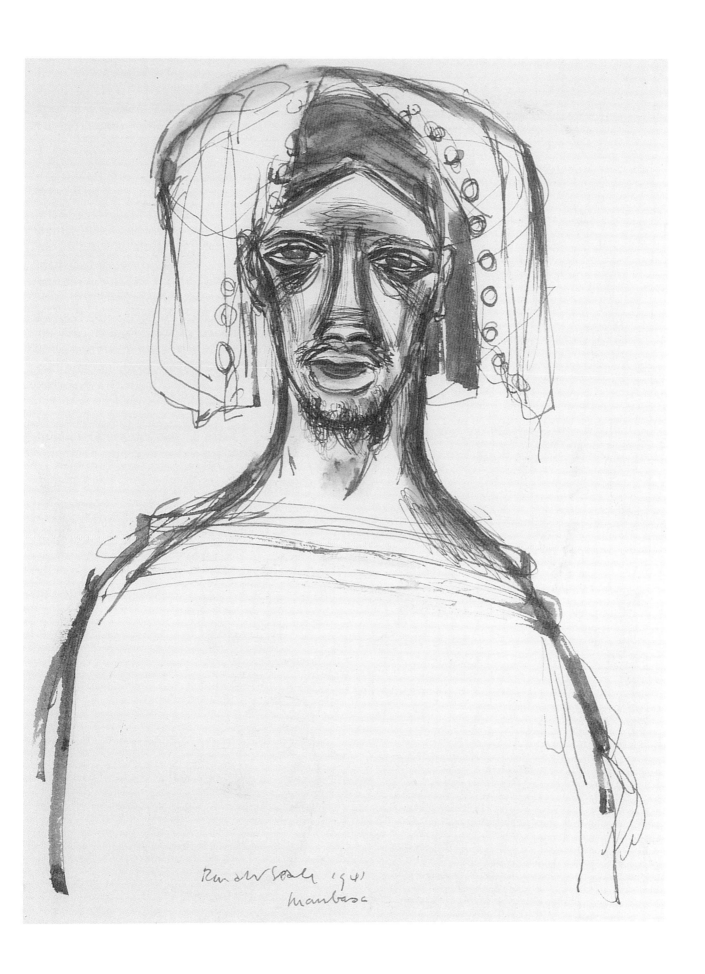

Ronald Searle 1941
Mombasa

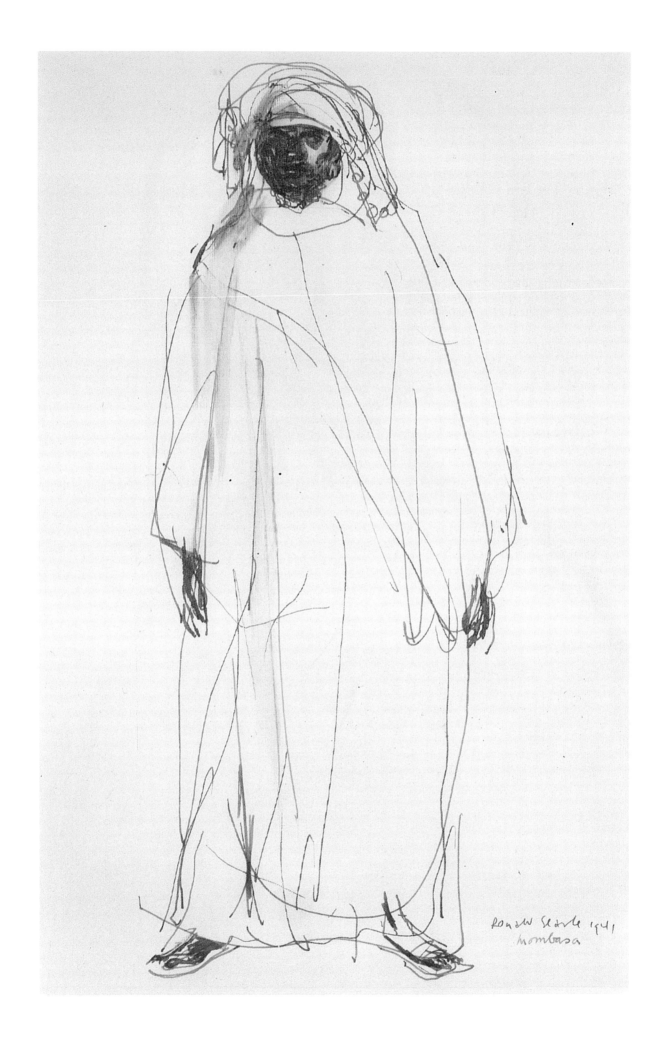

Ronald Searle 1941
Mombasa

By 29 December, as we sailed away
from Mombasa, the Japanese
Imperial Guards had already taken
Ipoh and General Yamashita's
euphoric army was almost half-way
down Malaya. The British, mean-
while, were steadily falling back.

After all the excitement of our two
African halts, and with two more
weeks at sea before being tossed
lightly into a battle that was already
lost, we, the awaited reinforcements,
settled down peacefully for the long
journey across the Indian Ocean. We
were disturbed only by the occasional
lecturer who cheerfully told us that
the Japs, being physically unable to
close one eye (honest), could neither
take aim nor shoot straight and
(seriously) we'd got it made.

But as we had no particular picture
in our minds of what a bunch of Japs
might look and act like, let alone
shoot like – unless it was something
like Fu Manchu and his lot – our
morale was not affected one way
or another.

More demoralizing was the fact
that, to settle comfortably on the
shady side of the deck, we now
had to undo the two top buttons
of our tropical shorts . . .

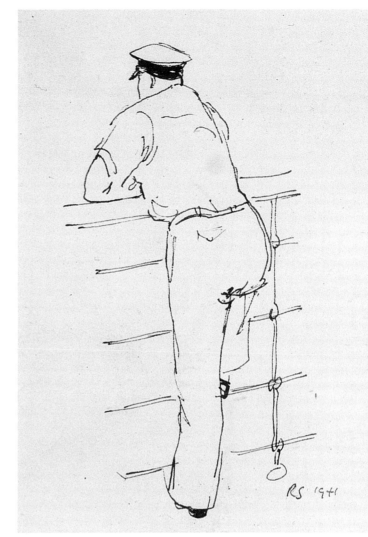

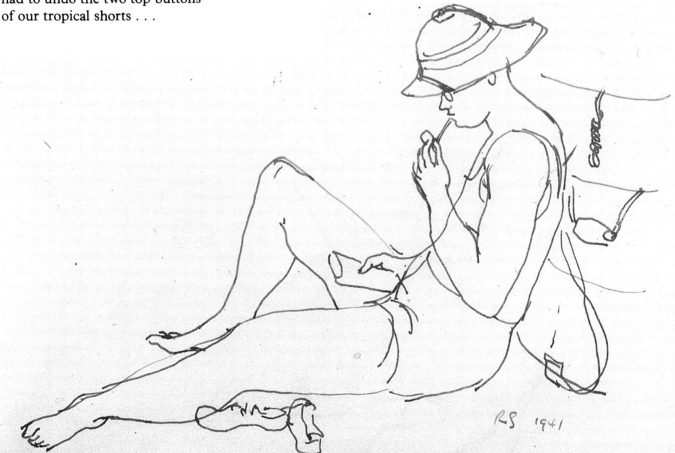

We passed by the Chagos Islands . . .

Ronald Searle 1942
Chagos Islands

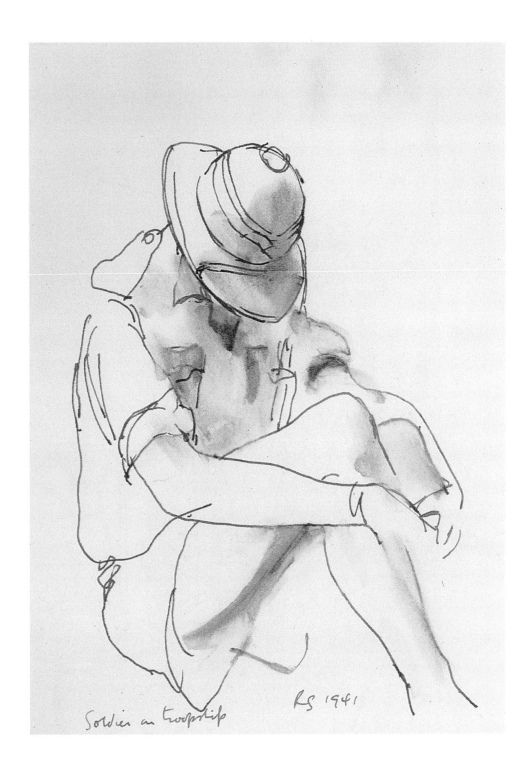

Soldier on troopship

RS 1941

. . . and on 13 January 1942, after a voyage of two and a half months, we disembarked at Singapore Island in torrential rain. It was the luck of the devil. Japanese bombers, overhead and unopposed, were unable to find us through the cloud, so they dumped their load elsewhere and left. Shortly after, unfit, unacclimatized, unenthusiastic and untrained in jungle warfare, the 53rd Brigade was rushed to the front – by now over the road in Johore – and pointed at the enemy.

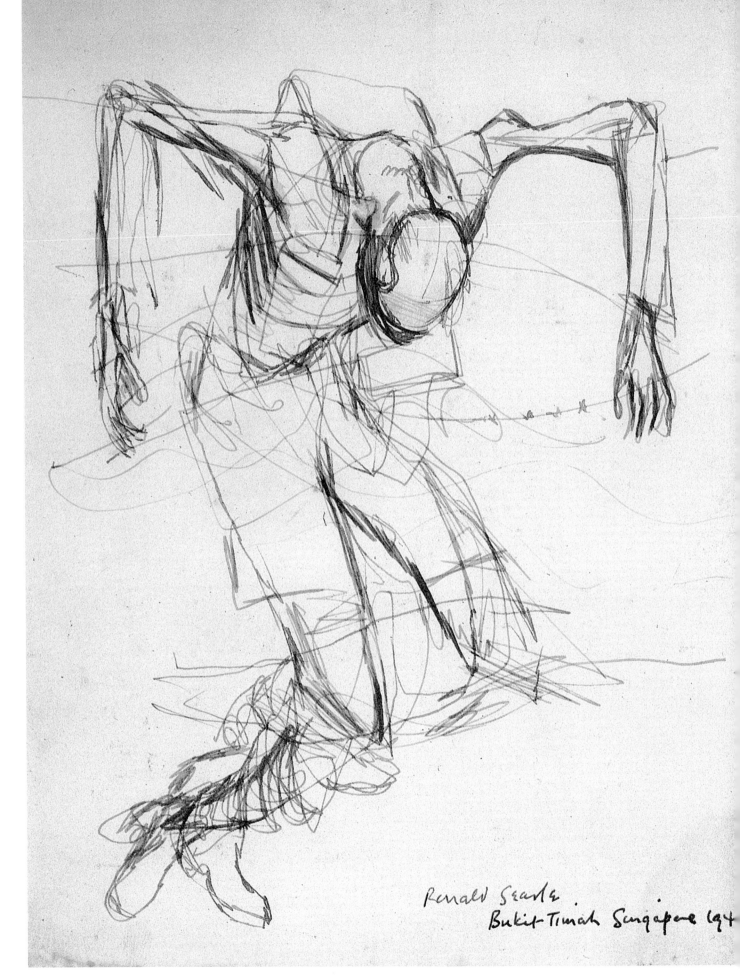

Ronald Searle.
Bukit Timah Singapore 194

3

The Lost Battle

13 January–15 February 1942

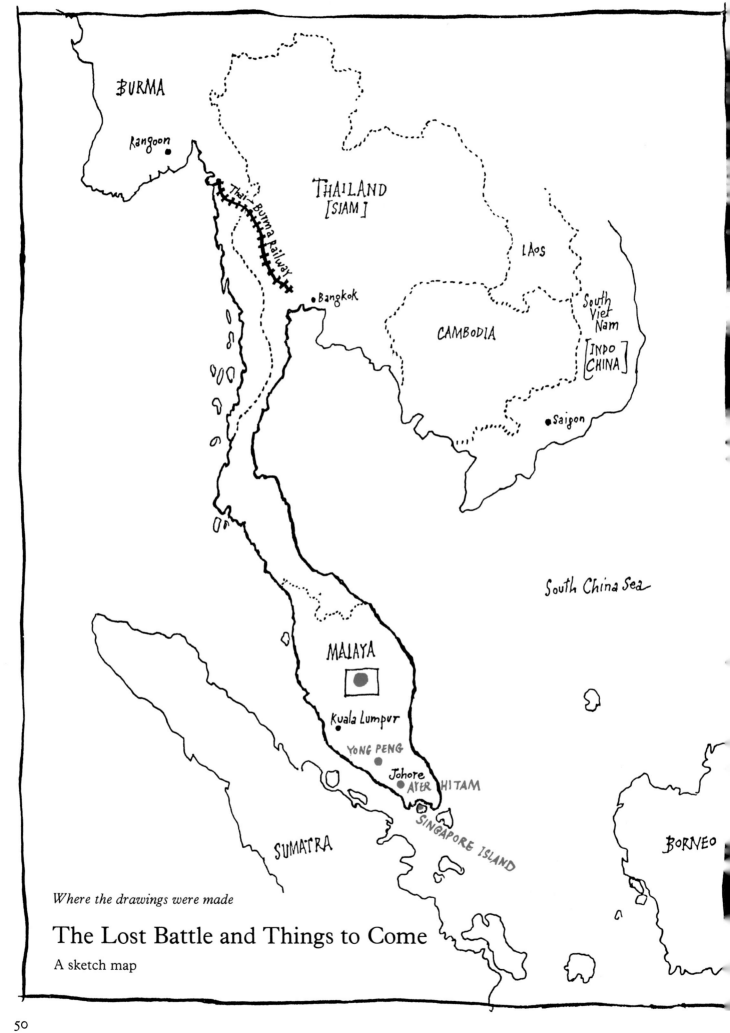

BURMA

Rangoon

THAILAND
[SIAM]

Thai—Burma Railway

Bangkok

LAOS

South
Viet
Nam
[INDO
CHINA]

CAMBODIA

Saigon

South China Sea

MALAYA

Kuala Lumpur

YONG PENG

Johore
AYER HITAM

SINGAPORE ISLAND

SUMATRA

BORNEO

Where the drawings were made

The Lost Battle and Things to Come

A sketch map

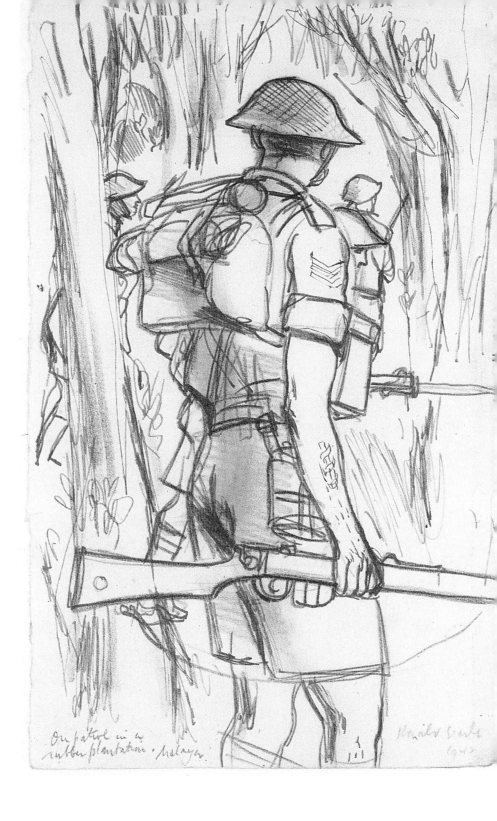

On patrol, moving
forward for once

Our battle, or rather our retreat,
surprisingly enough, lasted a month. The
confusion was unbelievable throughout –
at least around us. Where we were road-
bound, the Japanese were not. Where they
could rely on the initiative of small
guerilla groups advancing swiftly,
infiltrating and savaging anything they
surprised, we lumbered on with our
desert warfare equipment – gas masks
included.

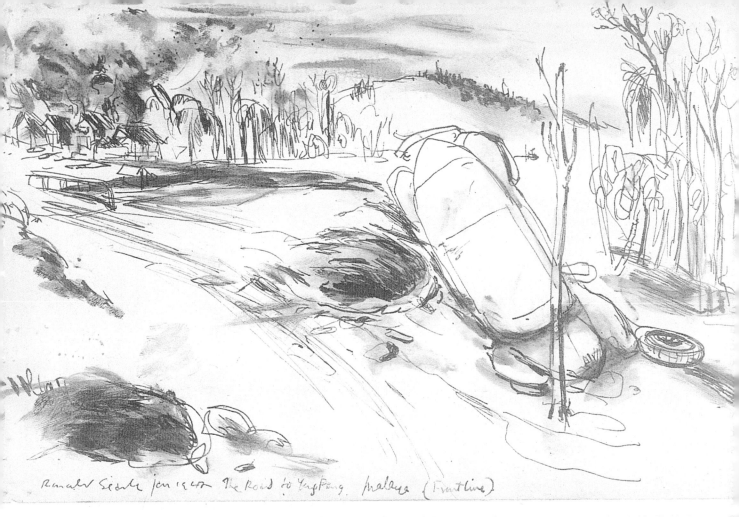

Ronald Searle Jan 1942 The Road to YengPeng. Malaya (Frontline)

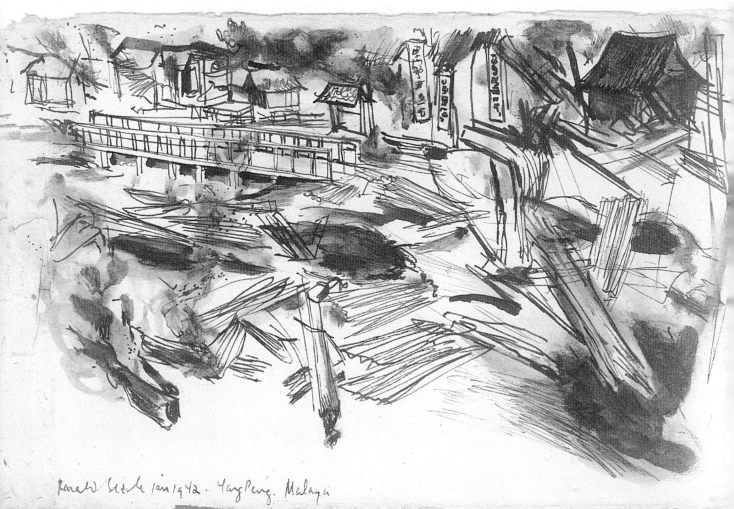

Ronald Searle Jan 1942. YengPeng. Malaya

The retreat to the Bakri-Yong Peng road, after one of the most bloody battles of the campaign, was a shock baptism for us world wanderers who had been precipitated into that sector of the front. We arrived up there as the cut-up survivors were coming back. Worse, once the battered infantry had retreated, we startled Engineers were told to head towards the Japanese (wherever they might be by now) and destroy anything that might be of comfort to them. And good luck. It was a scorched-arse policy at its most refined. In the suffocating tropical heat, among abandoned equipment, filth, smoke, blood and rubble, my final memory of Yong Peng and Ayer Hitam was of feeling my skin blister as we plunged through the flaming ruins of the villages we were burning. We eventually lumbered off in our trucks to seek a unit that would take us in, finally ending up with the remnants of the carved-up 11th Indian Division, where the Bengal Sappers and Miners fed us a consoling chupatty or two.

Meanwhile the Japanese moved forward to chop into small pieces all the wounded that had to be left behind. And so it was all the way down the rest of the mainland, until we backed off Johore onto Singapore Island. After that there was only the sea. Not surprisingly, I have only one or two sketches of those days.

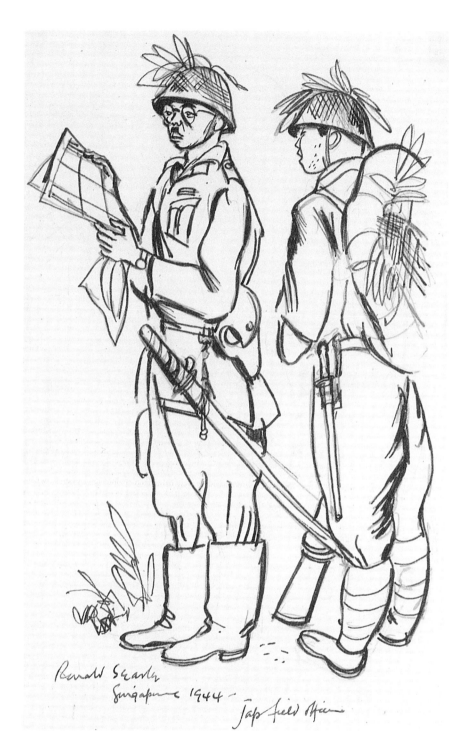

Japanese in the field.
Drawn later, but similar
to what we could not
see facing us now.

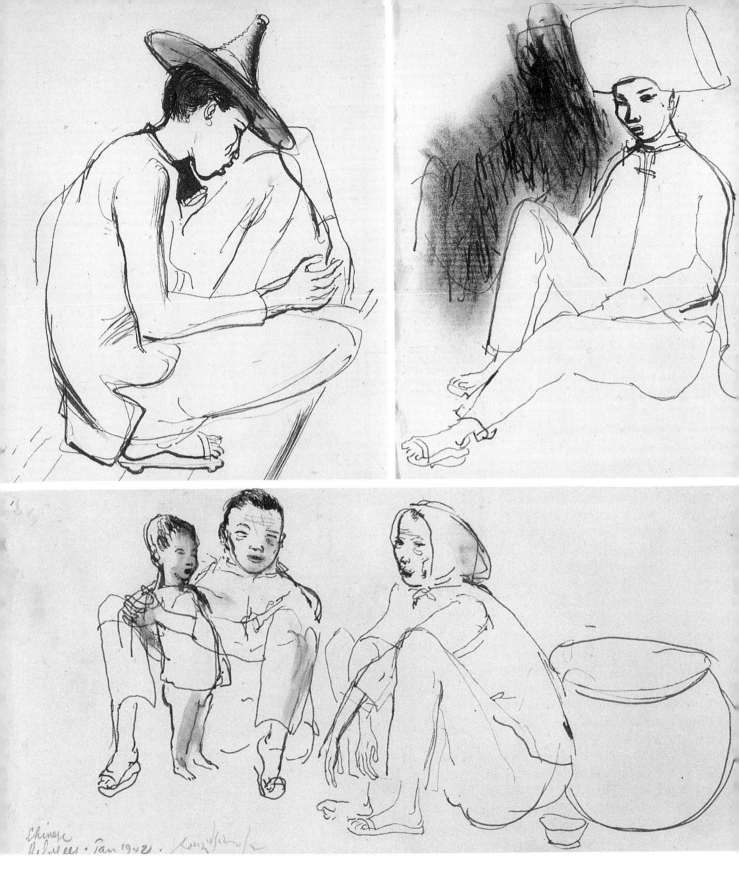

Chinese
Refugees · Jan 1942 · [signature]

The plight of the refugees was appalling. Something like half a million people – mostly Chinese it seemed – had fled before the advancing Japanese. On foot and on bicycles, with a handful of possessions, they added to the general confusion by congesting what roads there were to the front. Now most of them were huddled in the already cluttered streets of Singapore.

At intervals, as Japanese aircraft dropped sticks of bombs on the city, massive waves of human misery would rise and run from one area to another. Only the heavy thumping of hundreds of bare running feet and occasional brief gasps and sobs broke the silence that followed the explosions. It was uncanny and frightening.

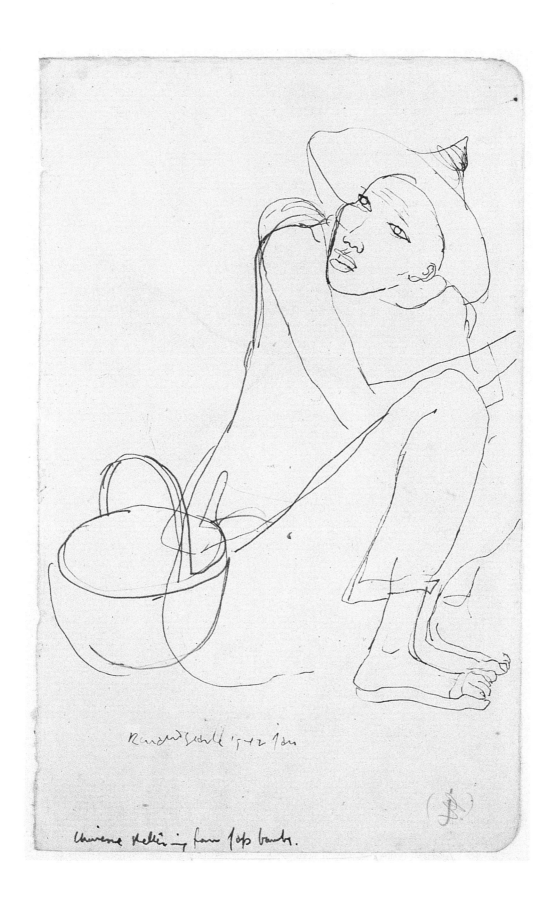

Rudolf Scholz 1942 Juni

Unsere Kellnerin vom Jap. Baude.

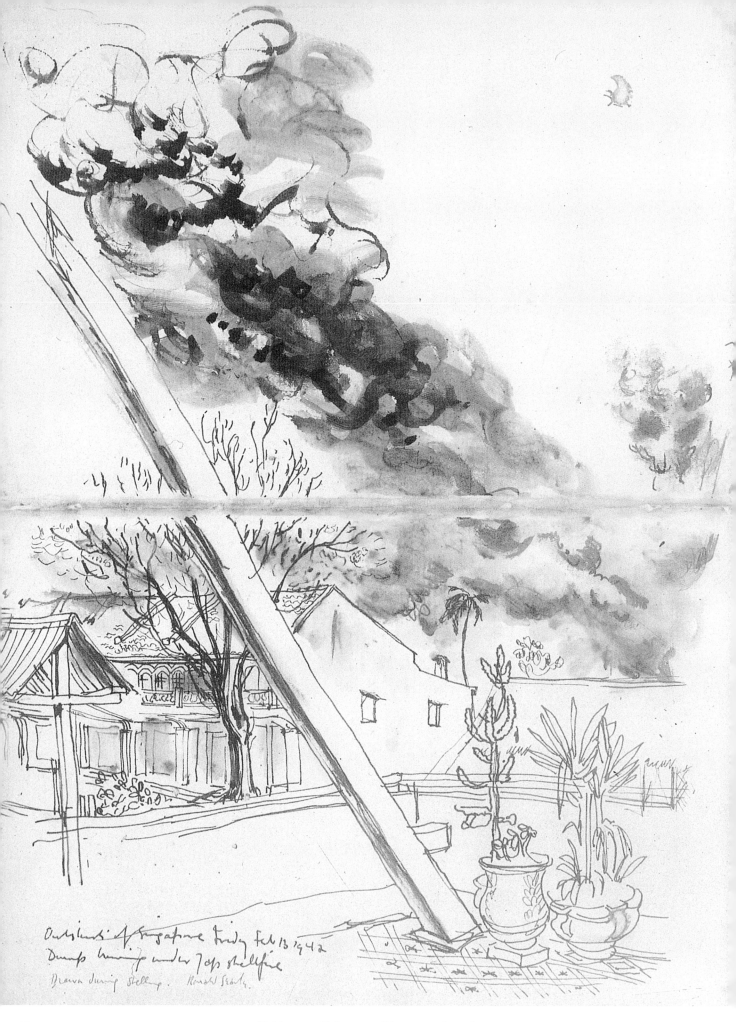

Outskirts of Singapore Friday Feb 13 1942
Dumps burning under Jap shellfire
Drawn during shelling. Ronald Searle.

Friday, 13 February. Singapore burning.

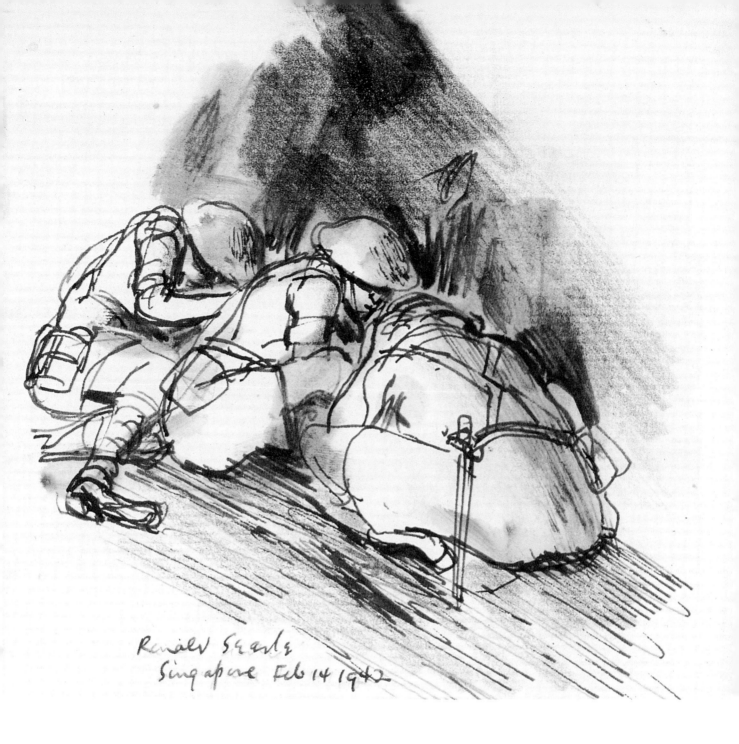

Ronald Searle
Singapore Feb 14 1942

On the morning of 31 January 1942, on the assumption that everyone who could had got out of Johore State and back onto the island, the Causeway linking Singapore to the mainland was breached and Malaya (as well as any serious future British influence in the Far East) was lost. In fifty-five days, General Yamashita, with a highly-trained but numerically inferior force, had pushed the combined divisions of an Australian, Indian and British army off the mainland and into the trap. Now some 80,000 troops, the remaining mixed population and half a million refugees were in a state of siege in an area approximately twenty-six miles by fourteen.

On 9 February the Japanese established a foothold on the island. On 10 February Churchill signalled that 'There must be no thought of saving the troops or sparing the population. The battle must be fought to the bitter end . . . Commanders and senior officers should die with their troops . . .' (Ho, ho.) By Friday the 13th the Japanese had reached the outskirts of the town and everything came easily within shelling range. On the 14th they closed in, shelling, mortaring and strafing what was now a tightly-packed sardine tin . . .

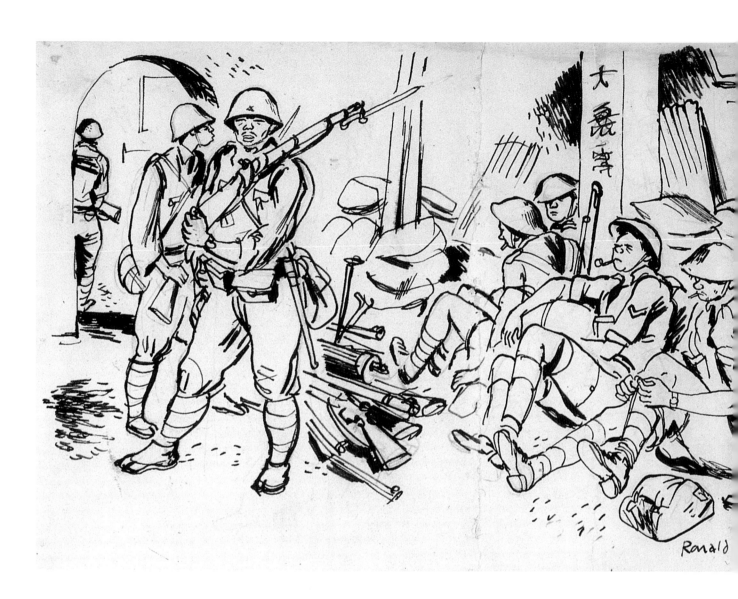

. . . and so, on 15 February, Singapore
capitulated to prevent further massacre –
not least because the Japanese now
controlled the water supply and could turn
off the tap whenever they wished. Years of
inept, incoherent and chaotic political and
military mismanagement had reached
a logical conclusion. But that was no
consolation to us – the poor unfortunates
who were now prisoners because of it.

'Banzai!' Victorious Japanese
troops occupy Singapore.

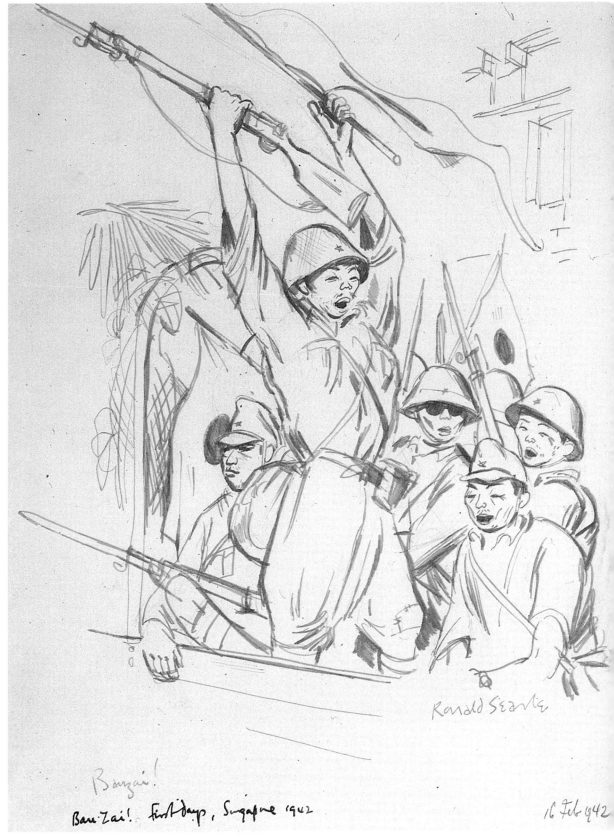

Banzai!

Ban-Zai! First days, Singapore 1942

Ronald Searle

16 Feb 1942

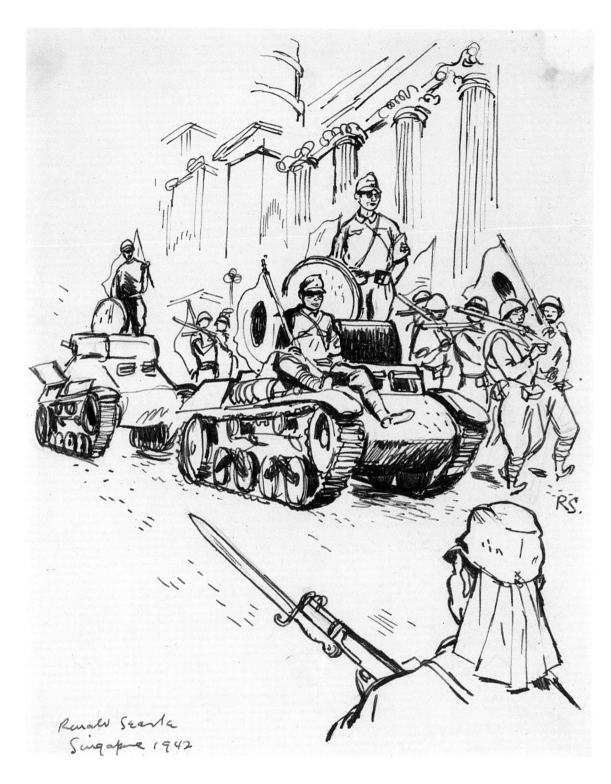

Ronald Searle
Singapore 1942

We were more curious than apprehensive
to see the unstoppable and, until now,
virtually invisible army that had kept us
on the run. They were a sinister-looking
lot, but no scruffier than we were by now.

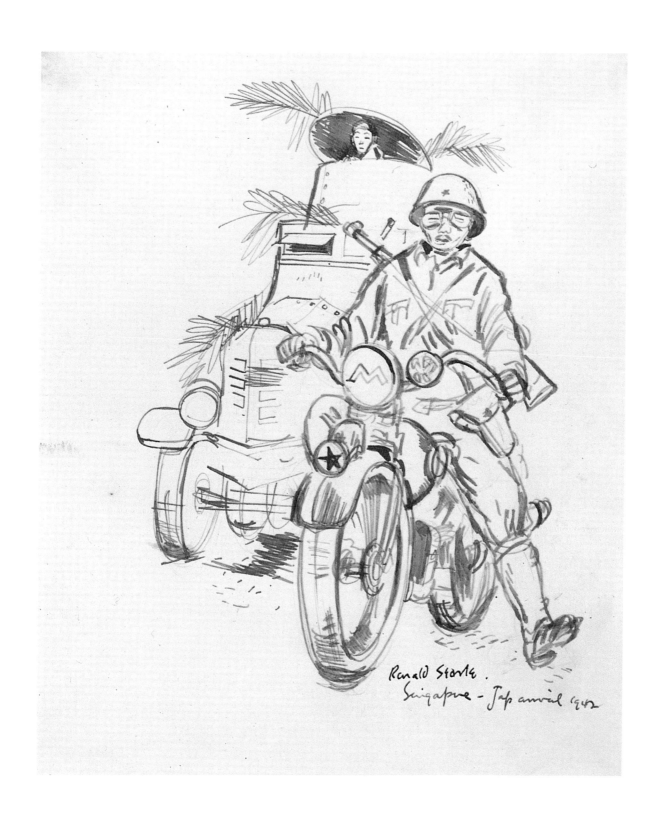

Ronald Searle.
Singapore – Jap arrival 1942

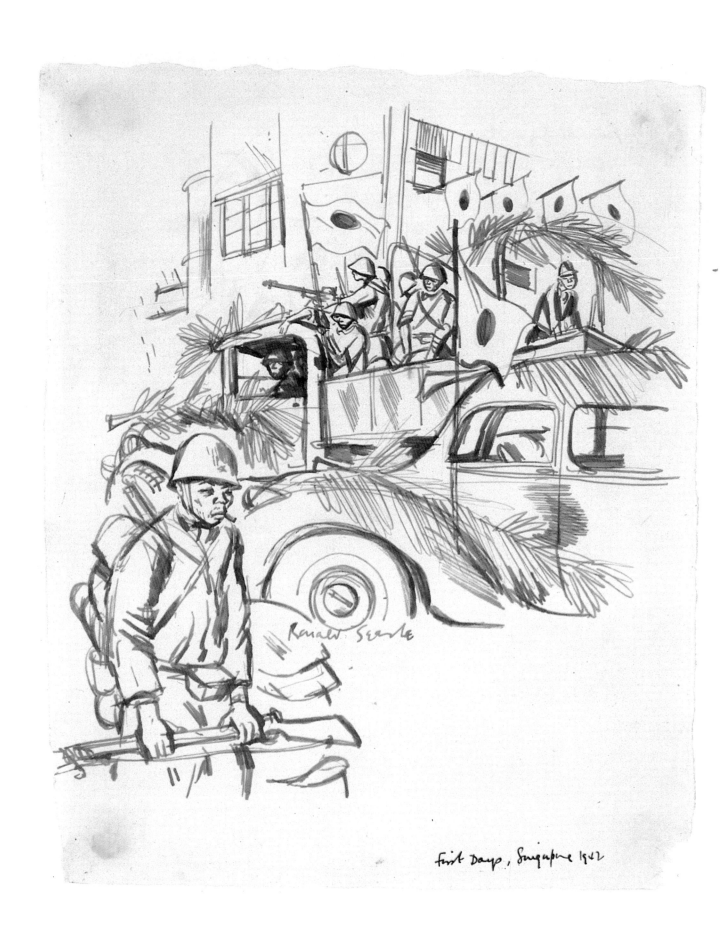

First Days, Singapore 1942

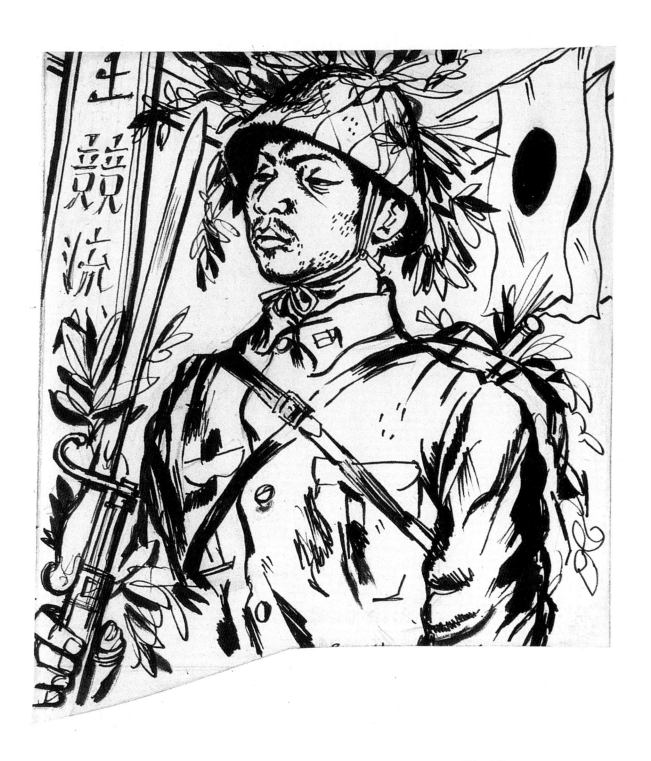

The Victor.
A suitably symbolic sketch
(authenticity of the Chinese
characters not guaranteed)
made in the early days of
captivity.

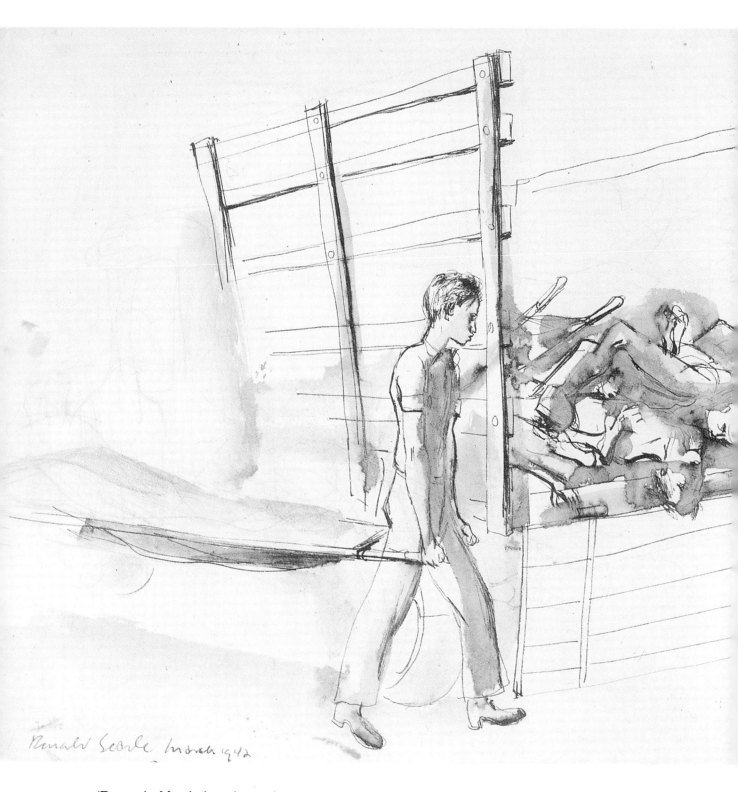

(Drawn in March, but observed
shortly after capitulation.)

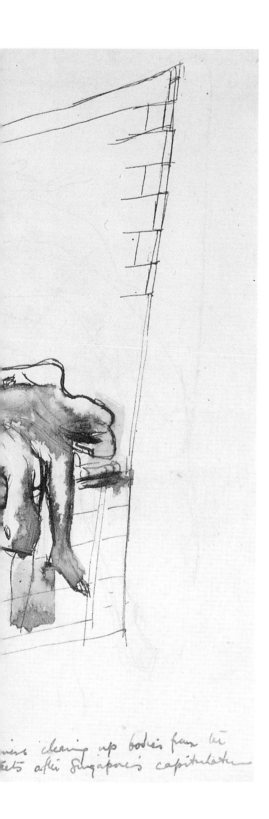

...iers cleaning up bodies from the streets after Singapore's capitulation

The tidying-up soon began. First, of the bodies that had been strewn about the streets for days . . .

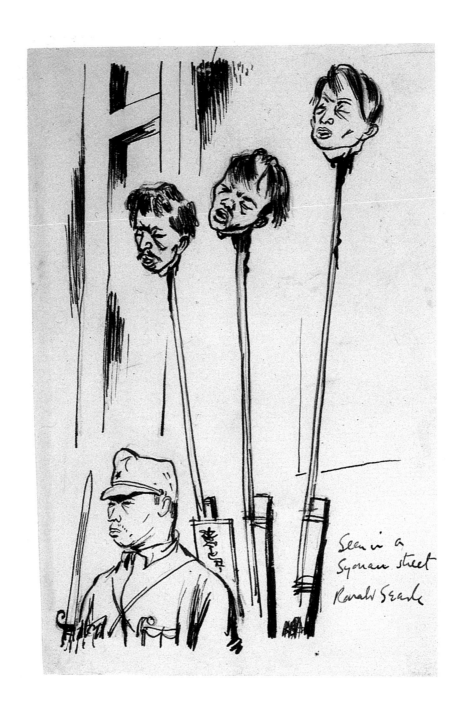

Seen in a
Syonan street
Ronald Searle

. . . and then of 'unco-operative' Chinese
and Malay civilians, whose heads were
displayed on street corners of the town –
now renamed 'Syonan' – as a warning to
others. It is estimated that 20,000 Chinese
alone were shot or beheaded during the
first few days after capitulation.

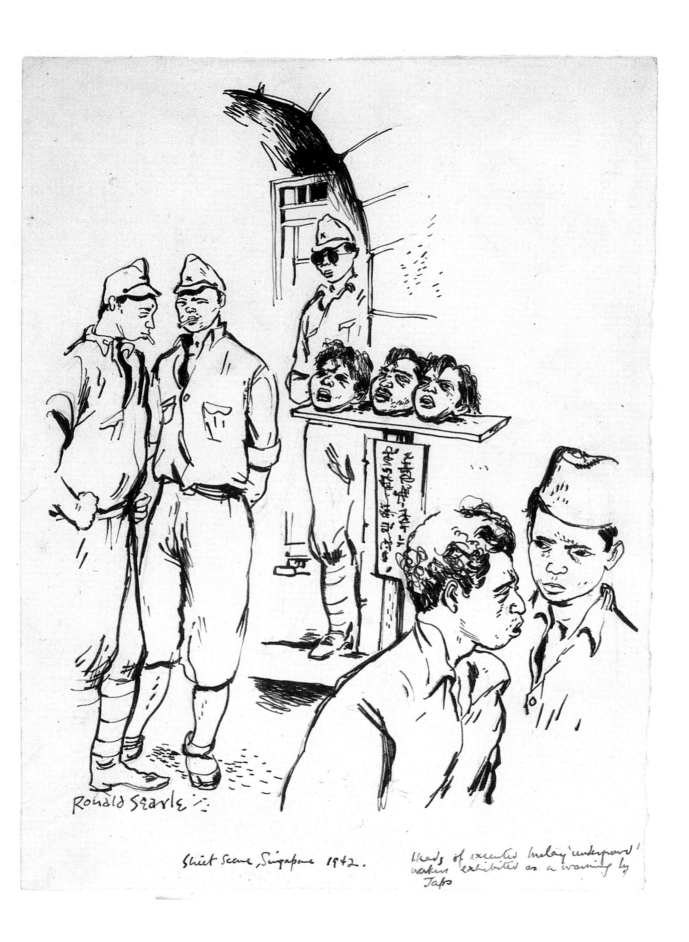

Ronald Searle

Street Scene, Singapore 1942.

Heads of executed Malay 'underground' workers exhibited as a warning by Japs

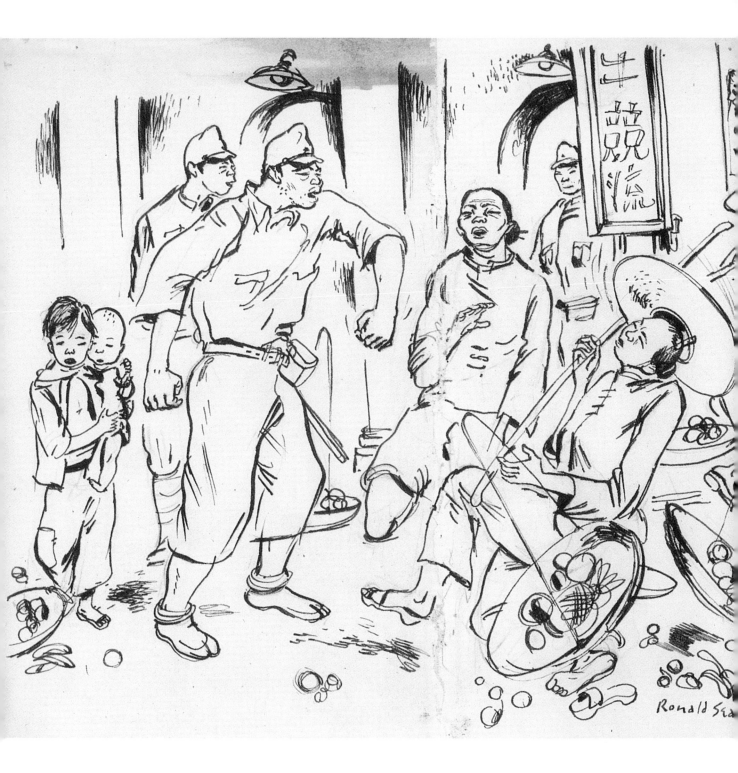

Some Chinese were lucky and were
merely beaten. In this case, for selling
fruit to British prisoners.

Or simply for amusement.

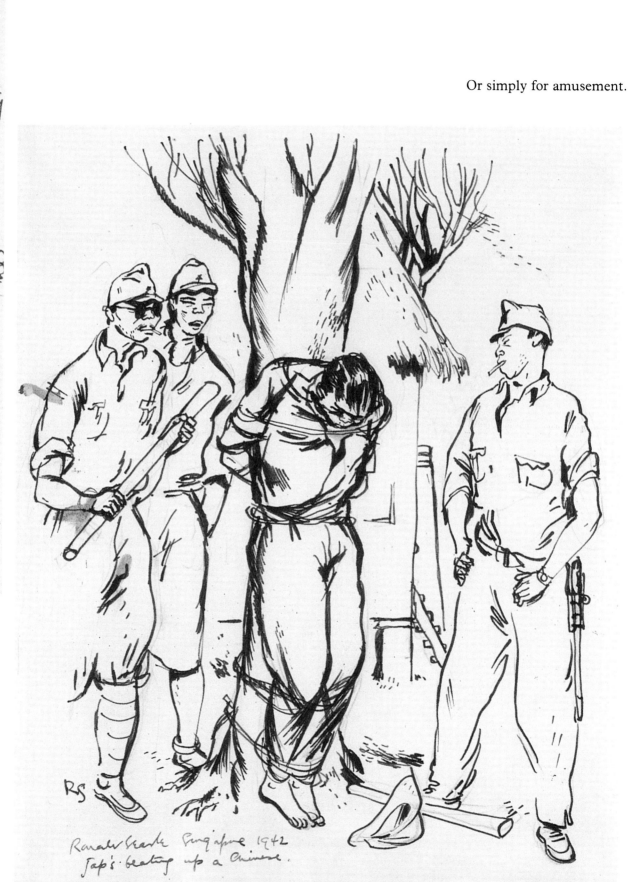

Ronald Searle Singapore 1942
Jap's beating up a Chinese.

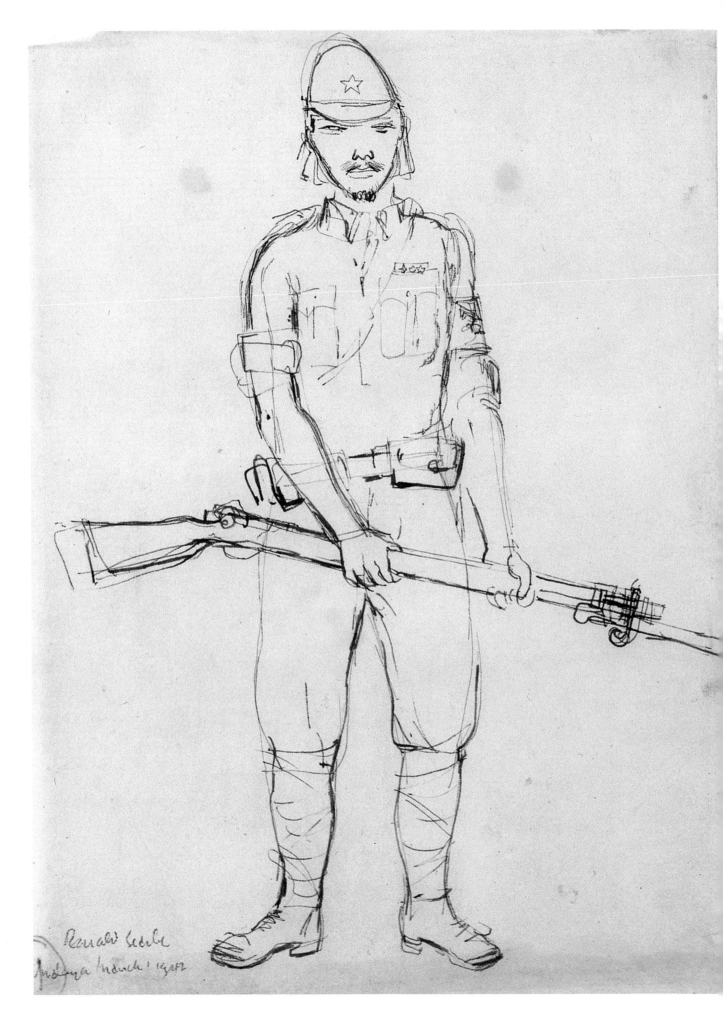

Ronald Searle

Sydney March 1942

4

POW No 1/5594
Changi Camp

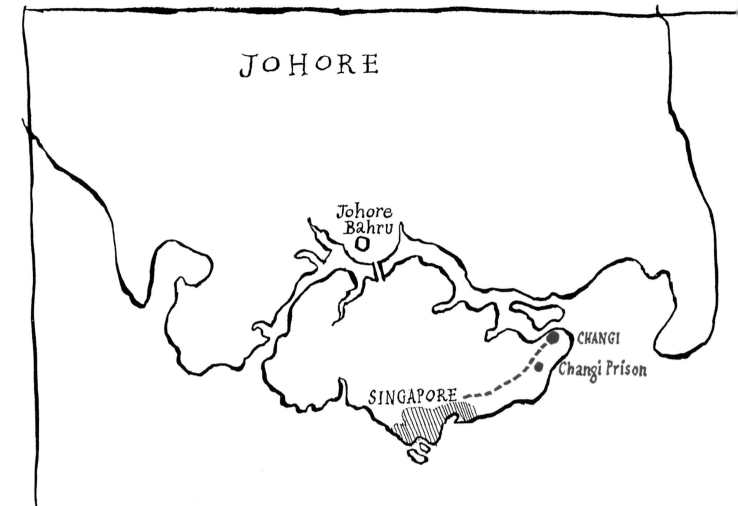

Where the drawings were made

Singapore Island and Changi

A sketch map

On Tuesday, 17 February 1942, after forty-eight hours of being shoved here and there and awaiting news of our fate, we were disarmed and told that we were to be walked to Changi, an area on the eastern extremity of Singapore Island. Fifteen years before, Changi had been a mixture of uninhabitable mangrove swamp and virgin forest, but it had since been reclaimed as a military base. All troops were to be confined there until otherwise disposed of. In the next two days more than 52,000 of us shuffled the fourteen miles from Singapore in crushing equatorial heat, loaded down with what possessions we had managed to salvage from the shambles of the last few days.

We passed between what seemed to be the entire native population of the island. My now hazy recollection of that march is one of a forest of hands waving little rising-sun flags at us, a dirty, thirsty, sweaty and demoralized herd of losers. We eventually made our way past Changi Gaol – a future 'home' – into our first taste of confinement and an uncertain future. I was to stay in the Changi barracks area until 8 May the following year, when I was transported to the Siamese jungle with 'H' Force working party.

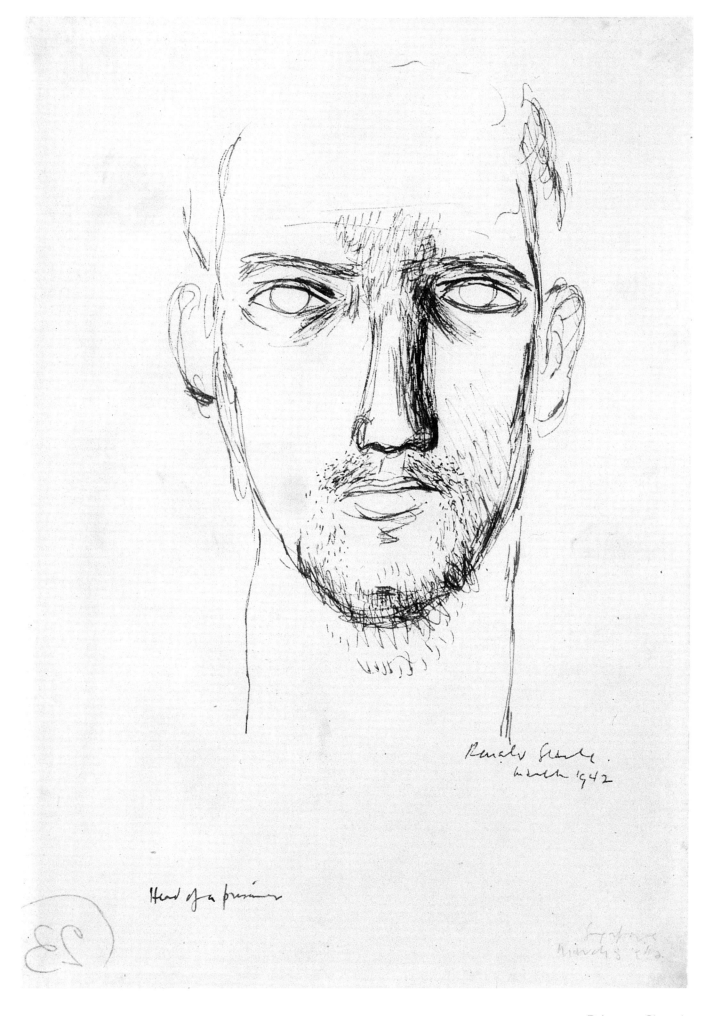

Ronald Searle.
March 1942

Head of a prisoner

Prisoner, Changi 73

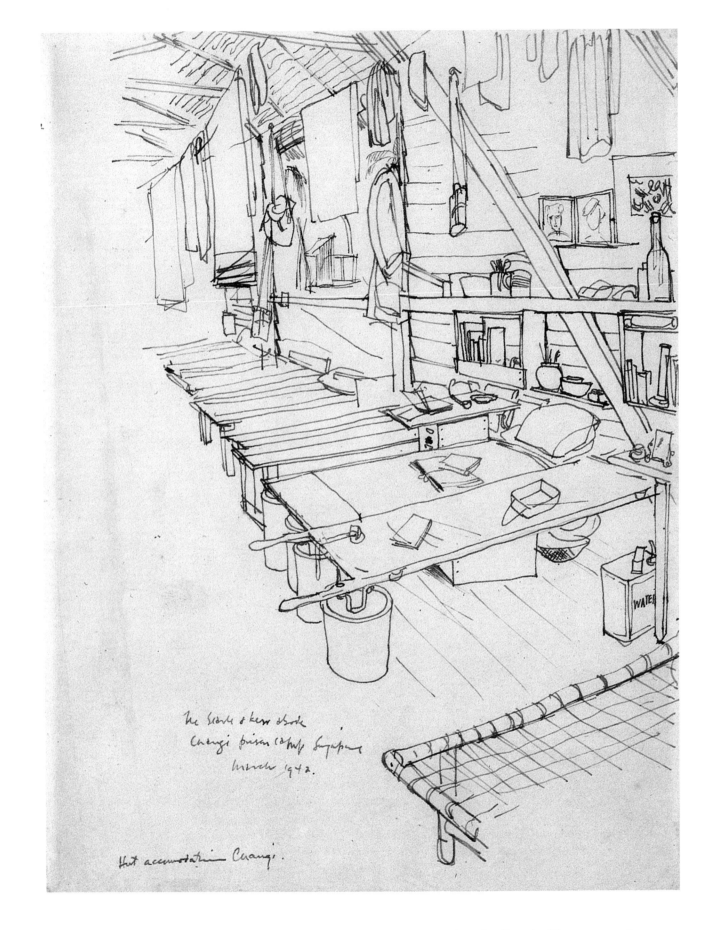

The scene + base abode
Changi prison camp, Singapore
March 1942.

Hut accommodation Changi.

First, at Changi, we lay on the ground where we fell. Later we were allotted accommodation in India Lines – sixty men to each ex-Punjabi wooden hut thatched with palm fronds. Very romantic. Next we stole anything as yet unstolen, with which to concoct a bed and arrange a personal nook of our own.

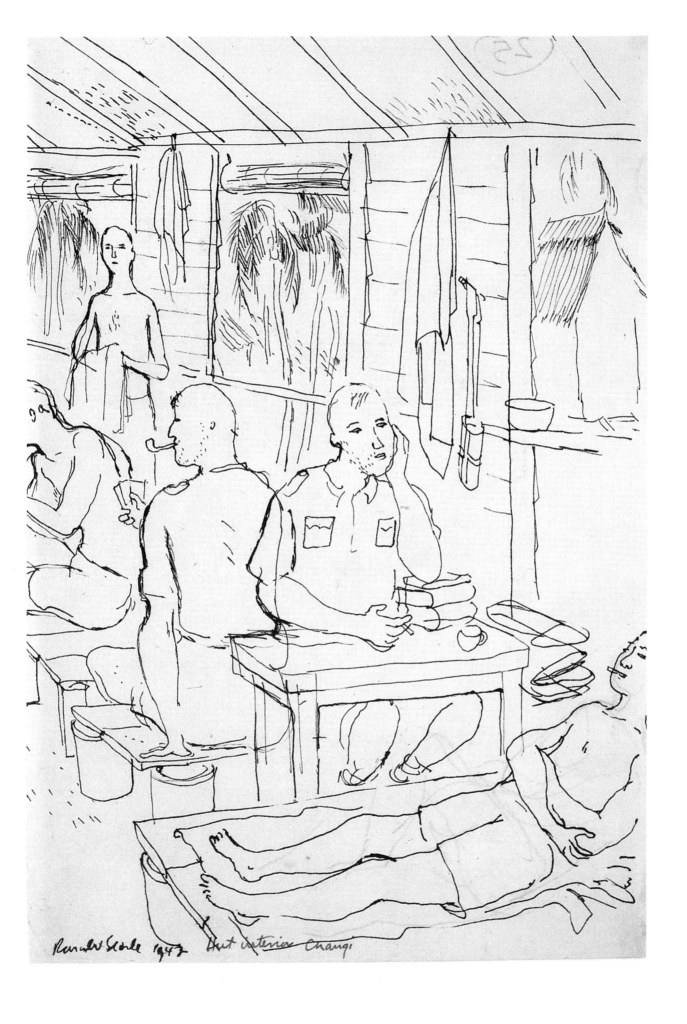

Ronald Searle 1942 Hut interior Changi

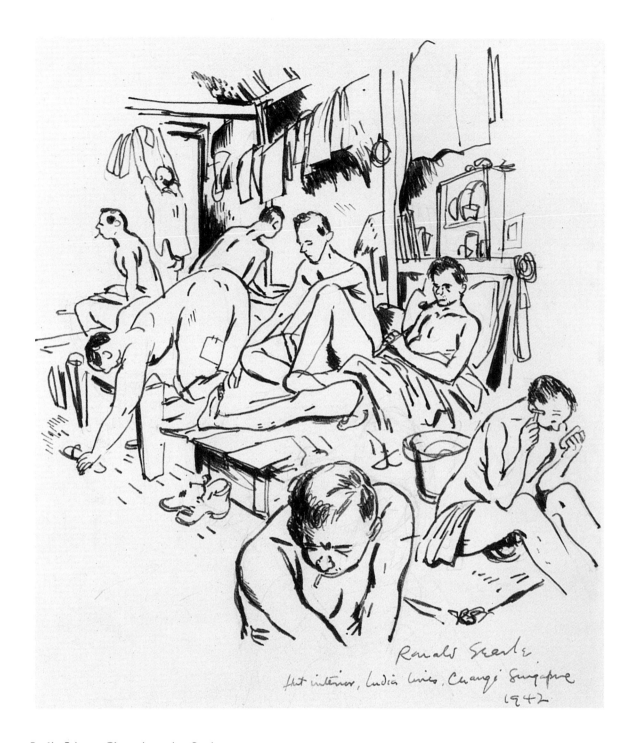

India Lines, Changi, again. Spring 1942

A clumsy, but authentic
sketch. I was already
having trouble with my
one and only faithful pen.

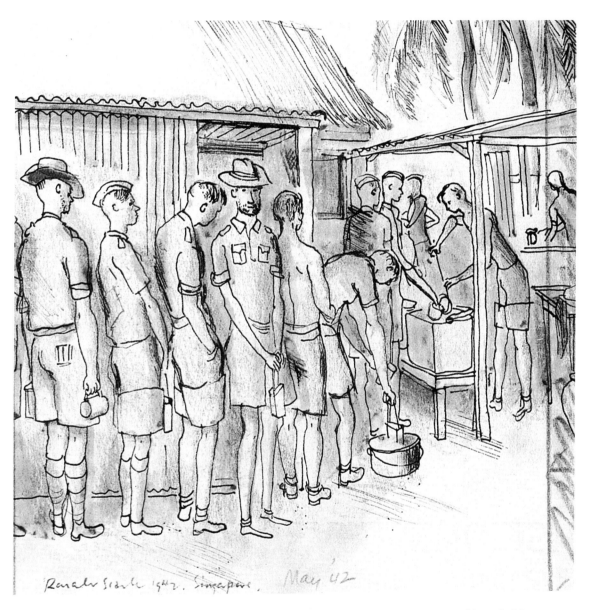

Changi, May 1942.
Prisoners queueing
for their rice

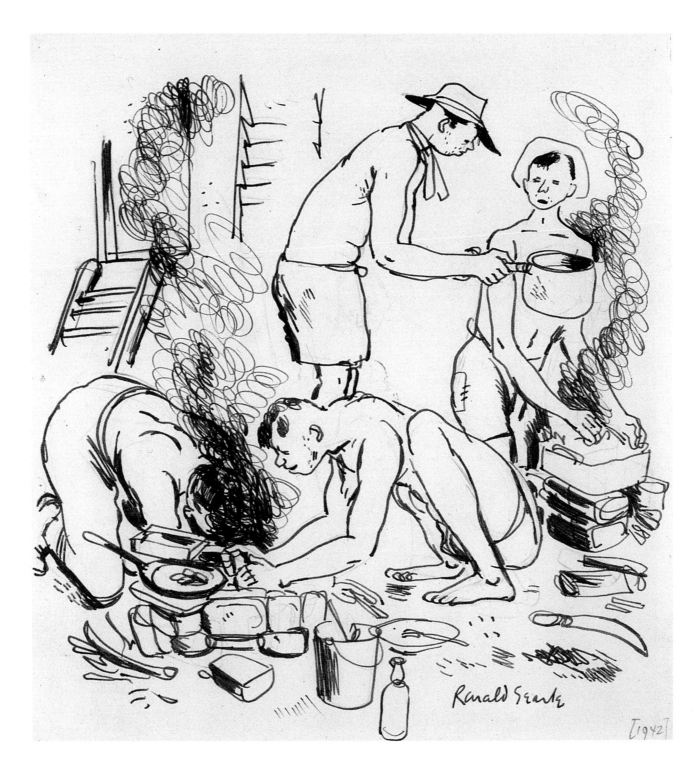

Prisoners cooking scrounged scraps

RIGHT March 1942.
Some of us were already getting that
slightly glazed look of the imprisoned.

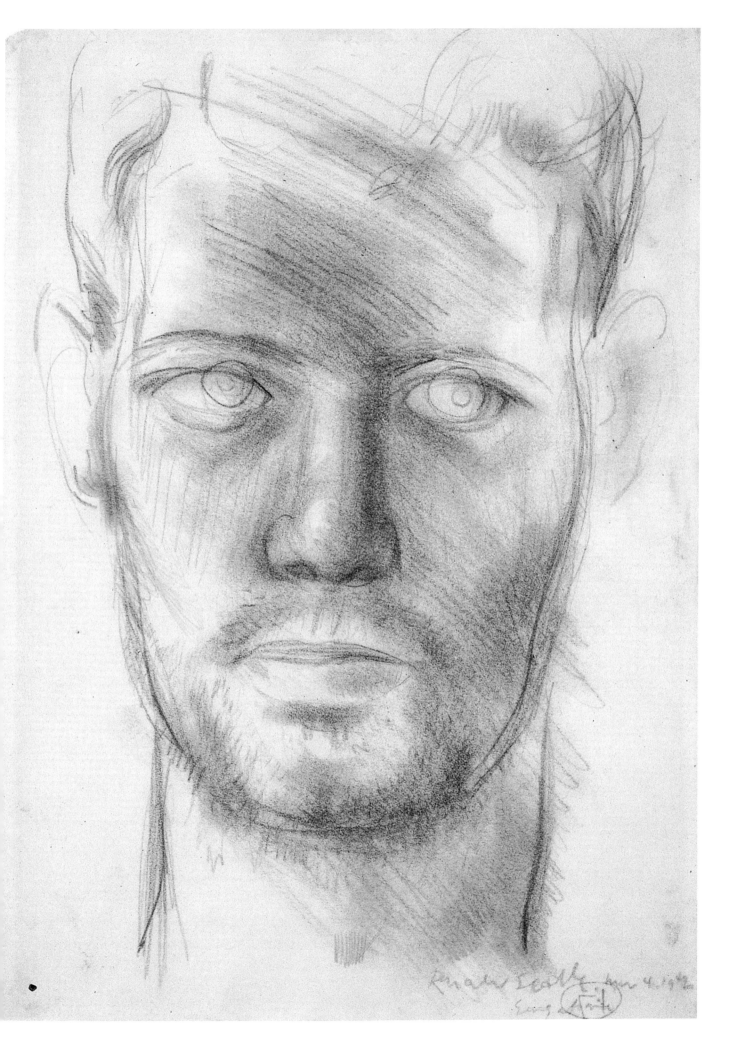

In those early days behind the wire we saw few Japanese and were more or less left alone to restore our own order out of the ungentlemanly and unmilitary chaos. Occasionally we were assembled to be beamed over by some impeccably-dressed high-ranking military visitor, who would tell us to be good or be shot. Additionally we were not, it appeared, recognized as conventional prisoners-of-war as established by well-meaning but misguided politicians, but as shameful captives. The traditional Japanese military philosophy allowing no alternative to victory but death, we were the dishonoured, the despised, the lowest of the low. Armbands were issued to this effect, to be worn by certain of the camp administration, bearing the inscription in Japanese: 'One who has been captured in battle and is to be beheaded or castrated at the will of the Emperor.'

After about a month we were divided up and more firmly wired into smaller areas – more closely patrolled but, happily, not yet castrated. The Emperor, no doubt, had other trifles on his mind.

Food was increasingly scarce – a little rice with the odd trimmings, plus anything edible that walked, wriggled or flew, or that could be scrounged or bartered through the wire – and at best we hit four hundred calories a day. Meanwhile clouds of flies clung to us, and an exotic variety of insects ate us. Bites and scratches began to turn into uncontrollable, flesh-consuming tropical ulcers.

By summer we were generally ill and ragged. Before the end of the year five hundred prisoners had died of 'natural' causes and seven had been executed.

Fortunately we did not know that this was merely the beginning . . .

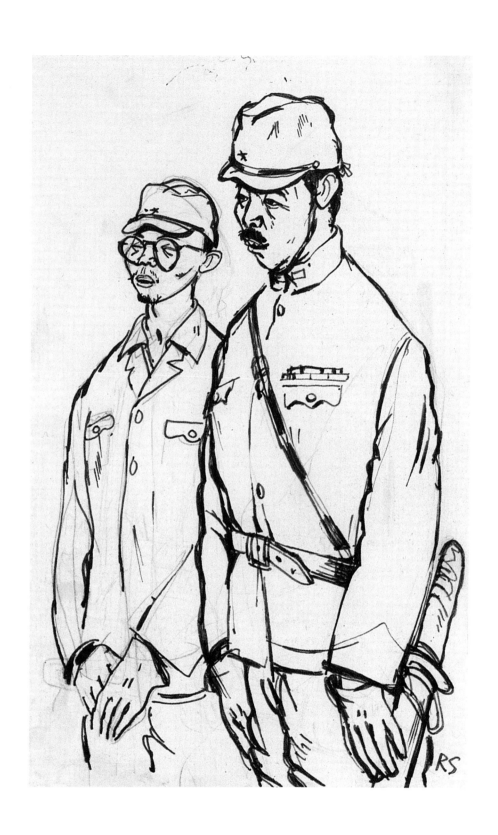

Inspecting Officer, Changi 1942

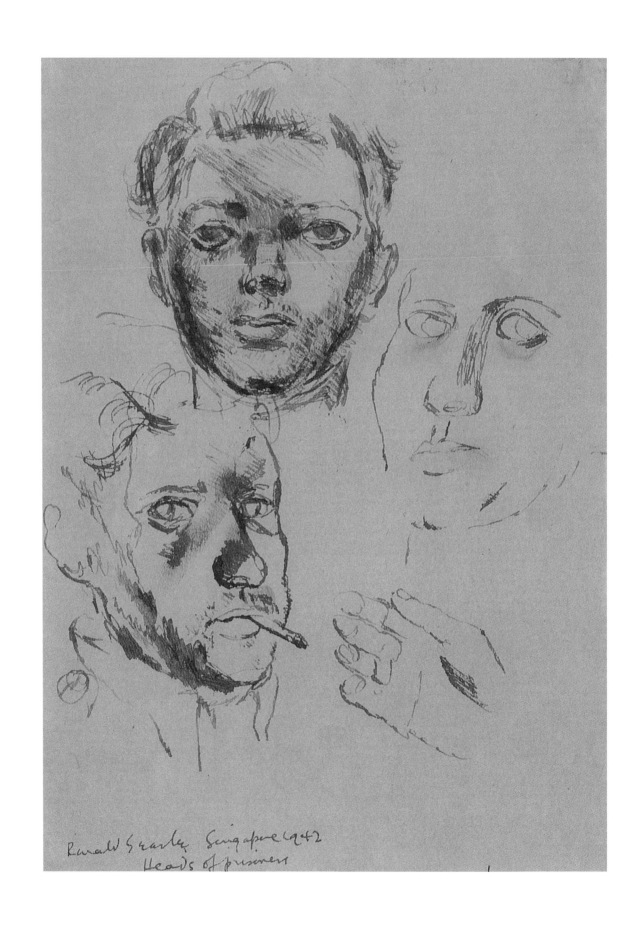

Ronald Searle Singapore 1942
Heads of prisoners

More prisoners.
There were plenty of heads (still attached) to sketch

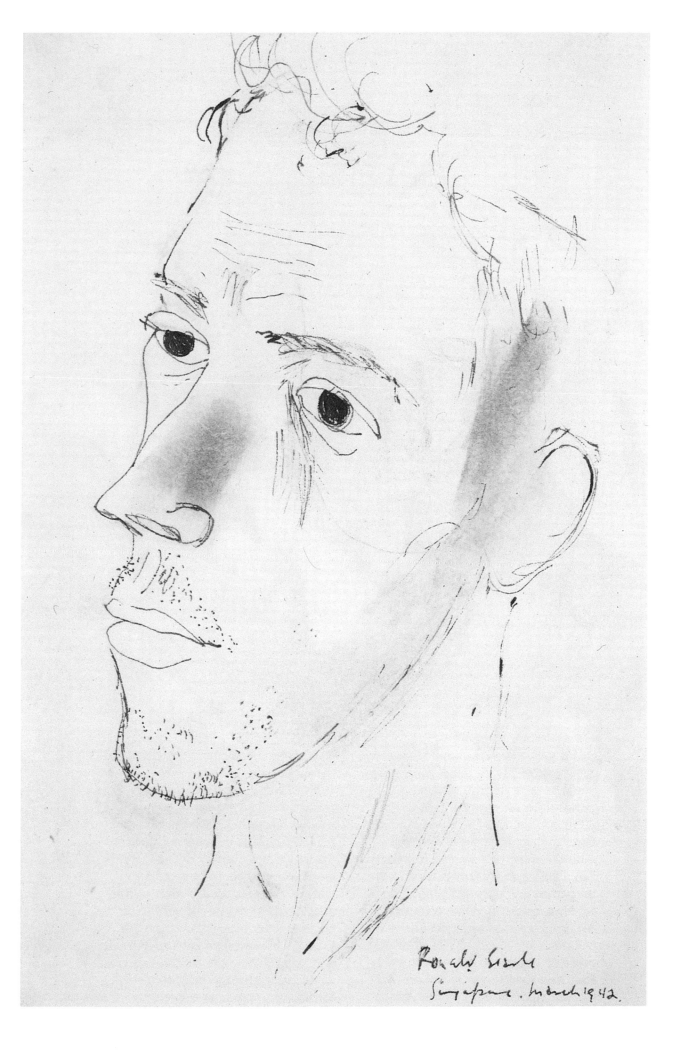

Ronald Searle
Singapore. March 1942.

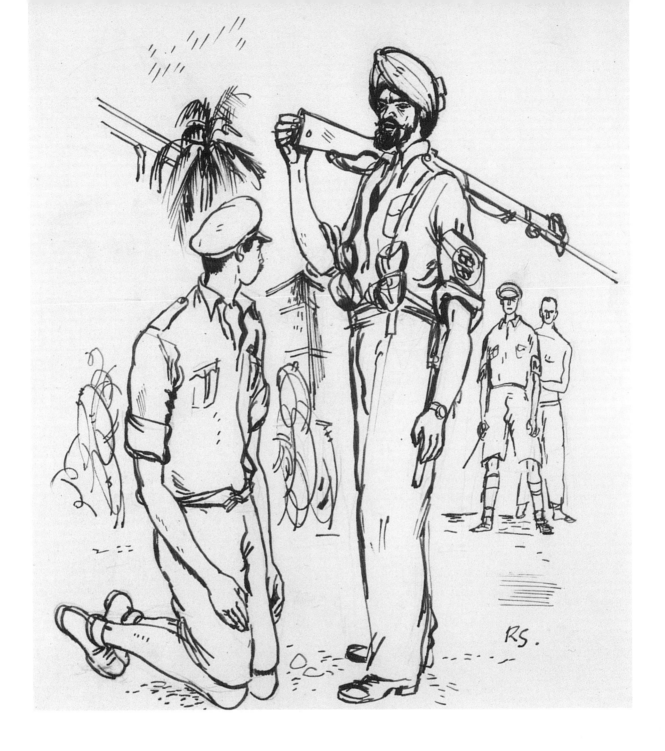

Of the 65,000 Indian Army troops taken prisoner at the fall of Singapore, but kept separate from us, about 25,000 accepted the glad tidings that the Japanese loved them and needed them to help drive out of East Asia a common enemy – British Imperialism. Consequently they retained their arms and were welcomed into a Tokyo-inspired Indian National Army whose object was the liberation of India. The final aim was to aid the eventual setting-up of a 'Greater East Asia Co-Prosperity Sphere' for the benefit of all. Asia for the Asians – under the benevolent guidance of the Japanese.

However, for the moment they – and especially the Sikhs – were needed for more vital jobs, including that of guarding us, in order that the maximum number of Japanese combat troops could be freed for further victories. So the most visible guard duties outside the wire were taken over by the Sikhs, who gratuitously thrashed any unfortunate who caught their eye. In this case, an officer is about to be beaten for failing to salute as expected.

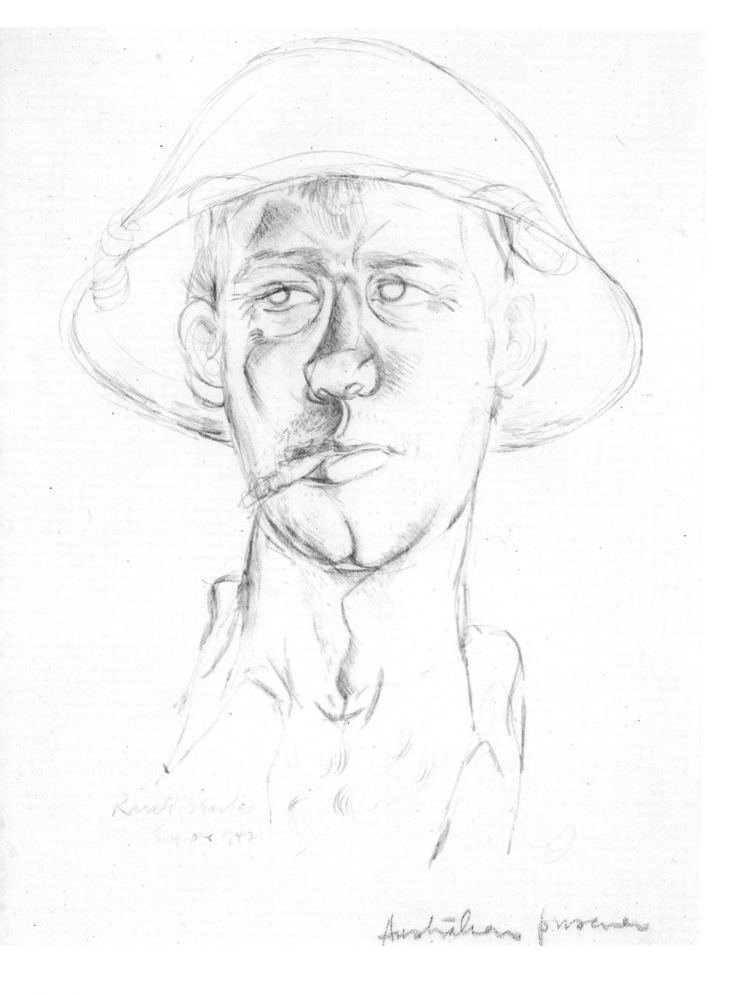

Ronald Searle
S'pore 1942

Australian prisoner

Australian prisoner

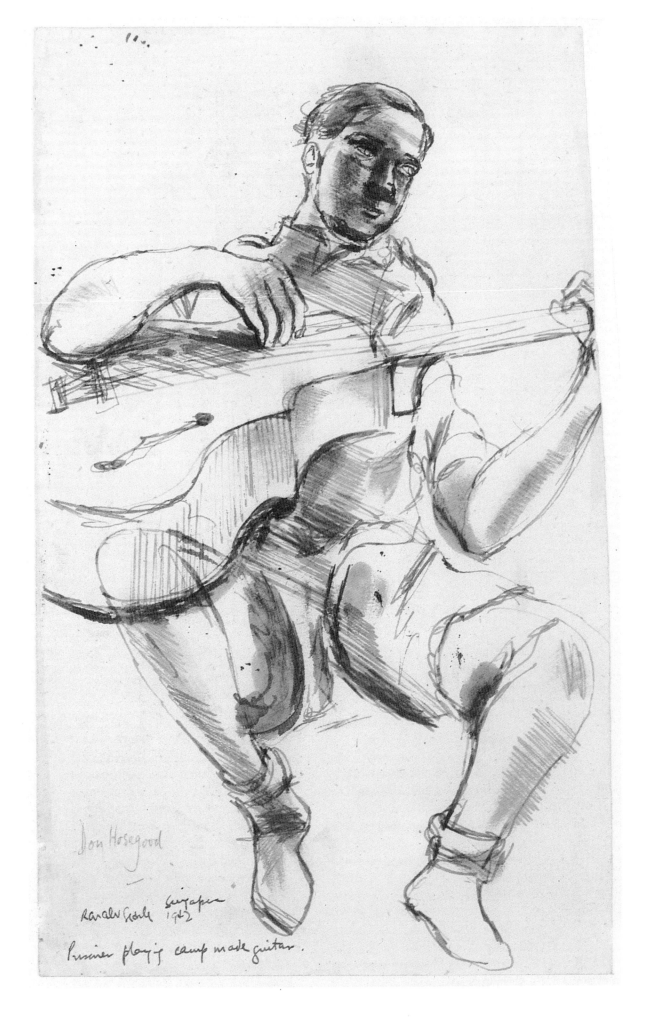

Ronald Searle Singapore 1942

Prisoner playing camp-made guitar.

Prisoner playing his camp-made guitar

.nd prisoners lying around listening . . .

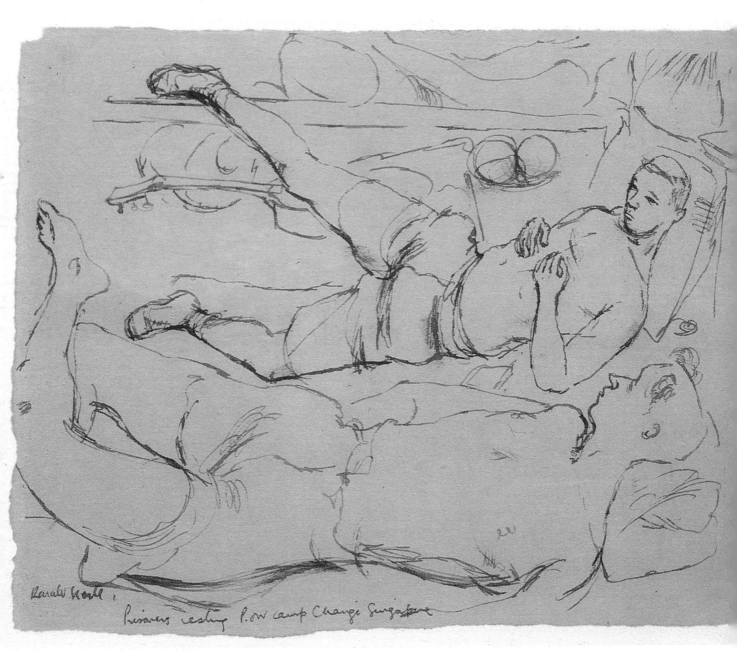

Prisoners resting P.O.W. camp Changi Singapore

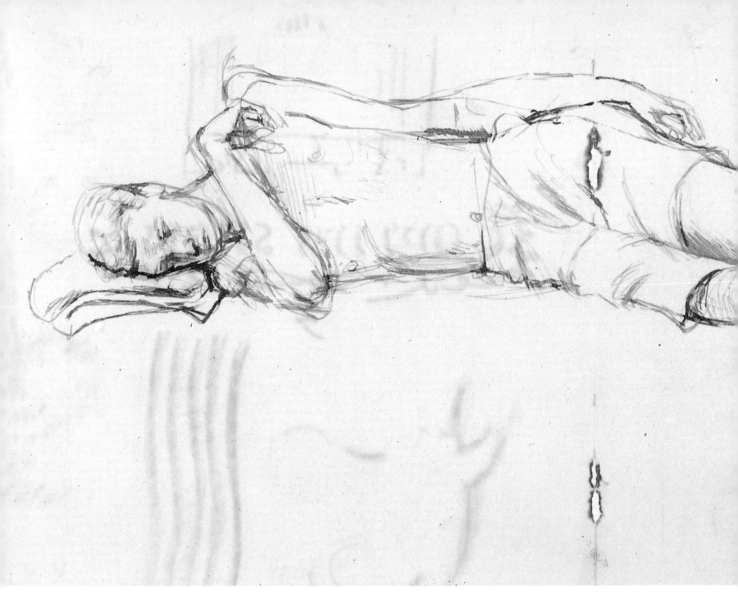

. . . or sleeping. But not for long.

Ronald Searle Singapore 1942
Prisoner asleep.

With an inscrutably oriental wave of the brush we were now, it appeared, considered as being embodied into the Japanese forces; even if only as disposable captives. So to this end, Tokyo dispatched us a general, complete with truckload of administrators, to get us into some sort of shape that would be acceptable to the Emperor.

On 30 August the appositely-named Major-General Fukuye announced that all captives would be 'given the opportunity' to sign an undertaking not to attempt escape. As Geneva Convention POWs, our camp commanders advised us against it and Fukuye was not pleased. The next day we lined up in the blistering sun for an interminable complete count of prisoners, stretcher cases included. .

On 1 September, silence . . .

The notorious form

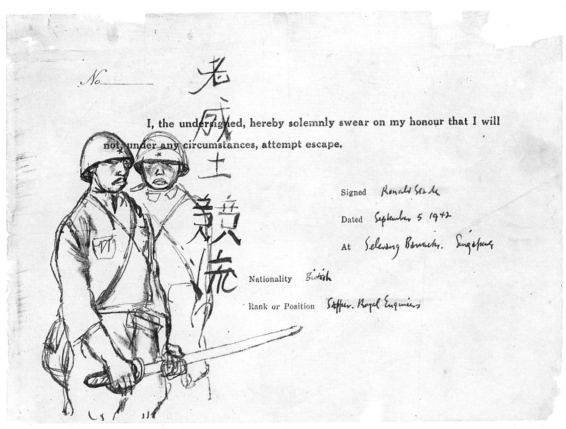

On 2 September, senior camp commanders were escorted to witness the execution of four 'recaptured' prisoners. These were told to dig their own graves on the beach by the camp and were shot. Immediately after this, all the men were ordered by the Japanese to be ready to move off with what they could carry. We were given from noon to 6 p.m. for everyone to gather in one small area of the military base, Selarang Barracks, or be shot. Incredibly, every man able to stand upright and shuffle two miles got there by the 6 p.m. deadline. Some 15,400 of the 17,000 or so Changi prisoners were herded into an area built for nine hundred peacetime troops. About 6000 were squeezed into the seven barrack blocks and the rest of us, about 9000 men, remained in the open.

We were informed that if we continued to refuse to sign the undertaking not to escape, we would remain there indefinitely. This meant living at sea level, ninety miles from the Equator, with two working water-taps, no sanitary facilities and no food other than what we might have carried in with us. We held out for three days in this 'Black Hole' of Changi. By the 5th an epidemic of dysentery and diptheria, if not worse, was beginning. Further threatened by Fukuye that all the sick and dying left behind in the camp would be brought here and dumped in with us, our harassed camp commanders tried to persuade the Japanese to make the signing an order. They succeeded and later that day we signed 'under duress' and we were led back to our own areas again, through the inner circle of Indian guards and the outer ring of Japanese with machine-guns who had been watching over us.

The Selarang 'Incident' was not forgotten. General Fukuye was executed by the Allies in April 1946.

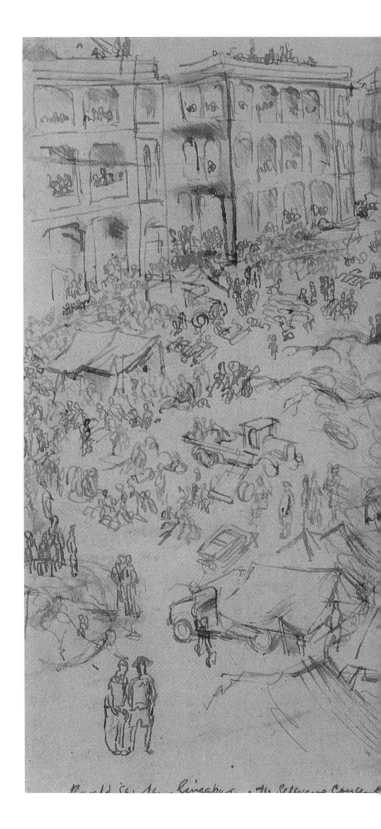

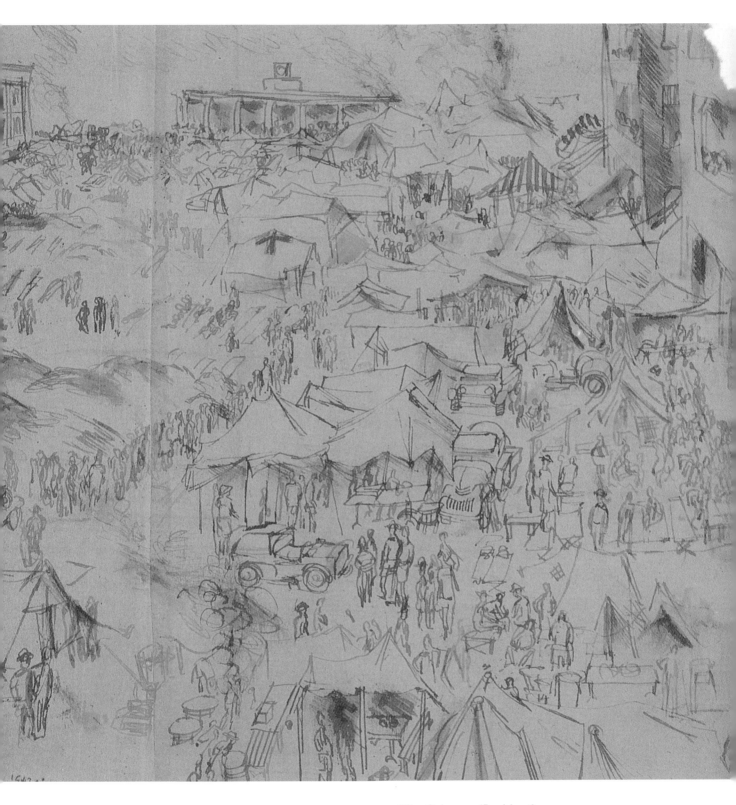

The Selarang 'Incident'
sketched from the roof
of one of the barrack blocks
on Thursday, 3 September.

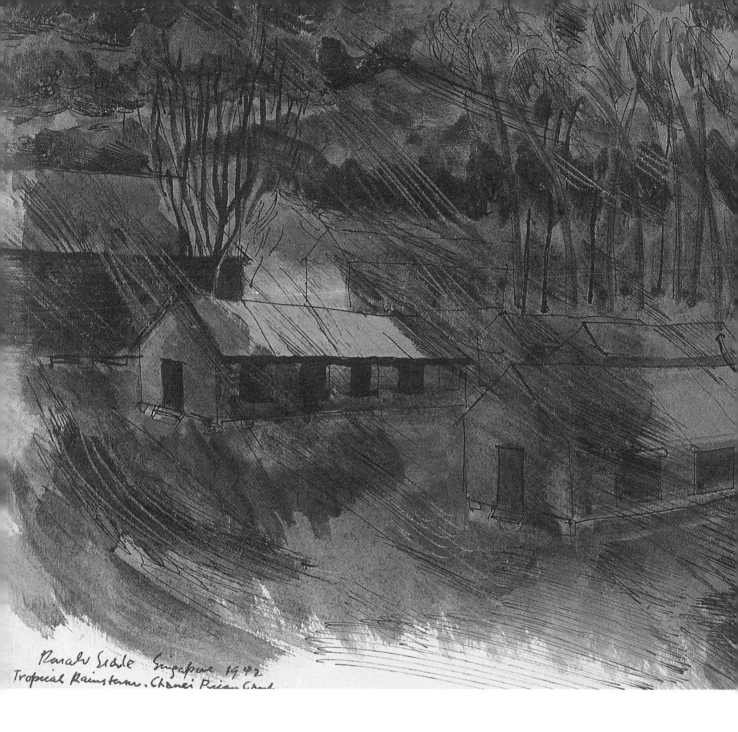

Ronald Searle Singapore 1942
Tropical Rainstorm. Chanei Prison Camp.

Once back in India Lines, we resumed
our somewhat shaky pattern of day-to-day
living. Other prisoners began to pass
through, bringing woeful tales from
surrounding islands. Many of them were
unfortunate local Netherlands forces from
Java and nearby Sumatra, *en route* for . . .
who will ever know? Our camp population
fluctuated wildly and by the end of
November, with increased demands for
labour to work on the docks, clear bomb
damage, tidy up battle areas, or to be
herded off to Japan to aid the war effort,
we were down to less than a fifth of those
who had walked here.

Whilst awaiting our turn to be
dispatched into the unknown, the north-
east monsoon came and went and by the
time our cat had kittens, we had already
been imprisoned a year. The kittens were
born on 2 March 1943, the day before my
twenty-third birthday, but we didn't have
the heart (or yet the stomach) to eat them
as a celebration.

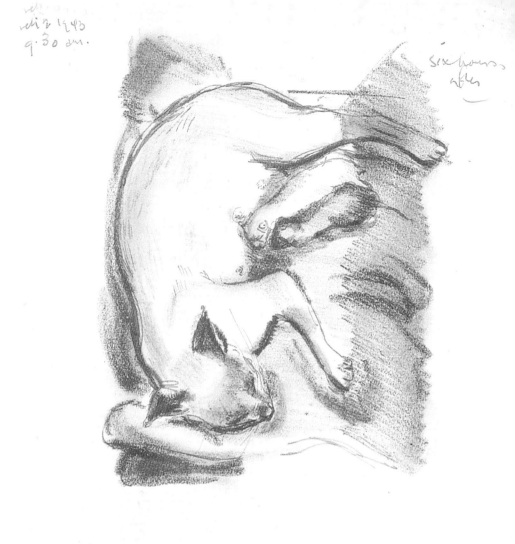

ABOVE Monsoon weather,
Changi, winter 1942

RIGHT Our cat, with
tingly delicious
kittens, March 1943

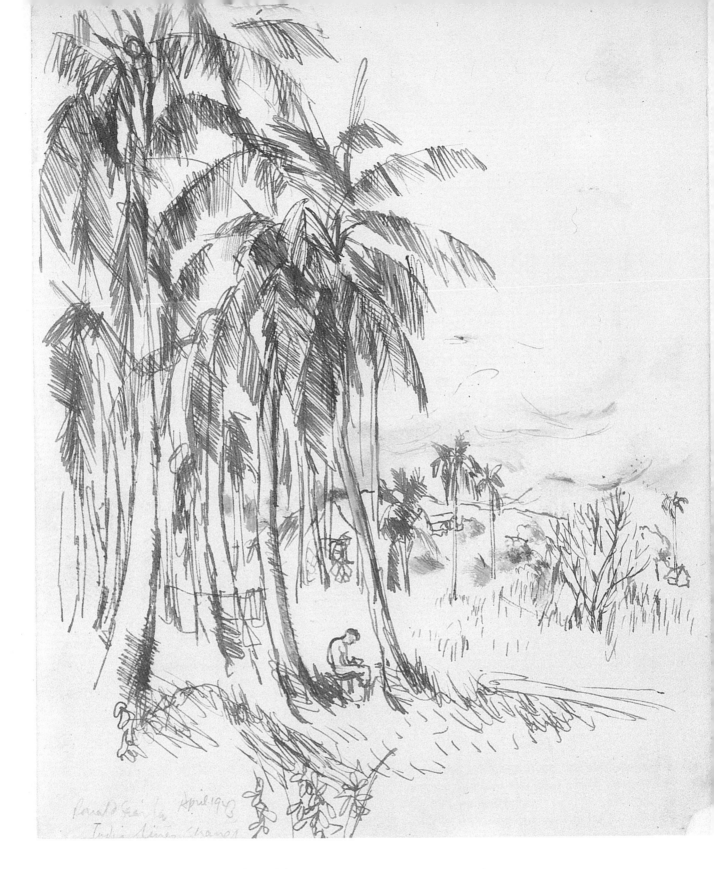

And so we say farewell . . .

On 8 May 1943 my turn came to go and
the fourteen months of incarceration
in Changi prison camp ended with this
idyllic little sketch made at the limit of our
area. With my back to the wire, under
gently swaying coconut palms, I had – for
a half-hour at least – transported myself
to another, less sordid island.

5
Siam

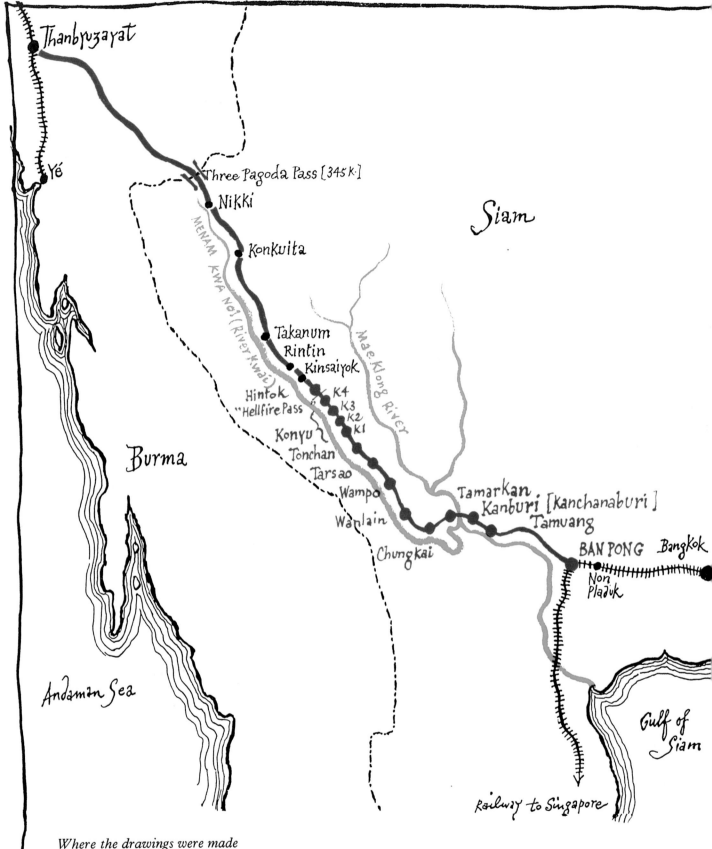

Where the drawings were made

The Route of the Siam–Burma Railway

A sketch map

Ban Pong, Siam, to Thanbyuzayat,
Burma. 415 kilometres of mountainous
and virtually virgin jungle. Inhospitable
country, to say the least.

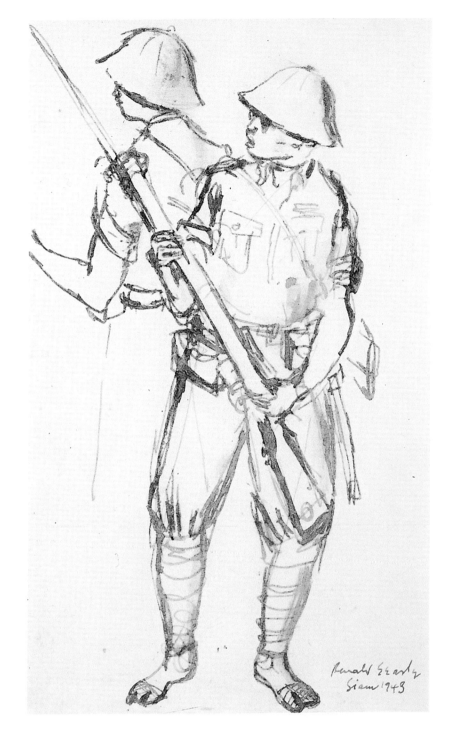

Ronald Searle
Siam 1943

In June 1942, Japanese supremos took the decision to cut a railway from south-west Siam to southern Burma. Until now this had been considered impossible. Most of it would have to be forced, virtually bare-handed, through some of the most hostile terrain in the world. The object was to overcome the increasing problem of supplying the army fighting on the Burma Front.

It was to be a crash programme. Ten thousand Japanese technical troops and overseers (slave drivers) were to be brought in. To carry out the work, there would be 55,000 expendable Allied captives and 135,000 Asian labourers to be 'recruited' from the area. This project, which has been compared to the building of the pyramids, was to be completed before the end of 1943.

It was; and if the men who died building it were laid end to end, they would roughly cover the 273 miles of track they built in that year.

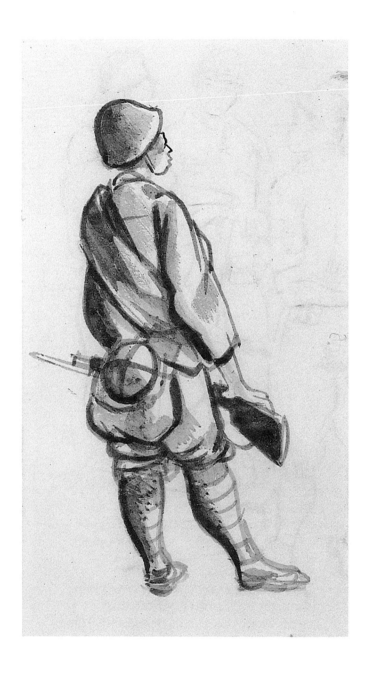

Squalid and disease-ridden as Changi had been, we were soon to be looking back at it with a touch of nostalgia. The order to move came with much running around, flashing of torches and Japanese shouts and curses, on the night of 8 May. For some months now, 'walking fit' had been rounded up and taken away for work in Japan and on a sinister-sounding project in Siam. Rumours had filtered back to Changi, indicating that something nasty was going on up there. So it was not without a certain amount of apprehension that we groped our way into the battered, open trucks that had come to collect us. We stood, wedged solid, for the tenth counting of heads, then lurched off into the frangipani-flavoured darkness, for Singapore Station.

'G' Force having been shipped to Japan the previous week, our allotted letter was 'H'. 'H' Force, comprising 3270 prisoners – of which our batch represented 600 – was shifted by train to Siam within a week. After more than a year of captivity, we hardly presented the ideal profile of a commando working force that Tokyo had in mind. Skinny, undernourished, suffering from a variety of tropical skin diseases and deficiency sores, our few remaining clothes rotting on us, and mostly without boots, we were, to put it mildly, an unsavoury-looking band. We were definitely not the ideal choice for a march of 160 kilometres into the jungle, to chop a railway through granite mountains and some of the most dense vegetation in the world. Our apprehensions were not unfounded. Two-thirds of our group died before the end of the year.

There are normally eight sardines to a tin. We were thirty men to a steel box wagon eight feet wide and eighteen long, and the fit was just as neat. There were two sliding doors in the middle, no room to lie down and just enough space in which to sit or squat for the five-day journey from Singapore to the Ban Pong railhead in

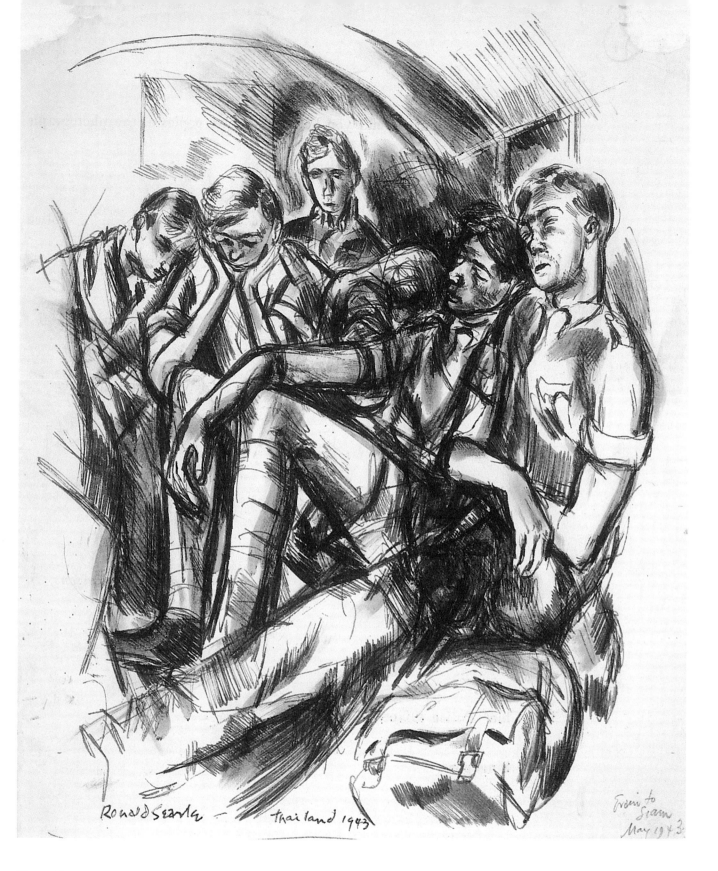

Ronald Searle — Thailand 1943

Train to Siam May 1943

Siam. By day the heat was unbearable and
at night we huddled in brightly moonlit
ice-boxes. From time to time we halted
at specific points and were ordered out
to be fed our rice, but otherwise
there was little relief. We were desperately
cramped, constantly thirsty and,
after five days, filthy.

Johre
Seen from the train

Not surprisingly there were moments
when the journey lost its reality and
became hallucinatory. Between the half
sleeping and half waking, the unremitting
movement became hypnotic and through
the open doors, the glimpses of other lives
and other places turned dreamlike.
It was the only way to escape . . .

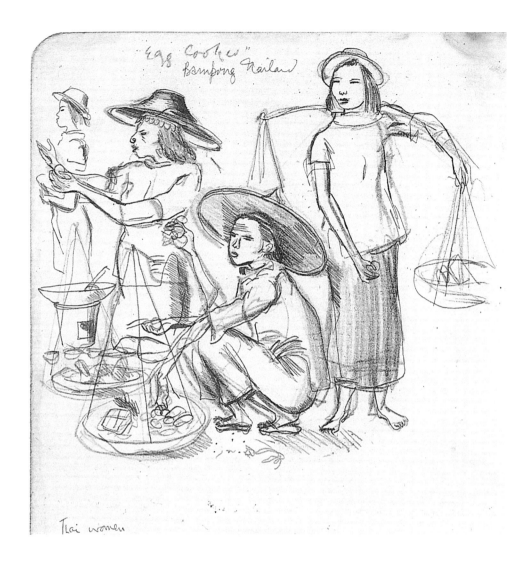

*Egg Cooker"
Bampong Thailand*

Thai women

After five (or was it five thousand?) days, we arrived on the night of 13 May. Evocatively named, Ban Pong proved to be nothing more than a stinking clutter of huts, an agricultural village of no consequence other than being about the last-but-one stop on the only line to Bangkok. For one unforgettable night we were housed on the edge of the village in well-used 'transit shelters' that were havens for an indescribable clutter of filth, open drains, rats, rubbish, scurvy dogs and every conceivable variation of foul fly. We lay on split-bamboo platforms just high enough to keep us out of the sewage that dribbled by beneath them, and reflected a little on our future.

But answer came there none – except to get up, seek food and forget it. Our Jap guards had disappeared soon after roll-call on arrival. There was no need to guard us from now on, anyway. There was nowhere to go. If we strayed, the locals – if they didn't kill us for what we carried – would return us to the Japs. This was the edge of the jungle in more senses than one. Meanwhile those locals were in here with us now, selling or bartering food for anything other than Japanese 'banana' money. Most of us managed to scrape up a trifle that could be exchanged for an egg or something anonymous out of a bowl of boiling fat.

At sunset on the 14th, with no regrets, we left Ban Pong behind us and headed along the road that would lead us up country. Marching by stages at night and resting in the heat of the day (105°F), we covered the 160 kilometres or so to our allotted sector of the railway.

The three slight sketches on these pages, made after a rough night during which we covered twenty-five miles, are the only notes I have of our 'long march'. After this I had no spare energy or even interest for drawing. We had not yet covered a quarter of our route and already many of us were reaching the limits of our somewhat meagre physical reserves. Along what was still a rough road, we were beginning to jettison any of our possessions that was not absolutely vital; anything to reduce what we were having to hump. Optimistically, I had brought several books with me. Miserably I now tossed most of them onto the road and, in a desperate effort to deduct a few more grams, ripped the covers off the one or two I hoped to keep a little longer. Meanwhile our nasty little guards, cursing like mad oriental coxes of some bizarre boat crew, urged us forward. Between-times they clubbed those unfortunates who now began to drop behind the rest of our ragged column.

Still further behind us we were trailed by a band of scavenging Thais, fighting among themselves over the pathetic pickings that we were dropping behind us like turds from a herd of beasts. When we stopped, we lay down in the dirt and slept. On waking we often found that much of what we had left had been stolen from under us by the same bandits.

By Tamuang village.
A bullock cart and children by the river.

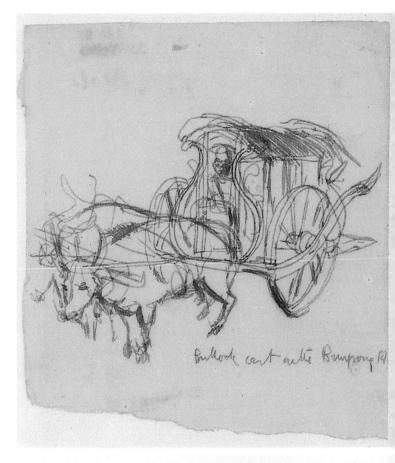

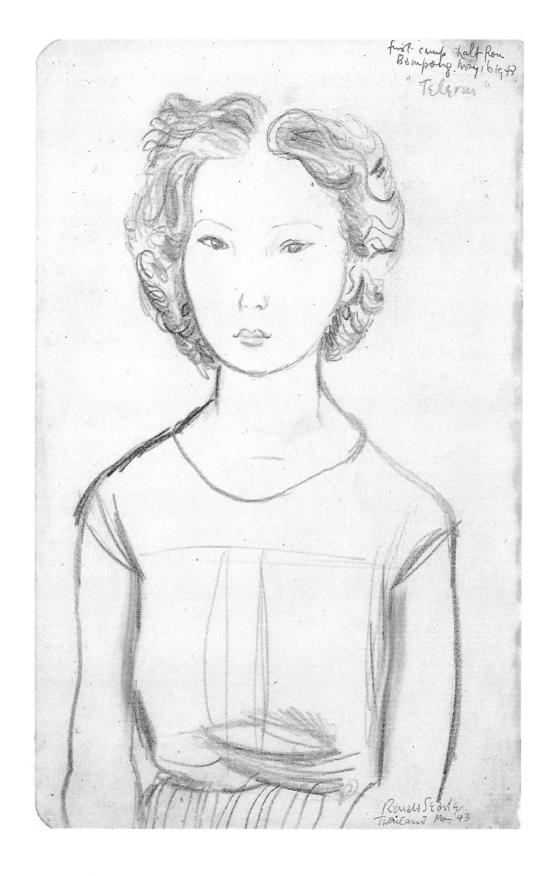

first camp halt Pau
Bampong May 16 1943
"Telerun"

Ronald Searle
Thailand May '43

A young Thai girl at Tamuang
let me sketch her. I had noted
that her name was 'Telerun'.
Later I realized that I had
misunderstood her pronunciation
of the name of her village.

The northbound road we were hobbling along roughly followed the east bank of the wide Mae Khlong river. On the occasions when we halted close enough to put our burning feet into it and to splash our faces for the first time in a week, we were rinsing ourselves in a dirty brown soup. Already swollen with pre-monsoon rains from further north, it was now swiftly carrying a remarkable variety of killer diseases and filth to its more inhabited banks further downstream, before losing itself in the Gulf of Siam.

By now I no longer had any idea of time. It was measured only by the space through which one dragged oneself toward the obliteration of reality by sleep. We had lost several men from dysentery, various fevers and total exhaustion. Some had dropped back out of sight, others had fallen down by the roadside and, if a good beating did nothing to move them, they were left there, supposedly to be rounded up by a following truck. We never saw them again.

Two miles beyond the old walled town of Kanchanaburi, before the Kwai merges into the Mae Khlong, we reached the Tamarkan crossing, after which we were to turn west to follow the eastern bank of the Kwai into the jungle. One and a half bridges crossed the Mae Khlong at this point, each about 500 yards long: a completed but nerve-rackingly unstable one made of wood, which we gingerly crossed, and the concrete buttresses of another, still awaiting the metal super-structure that would carry the future railway. No other bridges crossed rivers up here and certainly nothing crossed the River Kwai.

The path of the projected railway followed as closely as possible the eastern bank of the Kwai, to the point where it divided into its tributaries near Three Pagoda Pass. The two big bridges on the Kwai and on which we were also to work, were at Wampo and Hintok (an impressive

construction 400 yards long and a shaky 80 feet high). Wampo was 50 kilometres from here and Hintok twice as far. Both were viaducts that did not cross the river but hugged the otherwise impassable cliff face of this section of the east bank. As for 'The Bridge on the River Kwai', it crossed the river only in the imagination of its author; his idea of British behaviour under the Japanese was equally bizarre.

Memories of the final stages of that march are now hazy. I remember that the vultures, which circled lazily and hopefully over our heads during the daylight stops, did not follow us further than the end of the scrub-covered plains. The road had petered out as the undergrowth changed to forest and then into a vast cathedral of vegetation with a ceiling of unbelievable height that veiled the occasional light filtering through.

The forced marches continued through the nights and memories of them have become a compression of smells and feelings; plodding along a glutinous track thick with pitfalls, faces and bodies swollen and stinging from insect bites and cuts from overhanging branches that whipped back at us.

Now it felt and smelt as I had imagined the jungle would: encroaching, oppressive and rotting. We were very aware of it confining us, although we barely caught a clear sight of it at first. The frequent rainstorms became more violent and the approximate track turned into a quagmire of calf-deep black slime.

Going along the jungle track to work, from K.2. On 22 May, soon after our arrival up here, the monsoon broke and it rained almost non-stop until October.

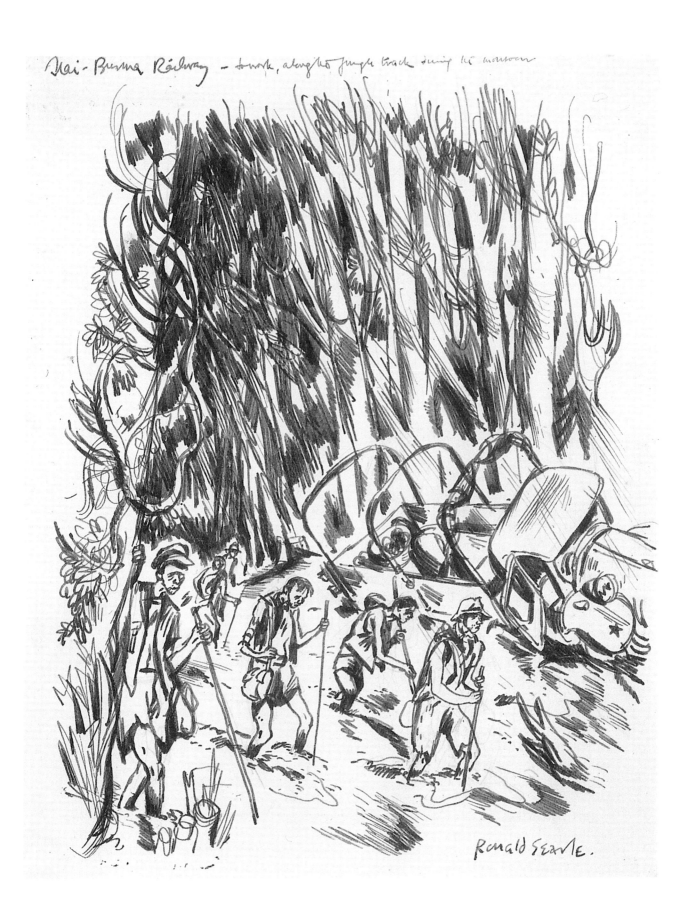

Ronald SEARLE.

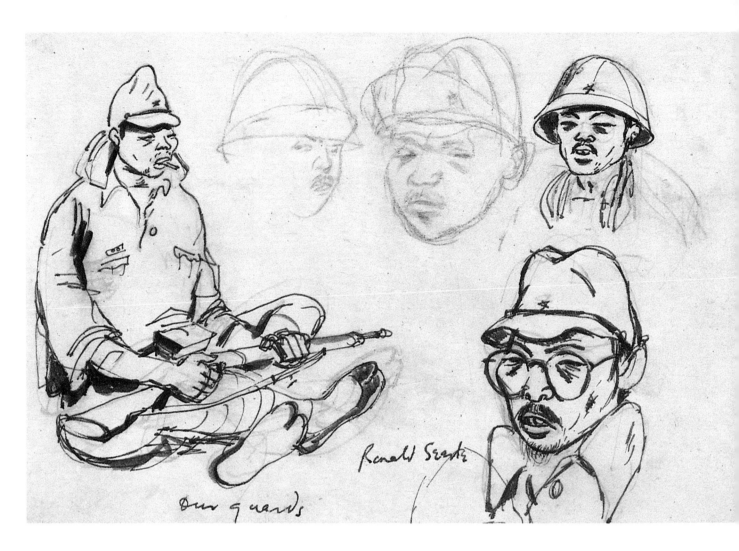

Our guards

Ronald Searle

Siam: Some of our
Japanese and Korean guards.
A somewhat basic lot.

Stumbling, cursing, slithering along the jungle track, I can still recall the bizarre sucking noise made by hundreds of feet being put down and pulled out of the mud.

Somehow most of us reached Kilometre 154, our allotted working sector, called Camp Konyu 2. Soaked to the bones, hungry, half-dead with exhaustion and half-mad from the strain of the march, we were herded off the track and led to a clearing in the nasty-looking undergrowth. Then, between night, day and stinging rain, just about able to remain upright in this field of slime, it dawned on us that there was no Camp K.2 – yet. We were to build it, starting now.

The camp was built and the labour on the railway began. Each day, before first light and by the glow of a great bonfire that burned continuously in the centre of the clearing, we lined up for our ration of rancid rice and a brew of tea. Then we were rounded up for roll-call. Our guards, being mostly useless at counting, preferred us to shout out our own number in Japanese. It did not pay to be approximate about it. If the expected total was short, it meant a thrashing for someone with the ubiquitous bamboo stick – and being beaten with bamboo is like being beaten with an iron bar.

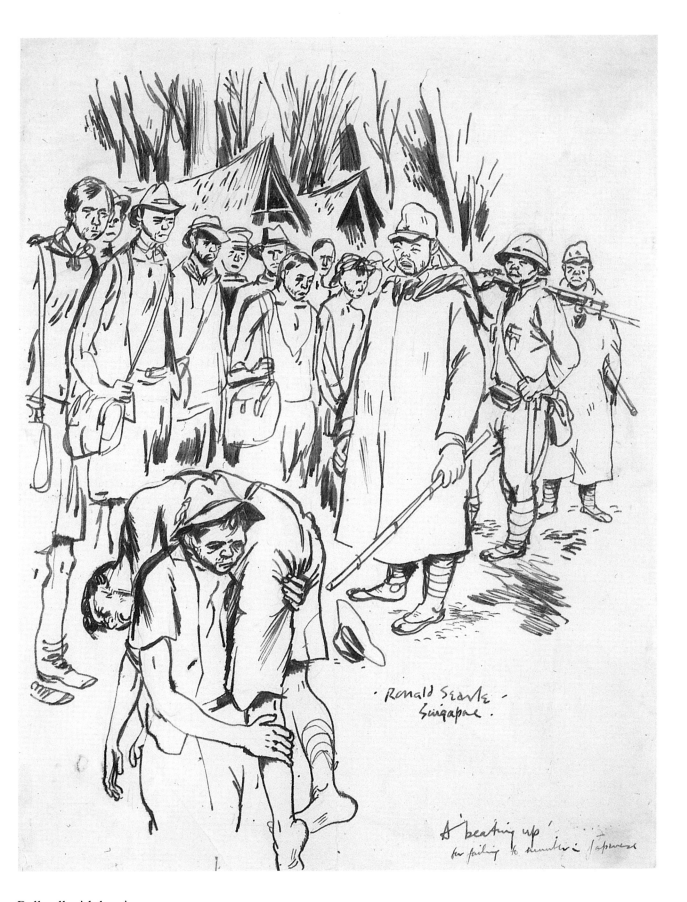

Roll-call with beating-up.
A sketch completed
in Changi Gaol, later on.

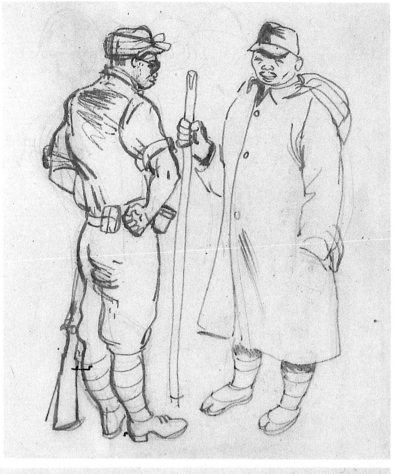

At first light, we were led down the
mountainside, through the morning
mists. Occasionally we caught
breathtaking glimpses of far-away
sunlit peaks of other mountains,
rising out of the cloud that concealed
the thousand miles of jungle between
us and freedom. When we reached
the bare rock just above the river,
we were put to work, cutting into it
with hammers and chisels until it was
too dark to see any longer. Then
we struggled back up to the camp that
we rarely saw other than by the light
of the bonfire. After two or three
weeks, when that cutting was
finished, we were moved further on
up the track to hack out another.

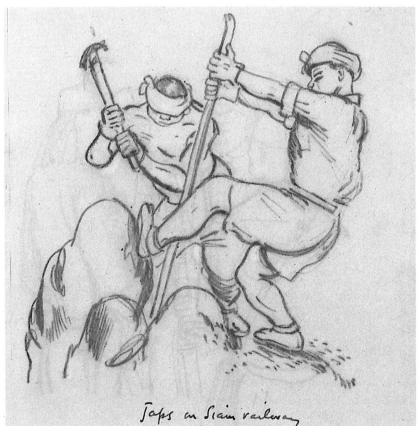

Japs on Siam railway

The Japs occasionally amused
themselves by showing us
how it should be done.

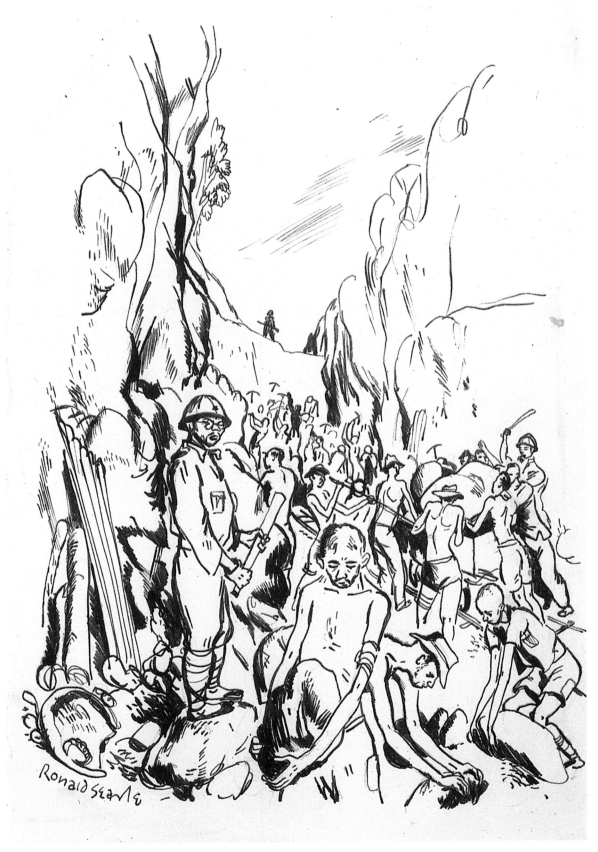

Siam-Burma Railway:
Prisoners cutting into the mountain
near Konyu, about June 1943.

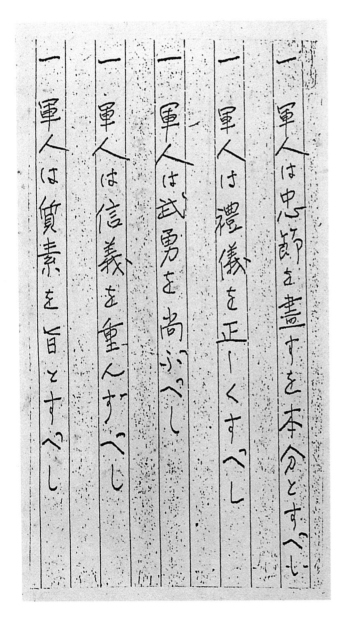

Soon the pace was pushed even harder. Tokyo had ordered a 'speedo', being afraid that the rapidly mounting casualties – especially from cholera, now spreading steadily through the camps – would delay the programme. Consequently it was no holds barred and any prisoner not visibly about to drop dead was forced to work. Needless to say, this did not decrease the casualty rate, nor did it speed the advance of the railway. Parading for the count at dawn, we were a sorry-looking lot. Most of us were suffering from something colourful or dramatic that made it misery to exert ourselves or stand for long periods. Nevertheless we went through the motions. As the first thin rays of sunlight appeared through the vast canopy of trees above us, the order to stand to attention was yelled. It was regularly answered with whoops from the families of gibbons that gazed down on us as our guards bared their shaven heads. Then the signal was given and we faced the east, bowing low five times as we chanted as best we could after our guards the soldier's 'prayer' established in the Imperial Message of the Emperor Meiji in 1883:

– *Hitotsu: Gunjin wa chusetsu o tsukusu o honbun to subeshi!*
– *Hitotsu: Gunjin wa reighi o tadashiku subeshi!*
– *Hitotsu: Gunjin wa buyu o toutobu beshi!*
– *Hitotsu: Gunjin wa shinghi o omonzubeshi!*
– *Hitotsu: Gunjin wa shisso o mune to subeshi!*

A soldier must honour loyalty as his most important virtue
A soldier must be impeccably polite
A soldier must be courageous
A soldier must treasure his principles
A soldier must be frugal

Our dawn chorus over, like good Japanese soldiers we politely, courageously and ever so bloody frugally, pushed off for ten hours or so of Imperial rock-breaking down by the muddy Kwai.

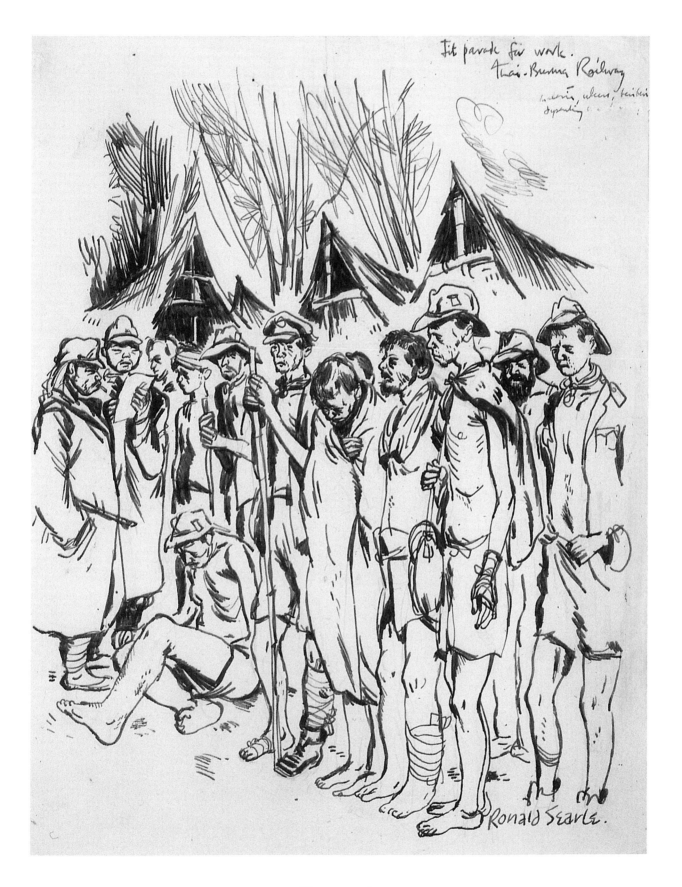

Dawn parade

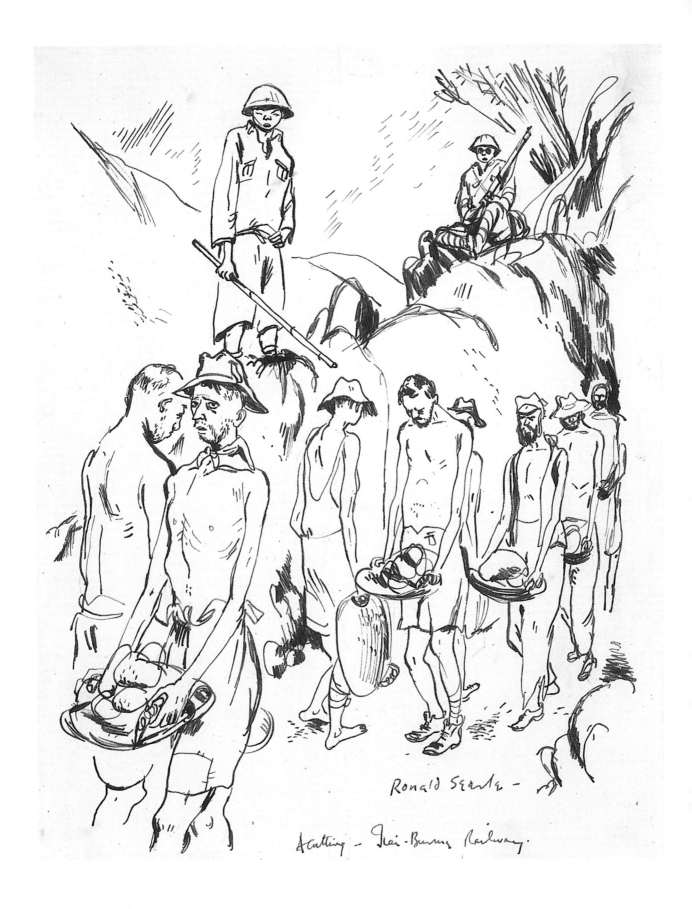

Ronald Searle —

A cutting — Thai-Burma Railway.

Our working methods were barely out of the Stone Age. The only modern convenience the Japanese could offer to aid our barehanded burrowing into the mountain, apart from a few basic tools, was a little explosive. We would drill holes for the charges millimetre by millimetre with a sledge-hammer and steel bar, a job that could take a whole day with hands that were swollen and numb. After blasting the rock face and breaking up the lumps that were too heavy to move, we were formed into an endless human chain. Then basketful by basketful, we hauled the tons of rubble to the edge of the cutting and tipped it into the valley below. This routine was perhaps the most soul-destroying of all our tasks. The never-ending trudging back and forth, which at the height of the 'speedo' could continue for as long as sixteen hours, often meant that we started walking before dawn and, with one break for rice and water, continued until long after dark. On many occasions there would come a bizarre moment when the mind liberated itself from the body and went off independently into the most incredible flights of fantasy. This detachment of the mental faculties from the miseries of the flesh may have its parallels in drug-taking or religious trances, but for us it was an involuntary act of self-preservation that protected some of us from going stark, staring ravers, leaving us just mildly demented.

It was not only the hard labour that nearly drove us out of our minds; it was also the insects, that curse of the jungle, and they ate us alive. Mosquitoes and foul fat flies were a horror, and their bites were often fatal. But it was probably the non-killers that made our lives the most miserable. At night after work, tired as we were, we were kept awake by the swarms of bedbugs that wandered over us, sucking our blood and nauseating us with their smell

when we crushed them. Day and night the lice burrowing under our skin kept us scratching. Sometimes giant centipedes wriggled into our hair when we finally got to sleep and stuck their million poisonous feet into our filthy scalps as we tried to brush them off, setting our heads ablaze. I think there were moments when any one of us would have preferred to brave the mountain lions rumoured to be out there somewhere, than face another bug.

Siam 1943: Lice

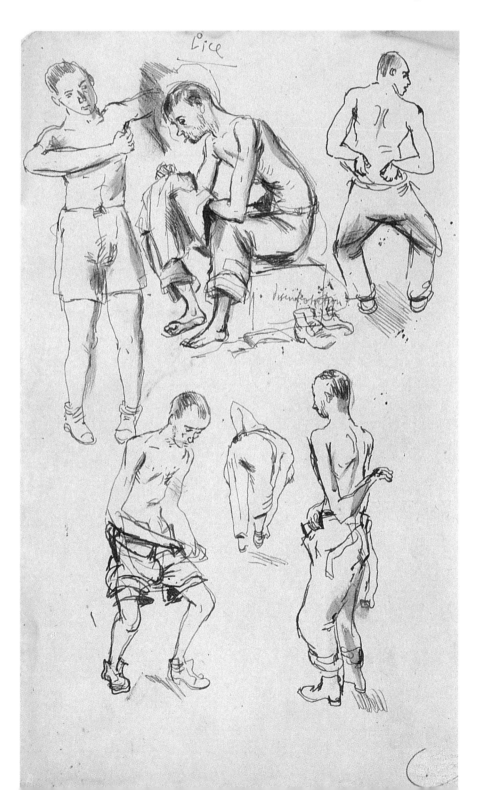

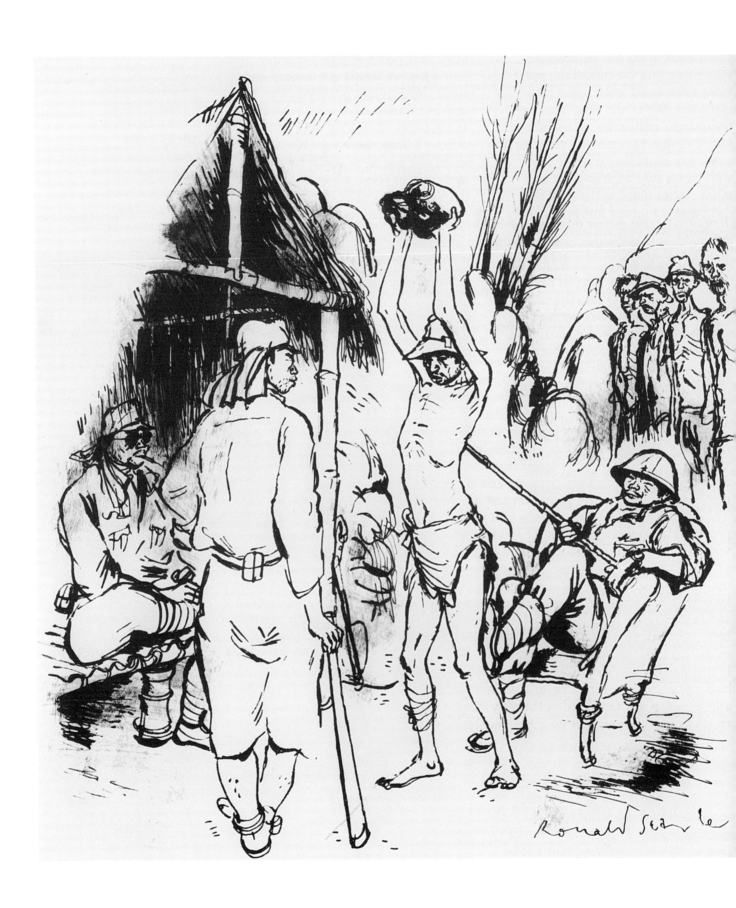

Some of our overseers had an extremely primitive sense of humour. During the noon break on the cuttings, they would frequently relieve their boredom by calling us into line before we had barely gobbled down our rice, to watch the torturing of one of us picked at random. The unlucky one might be made to hold a heavy rock above his head in the full sun, with a sharpened bamboo stick propped against his back. If he wavered, which he inevitably did, the bamboo spear pierced his skin. If he dropped the rock before an unspecified moment, which he always did, he was beaten and then given a cigarette.

Our midday rations were light – often little more than a bowl of rice with boiled seaweed. Not that there was a lot more awaiting us when we got back to camp at night. Food was scarce even for our guards. The Japanese were having supply problems and we were the last in line. But when you are constantly ravenous you eat anything that can be snatched, grubbed up or killed, however foul. There were a lot of us with the same thought, however, and you had to be swift about it. Woe betide any unfortunate substantial-looking snake that came within killing distance. It rapidly ended in the pot. I do not recall hearing of any prisoner being bitten by a snake although, God knows, there were enough venomous reptiles up there, but I have many happy memories of the reverse. Constrictors were perhaps the most delicious and the vision of a yelling band of starving prisoners chasing a twelve-foot, panic-stricken, silver and rainbow-coloured python, is an image that has stayed with me, summing up neatly the lunacy of that world apart.

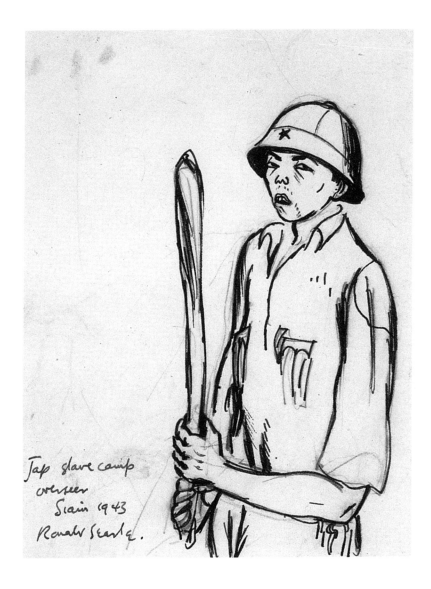

Siam 1943: Lunchtime games

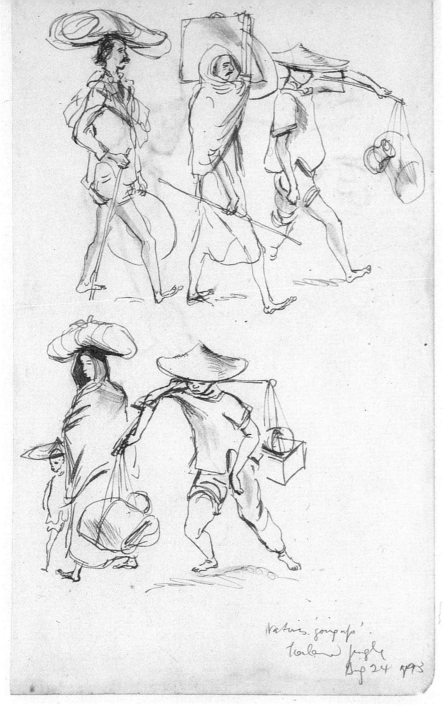

Natives 'gong up'.
Thailand jungle
Aug 24 1943

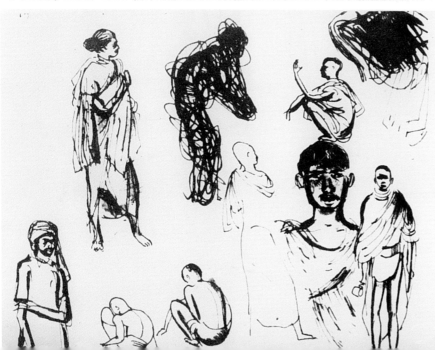

The slimy track we had followed to Konyu camp was the only way through the jungle and it linked the sixty or so labour camps dotted along the path of the railway. Cut through virgin forest by advance parties of prisoners who had been given no time to clear away stumps or half-buried logs, it was an uneven morass for most of its length, thick with hazards for our bare feet. The track was littered with bits of abandoned trucks, great broken branches covered in thorns, reptiles with a preference for a clear run through and, frequently, the abandoned corpses of unfortunate Tamils and Chinese 'recruited' from Malaya, who had got no further than this on their way to the promised dream job. (The Japanese amassed the vast Asian labour force that was necessary for this railway work by offering the incentive of a six-month contract under ideal conditions: splendid food, lots of money – and bring your families. Many did bring them and it was sickening to see women and small children passing through with bewildered-looking groups of Tamils and Chinese, to a miserable death.)

Whilst the Japanese awaited the completion of the railway, this jungle track also served as the main thoroughfare for troops heading for the Burma Front. They passed by

Another overseer

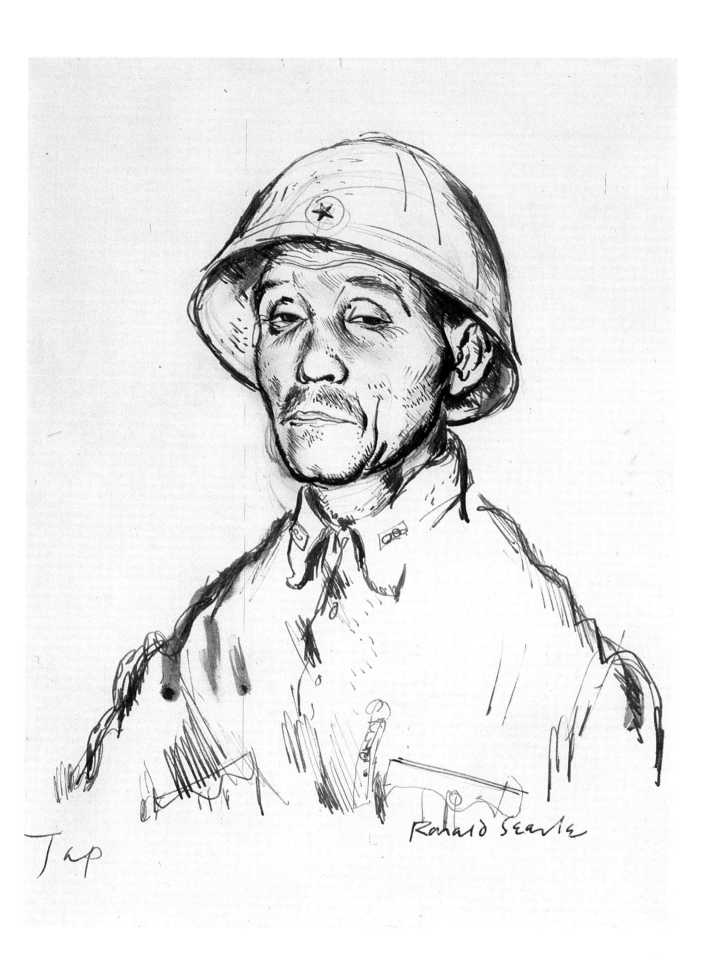

Jap

Ronald Searle

our camps in their thousands, sometimes on ponies with the heavier equipment, but usually on foot and mostly looking appallingly cheerful. Perhaps the sight of our gloomy faces boosted their morale. I can't say that the sight of theirs did much for us. Not that their morale needed much boosting. We had already been close enough to admire their courage and initiative in battle and their extraordinary capacity for physical endurance – however misguided this seemed to us. But it was precisely this virtue that permitted them quite happily to look on a walk of four hundred miles through the jungle, in monsoon conditions, as a routine effort for the Emperor. Their source of strength was an unquestioning belief that it was an honour to serve and die for the imperial divinity . . .

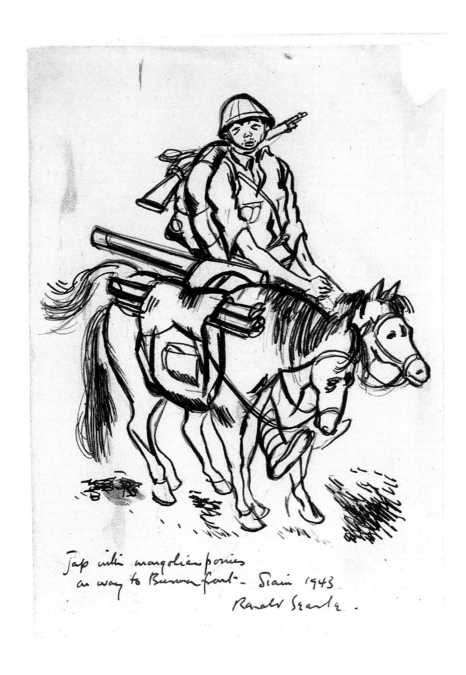

Jap with mongolian ponies on way to Burma front – Siam 1943
Ronald Searle.

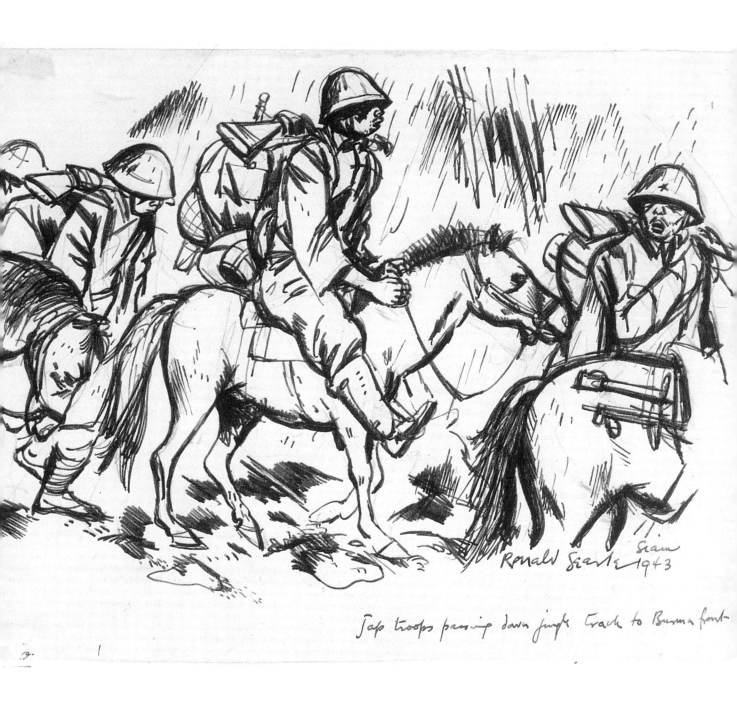

Ronald Searle 1943 Siam

Jap troops passing down jungle track to Burma front

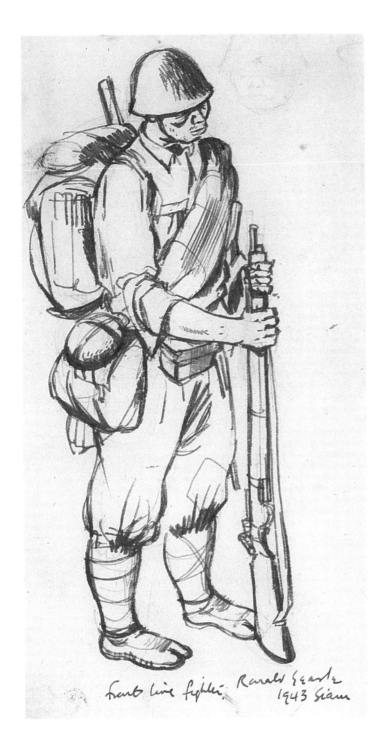

Front line fighter. Ronald Searle
1943 Siam

The code of the Japanese soldier declares: 'Duty is weightier than a mountain, while death is lighter than a feather.' It was not only the Imperial Guard that still embodied the *bushido* spirit of the samurai. It was to be found in every ill-fed, ragged common soldier – each of whom looked like a man from the Dark Ages – who passed by our camp. One could understand, even admire at a distance, the spirit that drove these emotional, somewhat hysterical warriors to early victories and ridiculous feats of bravery. But it was infinitely preferable not to be – as we were – on the receiving end of it. It made things no easier for us that the Japanese and their prisoners were so far apart in basic thinking, let alone their military codes. This inability to communicate on the same wavelength was a disaster for us and, in our current circumstances, literally a matter of life and death.

Meanwhile they continued to pass by, loaded down like Christmas trees with everything including the inevitable fan. The next world was not forgotten: a little doll and a token bag of food for the ancestors dangled from every belt next to the bayonet.

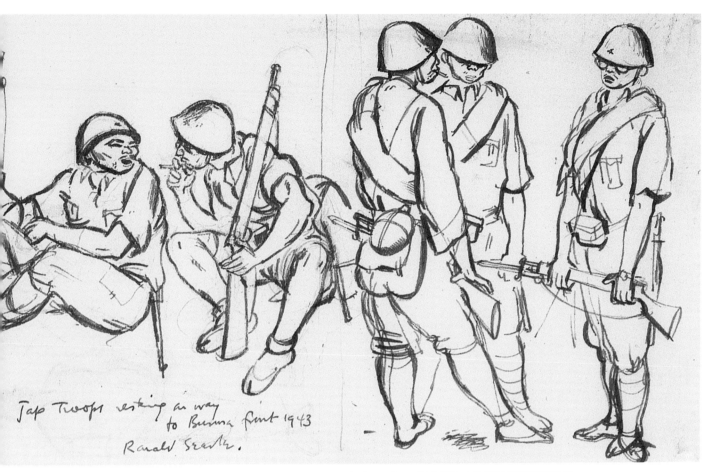

Jap Troops resting on way
to Burma front 1943
Ronald Searle.

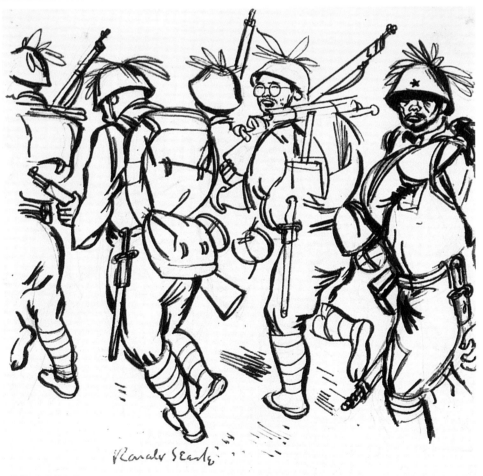

Ronald Searle

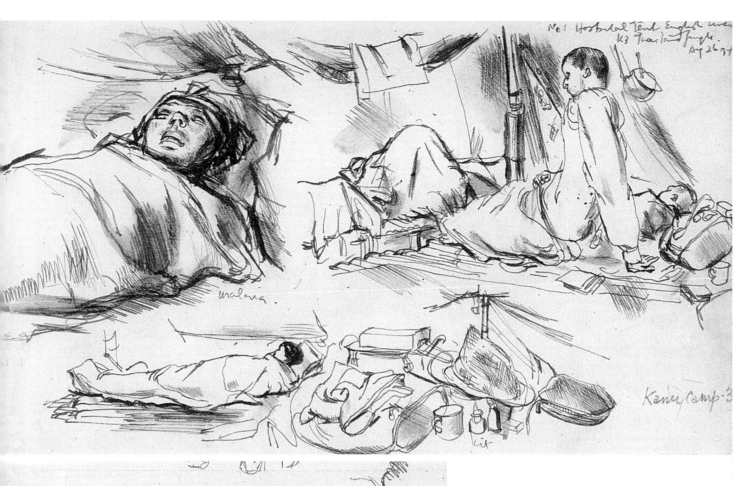

No! Hospital Tent English line
K3 Thailand Jungle
Aug 26 ?

malaria

Kanu Camp 3

kit

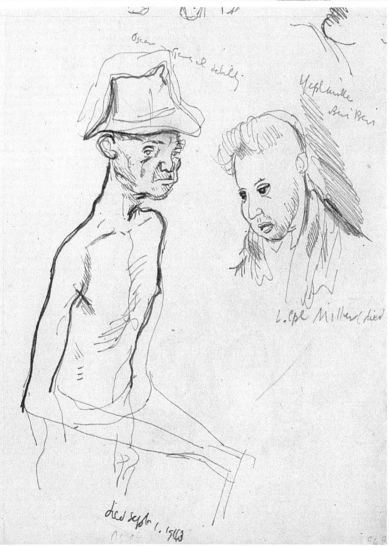

Oscar General Schilz

Yoplanthe
Beri Beri

L. Cpl. Miller died

died Sept 1. 1943

As the days dragged by our ranks got steadily thinner. Hundreds of men had died by now in every foul, unimaginable way, while we the shaken survivors prayed it would not be our turn next. Unfortunately, death was the number that came up most often in that lottery. If a passing fly chose to step into your rice ration as it was about to be eaten, there was no alternative but to throw the lot into the fire and go without. Although such a gesture was dramatic for a starving man, there could be no hesitation. The footprint of one of those filthy flies was enough to bring about a swift and agonizing death. We hated them and even today I am neurotic about being in the same room with one. What with the brutal pace of the work, the physical punishment that went with it and the continual round of sickness of one sort or another, most of us were little more than rotting bags of bones. The remaining fragments of our clothing were in rags, bandages were a thing of the past and we were now

protecting our festering wounds with strips of large leaves. We had been unable to wash for months and the little water available was barely enough for drinking. We ran out naked into wild storms but, with only our dirty rags to dry ourselves on, we were soon muddy and stinking again. Only the irrational and pig-headed desire to survive made it possible for us to drag ourselves forward into another day. There were times when most of us felt that perhaps those chums who had encountered The Curse of the Fly's Footprint were the fortunate ones.

In a tent which housed the dying and where the sketches on these pages were made, I think I reached rock bottom. Between bouts of fever I came round one morning to find that the men each side of me were dead, and as I tried to prop myself up to get away from them, I saw that there was a snake coiled under the bundle on which I had been resting my head.

A few sketches of dying friends in camps Konyu 2 and 3, July, August and September 1943.

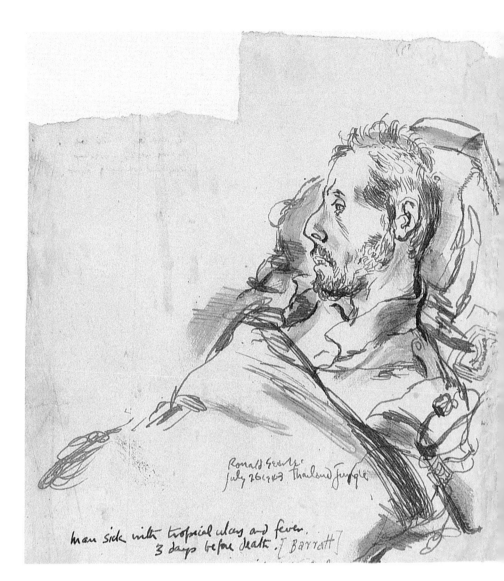

Ronald Searle
July 26 1943 Thailand Jungle

man sick with tropical ulcers and fever, 3 days before death. [Barratt]

Thailand Jungle. August 1943 Konyu

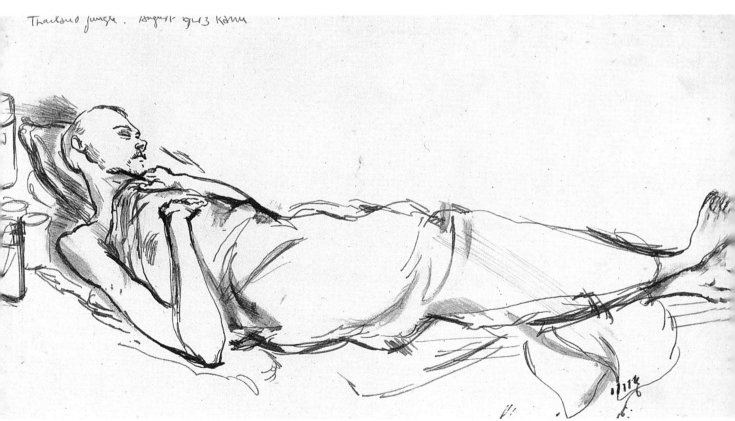

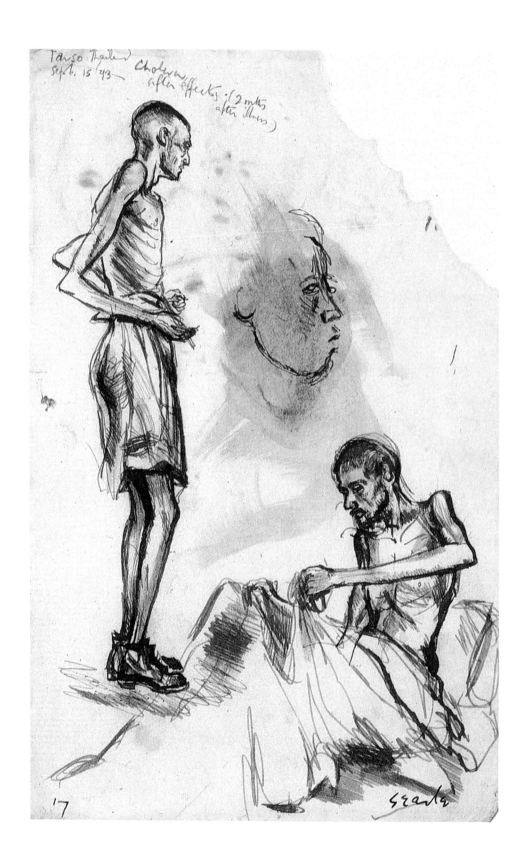

Tarso Thailand
Sept. 15 '43 — Cholera effects · (2 mths after illness)

17

Searle

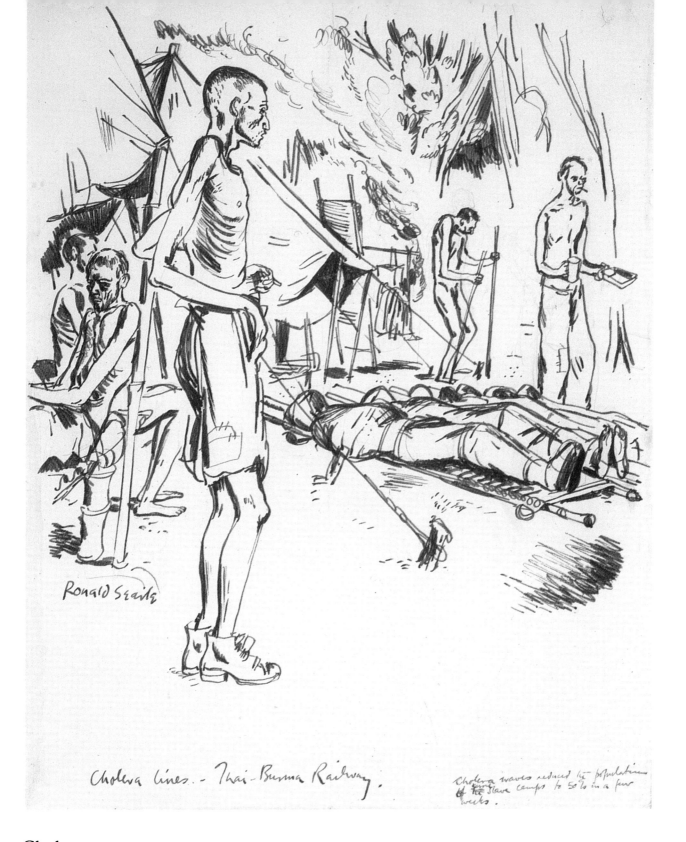

Ronald Searle

Cholera lines. - Thai-Burma Railway.

Cholera waves reduced the populations of the slave camps to 50% in a few weeks.

Cholera

LEFT A sketch note made in the cholera area at Tarso camp, for the completed drawing of the scene above made shortly after. The man in the foreground was a lucky survivor. Those who were not and who died that day, are waiting to be burned.

In May 1943, as we arrived at Konyu, cholera broke out at Nikki camp near Three Pagoda Pass. By June it had travelled 125 kilometres down the track to meet us. Cholera was virtually unstoppable under the sort of filthy conditions in which we lived and, like the twenty other

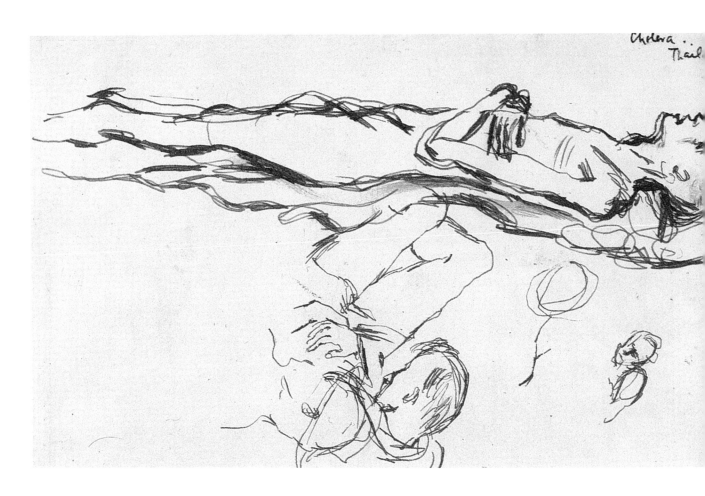

Siam 1943: Man dead of cholera

camps between us and Nikki, we very quickly lost a lot of men. There was little hope for anyone unfortunate enough to get infected. Without sophisticated emergency treatment – and there was little or nothing in the way of treatment let alone sophistication up there – one swiftly shrank to nothing and died within twenty-four hours – faster if one was lucky. To reduce the sources of infection, there were no more burials and from then on our nights were illuminated not only by a great ever-burning bonfire in the centre of the camp, but also by the Bosch-like glow of the funeral pyres that were now sending all too many of us up in smoke.

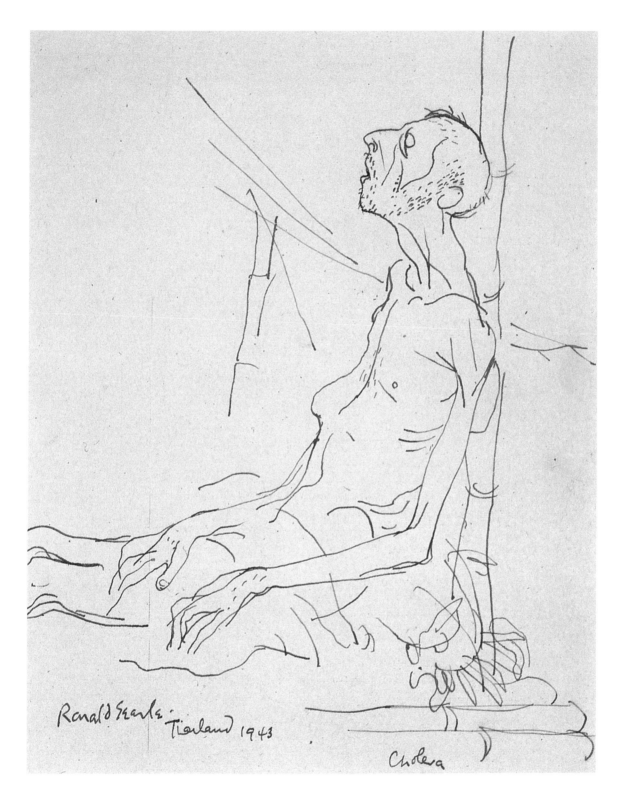

Siam 1943: Man dying of cholera

Looking back over the few drawings made in the jungle, those seemingly endless days have telescoped themselves in my memory.

Much of that lost time was passed in a no man's land of punch-drunk images. The hallucinating bouts of malaria, the constant beatings-up, the hunger, the total isolation, the wet, the rot, the heat, the thirst and, always, stinking old death permeating everything and breathing down one's neck – these all combined to make it difficult to retain a clear picture of the drama in which one was playing the non-speaking rôle of a worker ant. Yet, surprisingly enough, the process of drawing seems to have remained reasonably lucid. I must admit that, frequently, it seemed a stupid waste of what little energy I had left to continue drawing for no other reason than that of carrying out my self-appointed task of recording what I could of what was going on. It was often very hard to force myself to continue when all I wanted was to forget and escape into the reality of sleep.

Towards the end of October 1943 the railway was finished. The ceremonial spike – gold-plated of course – was tapped into place by a delighted gathering of Japanese dignitaries at Konkuita camp and that was that. It has since been estimated (I imagine the true figure will never be known) that over one hundred thousand Allied prisoners and Asian labourers died to achieve this folly that has since been swallowed by the jungle. The few survivors were gathered up from the camps and transported back to Kanchanaburi. The cholera-ridden Kwai and the jungle, now fertilized with what remained of our friends, were left behind.

I have no recollection whatever of leaving the jungle or of making the journey down to Kanchanaburi. Like most of the others I was probably light-headed with fever at the time and registering little beyond the orders of the Japanese. At this point my appearance was typical of the rest of us. I weighed about seven of my normal eleven stone, my leaf-bound legs were puffed up with beri-beri, large areas of my body were decorated with a suppurating crust from some exotic skin disease and one of my ankles was eaten to the bone by a large tropical ulcer. Apart from this, my three-weekly bouts of malaria had left what was still visible of my skin between scabies and ringworm, a pleasing bright yellow. However medically picturesque I may have been, behind the mess I was still alive and just about kicking.

When most of 'H' Force was eventually shifted from Kanchanaburi to be taken back to Singapore and returned to the authorities that owned us, I had to be left behind. I have one or two memories of a great hut in Kanchanaburi in which I lay, no longer able to move. High, endlessly long and crammed with skeletal-looking bodies sprawled on raised bamboo platforms, it was a luxury hotel compared with what we had just left in the jungle. I was adopted by a cheerful bunch of Australians and two Dutch officers, all of whom were still in rather a mess themselves. They nursed me, spent their money on eggs and extras from the natives for me, washed me and, of all unlikely things, procured some sulphur drugs from somewhere for me. Anything was possible for the Australians – even the impossible. They saved my life and got me back on my bare feet again.

Later, but I still do not know how or with whom, I was delivered back to Singapore Island where I arrived, after a five-day journey, just before Christmas 1943. There I rejoined the remnants of 'F' and 'H' Forces at Sime Road camp near the racecourse. A few months later, when we had sufficiently recovered to be of further use to the Japanese, we were once more loaded into trucks and on 4 May 1944 were driven off to our final destination as prisoners, Changi Gaol.

Prisoner convalescing from jungle sores,
Sime Road camp Singapore, January 1944.
Page from a sketchbook restarted
after a gap of four months.

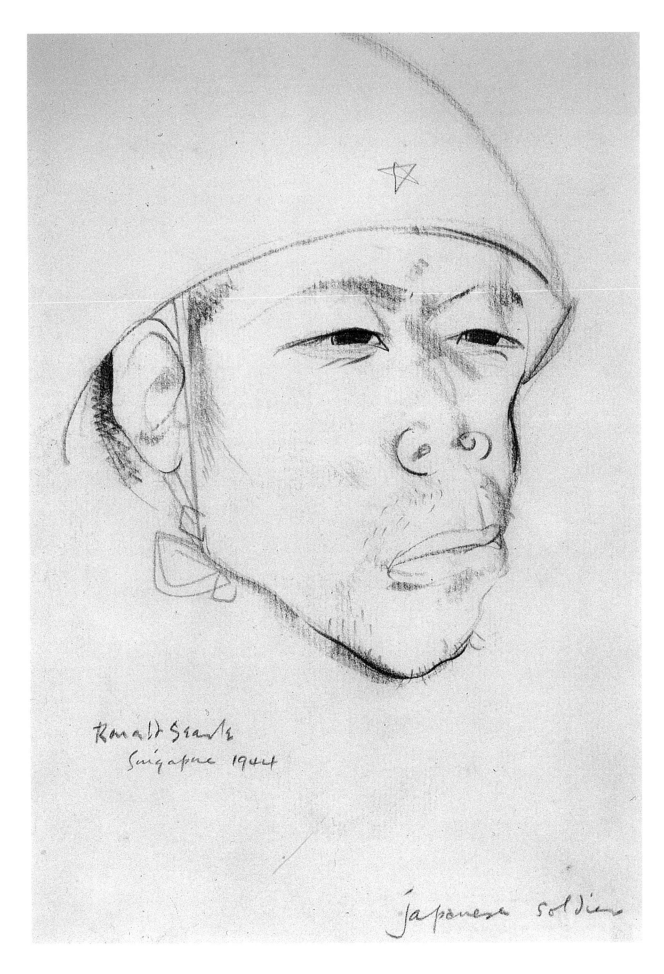

Ronald Searle
Singapore 1944

Japanese soldier

Prison guard, Changi

6
Changi Gaol

In May 1944 there was a sudden frantic reshuffling of prisoners when a small army of Japanese engineers arrived to organize the construction of a military airbase at Changi, with prison-camp labour, naturally. They took over Changi Barracks, transferring the remaining prisoners into Changi Gaol after 3400 civilians, men, women and children, had been moved on to Sime Road camp to change places with us.

Changi Gaol squats in a reclaimed swamp on the eastern extremity of Singapore Island, a few miles from where we were first imprisoned in 1942. As we approached it, our convoy turned off the main Singapore–Changi highway and halted in front of the great gate of the prison. Sweaty and dust-covered, we prised ourselves apart from each other and clambered down onto the blisteringly hot road under the prison wall with our miserable bundles. Our hearts sank into what was left of our boots at this first close encounter with Changi Gaol. It represented everything that some soulless little bureaucrat, still mentally in the nineteenth century, might conceive as a salutary 'modern' punishment complex. Bleak and positively sinister in the sheer acreage of its stone, concrete and steel, it had been built by the British government only eight years before, in 1936. It epitomized – and probably still does – all that is administratively desirable for degrading and psychologically diminishing the guilty, in the firm belief that confinement for a number of years in small locked boxes can be spiritually rehabilitating and physically cleansing both for them and for society.

The prison was surrounded by a vast unscalable wall with guard-posts incorporated into each angle. It enclosed long blocks of airless cells, three storeys high, a group of smaller service buildings and some bare exercise yards. The whole was dominated by a tall, square tower on which, normally, the Union Jack fluttered – but not at the moment. Now it was the Rising Sun that hung limply in the sticky afternoon heat. The only way into the prison was through a great metal gate suspended between dome-topped pillars that were vaguely indebted to some bastard form of oriental baroque. We shuffled through it wondering what was in store for us now.

Changi Gaol had been constructed to accommodate six hundred criminals – 576 Asian and a mere 24 European. Once we had joined the concentration of prisoners who had been gathered from the surrounding camps, there were over ten thousand of us confined inside and around the walls. Five thousand were squeezed into the cell blocks themselves. As many again were concentrated in the courtyards and under the walls in the huts that had housed prison employees. The Japanese administered from the tower.

Inside the cell blocks it was suffocatingly hot and claustrophobic; at night the outside walls threw back the heat they soaked up during the day. The rows of cells, their steel doors open, gave onto three storeys of gangways linked by metal stairways. A central well, from roof to ground level, was divided at each floor by a steel mesh. Every inch of it was spread with men; the Japanese had allotted one square metre of space to each prisoner. There were four men to each cell built to hold one person: one on the central block of stone intended to serve as a bed, one each side of it on the floor between the block and the wall and one full-length along the bottom, with either his head or his feet in the lavatory hole that was, fortunately, out of action. Otherwise these stone cubicles were bare and airless, despite a small grille-covered window out of reach by the ceiling. Along the gangways outside, the grilles over the central well were packed with sweaty bodies and those at the top could look down through the mesh at two other layers of skinny, barely human, flesh. The noise was rarely less than unbearable.

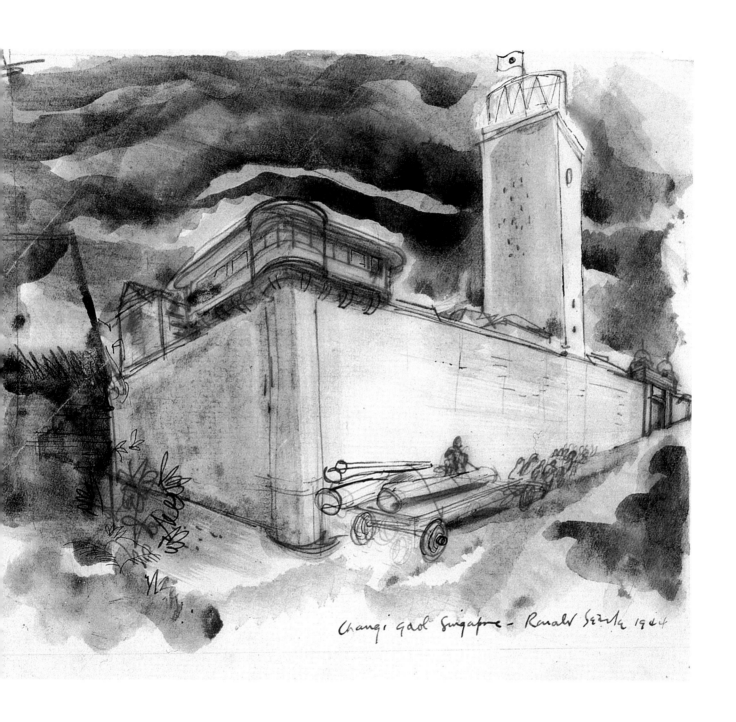

Changi Gaol Singapore – Ronald Searle 1944

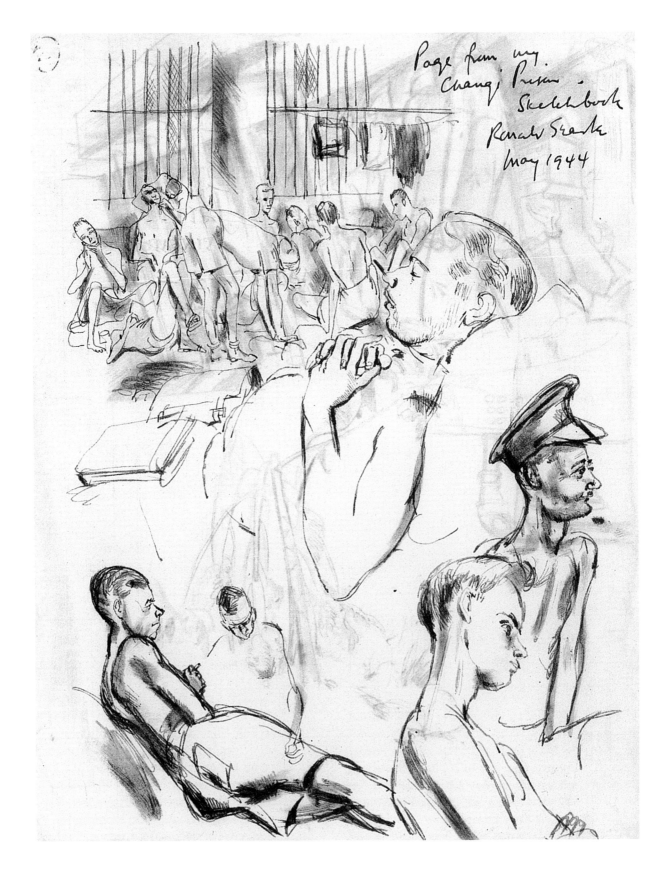

Page from my. Changi Prison. Sketchbook Ronald Searle May 1944

When we arrived, two hundred of us were wedged into cell C.1B, a completely bare, so-called 'mass' cell, with a lot of bars and a rough concrete floor on which to sleep. It was some months before we were moved into something more cozy.

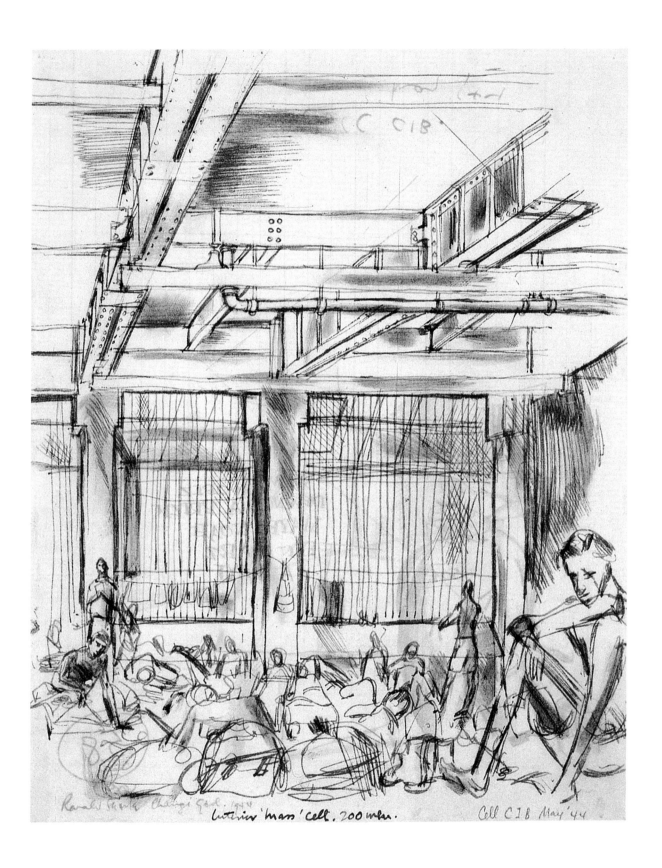

Ronald Searle Changi Gaol. 1944 Interior 'mass' cell. 200 men. Cell C.1.B May '44

OPPOSITE AND ABOVE Sketches
made soon after our arrival in cell C.1B,
Changi Gaol, May 1944

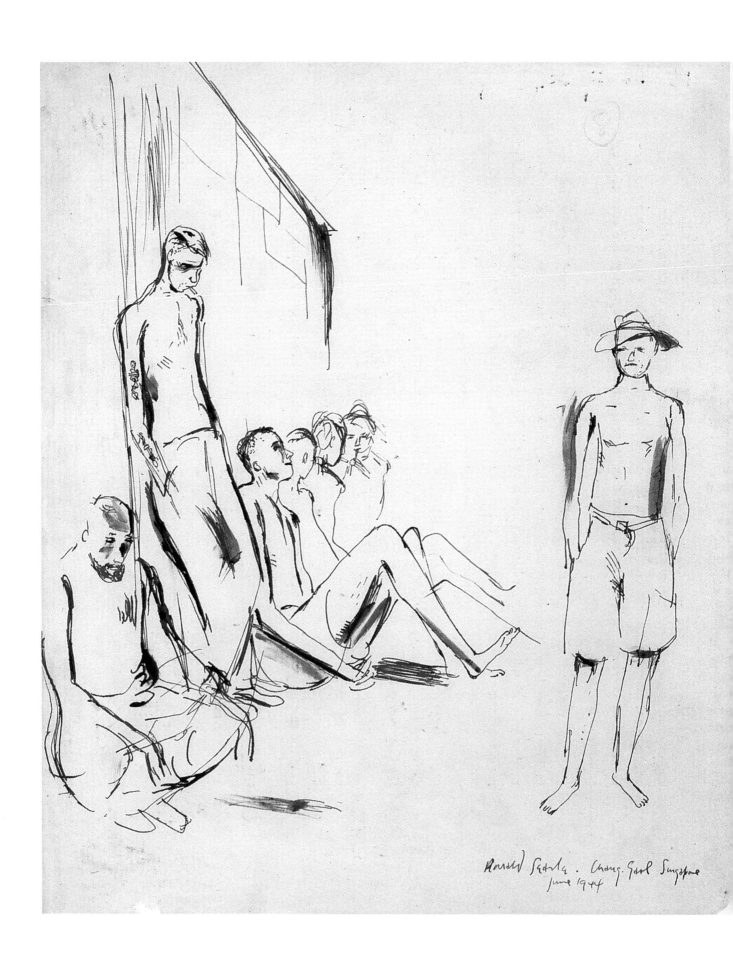

Ronald Searle . Chang. Gaol Singapore
June 1944

Still more prisoners were eased in by the Japanese, so that by June the gaol itself contained almost ten times more prisoners than it had been designed to hold. We were also a somewhat exotic mixture treading on each other's toes. British and Australians predominated, followed by Javanese, Balinese, Ambonese and Dutch. There were also a handful of American merchant seamen lucky enough to have been picked up by the Japanese submarine that sank them, a variety of odds and ends from other far-flung countries and, ironically, the officers and crew of an Italian submarine that had made the mistake of putting in to refuel in what they thought was a friendly haven – Singapore. To their mortification, their uncomprehending allies bundled them into prison with us; in their pristine white uniforms they looked extremely embarrassed at this unexpected obligation to mingle with the enemy instead of sinking it. However, they proved to have the philosophical resignation of all seamen and eventually their uniforms and their discipline became as tattered and as anonymous as our own.

At this point in our lives some sort of philosophical outlook was desirable, for one great curse of prison is that it allows too much time for reflection. We had been prisoners for more than two years. But in this seasonless part of the world time had no particular meaning any more and the future was a great big blank. We had no idea whether we were heading for a life sentence or a death sentence.

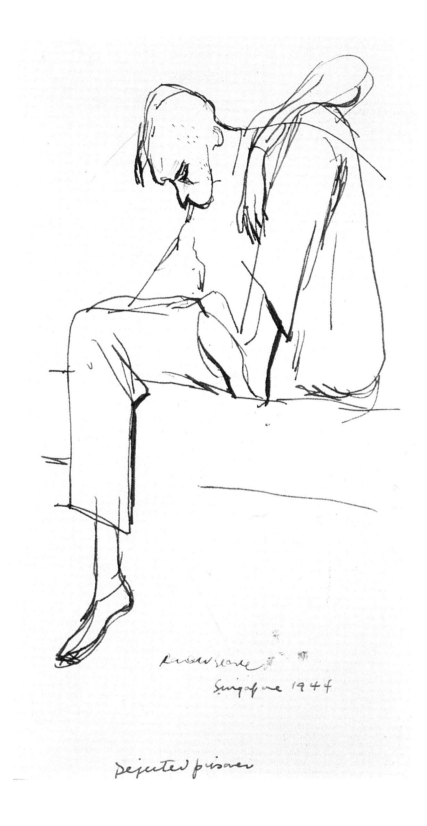

Singapore 1944

Dejected prisoner

Changi Gaol, June 1944

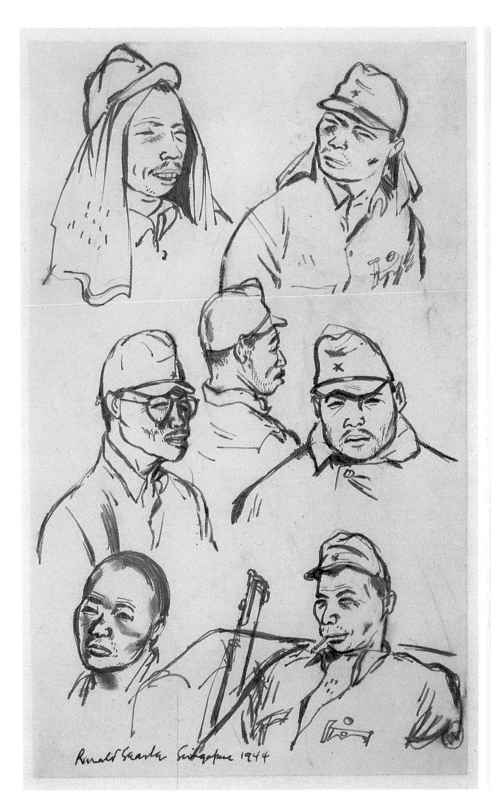

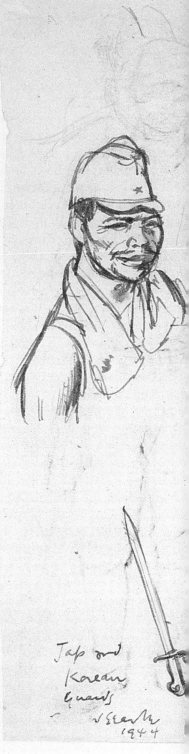

Jap and
Korean
Guards
R Searle
1944

Prison guards, Changi, 1944.
They told us that this was only
the beginning.

The Japanese would laughingly tell us
at every opportunity that this was merely
the beginning of their Hundred Year War
and it was hardly uplifting for our morale
to consider that most of us would be about
125 years old before being released to
savour the benefits of the Greater East
Asia Co-Prosperity Sphere. But, joking

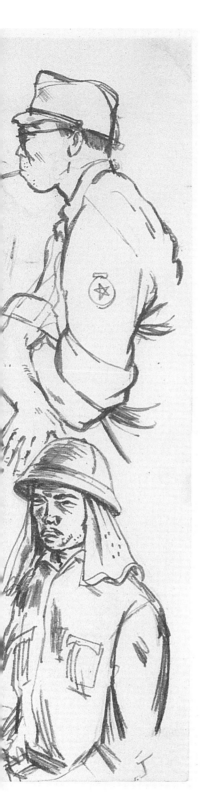

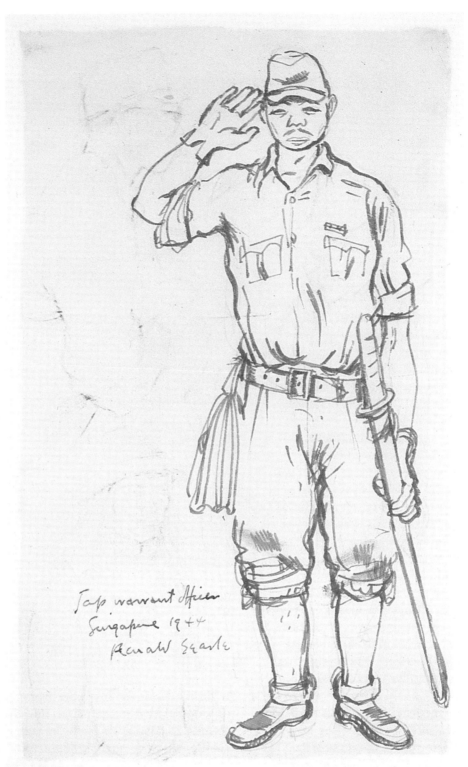

Jap warrent officer
Singapore 1944
Ronald Searle

apart, we could see no indication on the
horizon of freedom or long-term survival.
Yet somehow we still clung blindly to the
idea that Good must triumph over Evil,
and that sooner or later 'our lot' would
come and get us out of there. And the
way things were going, the sooner
the better . . .

Meanwhile the realities of confinement effectively crowded out our nebulous hopes. Those of us who were still upright after the excursion to Siam were, nevertheless, still coming out of the shock of the experience. But although some of us were mentally and physically fragile, we were infinitely better off in this overcrowded, stinking gaol than we were in the isolation of the jungle where we were never out of sight of the Japs. Apart from that, many of the old problems were still there. As a result of the never-ending round of illness and labour, we were miserably thin and wasted. The food situation, always precarious, was now verging on the dramatic. Two years of undernourishment were having their logical effect. Our eyesight was deteriorating, we were losing our memory ('Changi memory' was to become medically notorious) and our lower leg muscles were often as difficult to control as our bowels. Our teeth loosened or fell out and pellagra left us with raw, swollen tongues and fierce burning patches on our skin.

Sick prisoner, Changi Gaol,
July 1944

As there was never any relief from the tropical heat in the prison and no clothing to protect us from the sun outside, we were rarely able to enjoy the luxury of being able to escape the offensiveness of our bodies for even a moment.

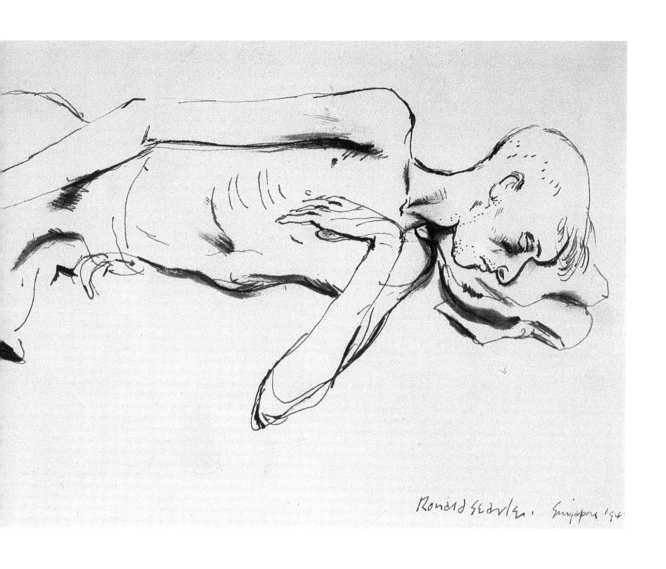

Ronald Searle, Singapore '4

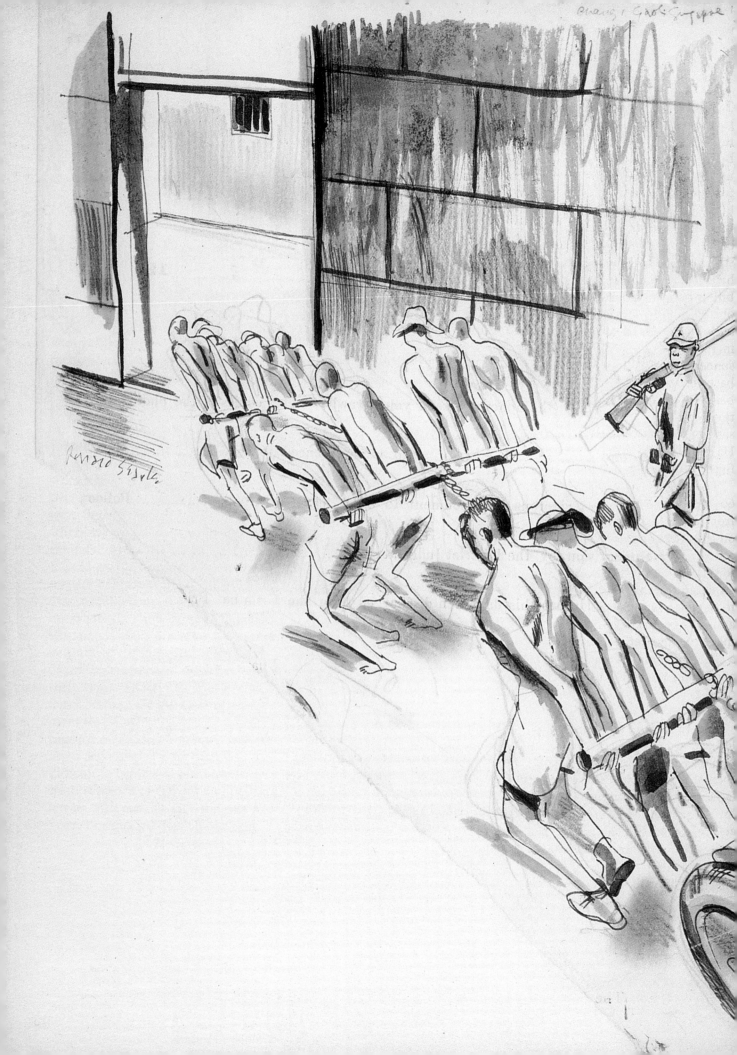

The Herculean project of flattening the surrounding Changi area and turning it into a military air-base, by using prisoners to reshape the undulating coastal landscape, was well under way. All hills that might be an embarrassment to future runways – and there were several big ones – were to be removed and spread about somewhere else. A long hard job with modern trucks and bulldozers, an agonizingly endless one with only hand tools. Every day at dawn a party of 900 prisoners was marched off to dig. Fourteen to sixteen hours later they were herded back into the gaol worn out, burnt black by the sun and half blinded by the intense glare thrown up from the sandy ground they were levelling. Hardly surprising that the work finally took one and a half years.

There was also 'P' Party, a gang of 600 prisoners who were transported from the prison each day to labour on the docks and at Singapore railway station. This was preferable to the work on the airfield as, although the ships and trains were to be unloaded or loaded with ammunition or other inedible military goods, there was always a chance of contact with the locals and doing a deal on the black market, or of gathering a morsel of news if not of food.

The remaining prisoners, those left around the prison because of weakness or illness, tried to make themselves invisible. But sooner or later most of them were rounded up for some disagreeable task, such as acting as a beast in harness to haul trailer-loads of tree trunks here and there.

Finally, anyone not on a working party received half rations.

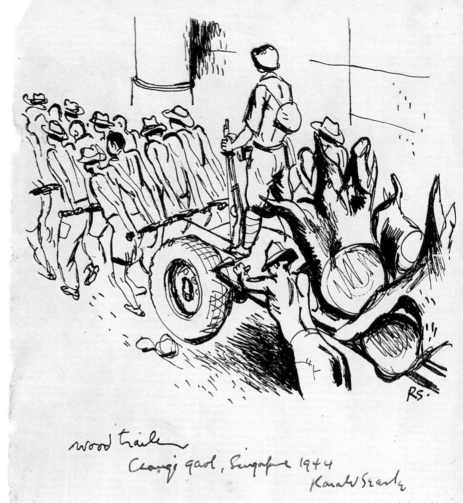

wood trailer
Changi gaol, Singapore 1944
Ronald Searle

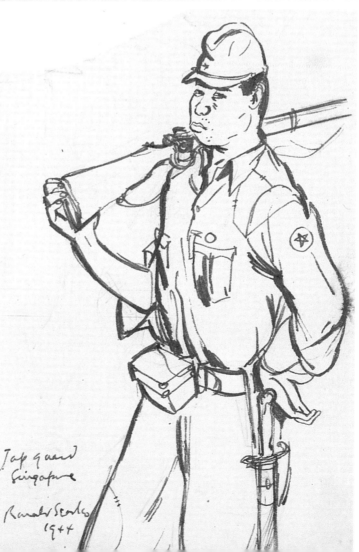

Light duties' for sick men,
Changi Gaol, July 1944

Jap guard
Singapore

Ronald Searle
1944

LEE ONG TECK
生活工業社出品
THE LIFE INDUSTRIAL INS
BATU PAHA... ...HORE

From my 'P' Party sketchbook.
Glimpses of the outside world
from a passing truck or whilst
working on the docks at Singapore,
July and August 1944.

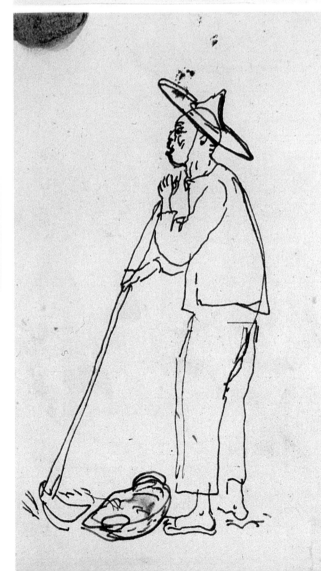

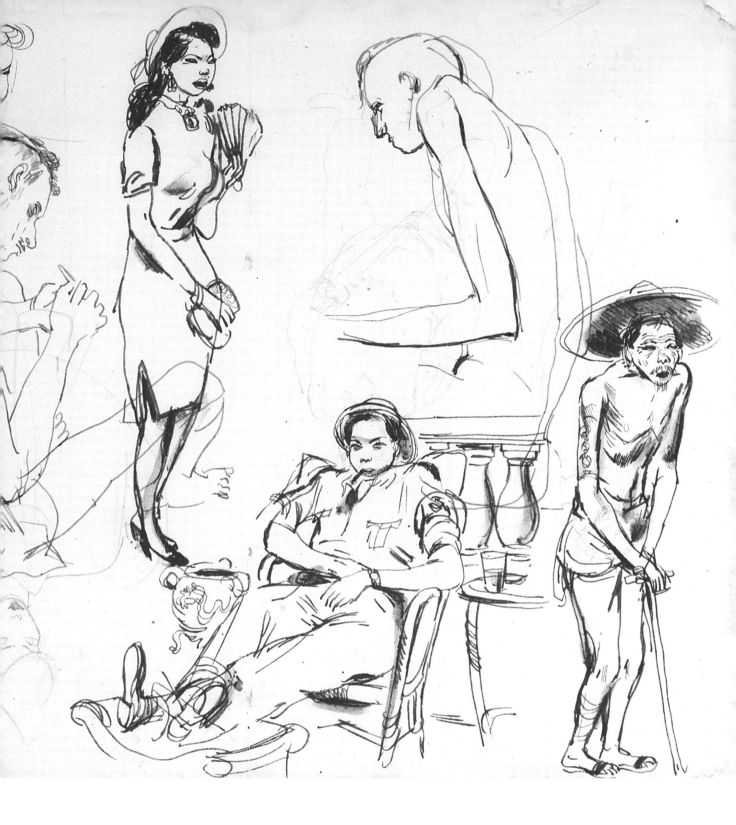

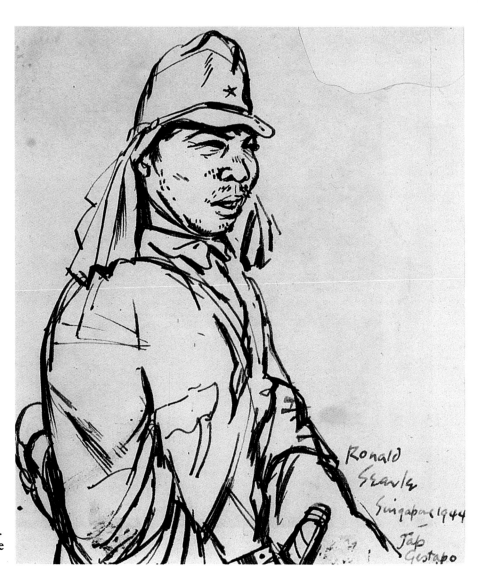

Singapore, 1944.
A member of the
Kempei-tai.

The *Kempei-tai* – the Japanese equivalent of the Gestapo – had their own, much nastier prison in Outram Road, Singapore, so they did not bother too much with ours. Outram Road gaol had a sinister reputation and very few prisoners who were taken in for 'questioning' ever came out again. On those occasions when the 'Kempi' did descend on Changi Gaol it was often to the surprise of the Japanese administration as well as to ourselves. They systematically searched our cells and belongings, tore the place apart in their hunt for radios or signs of subversive activity and occasionally took someone away. Once or twice they actually returned to Changi with the barely living remains of those who had been taken away for interrogation. But this was only a formality. In fact they were returned for their eventual burial. I was always terrified that one day they would stumble on my drawings. But they never did and my head remained on my shoulders.

The *Kempei-tai* were a very special lot and from what we saw of them we consoled ourselves that we were, on the whole, better off in the hands of officers of the old-fashioned Japanese military tradition, with the simple bullies that we had as guards, than we would be in those of a band of highly trained, merciless thugs.

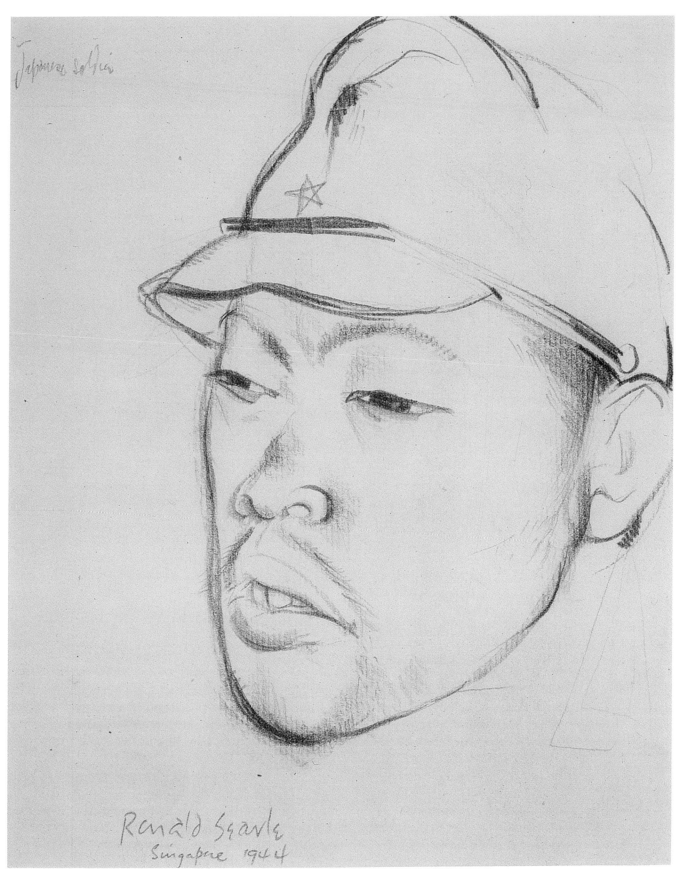

Japanese soldier

Ronald Searle
Singapore 1944

Prison guard, Changi Gaol.
Better to be in his hands . . .

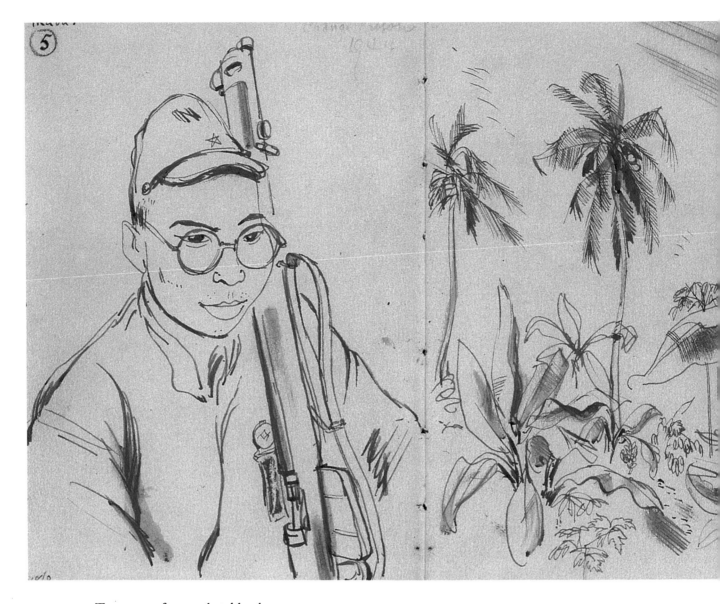

Two pages from a sketchbook.
Ikeda and some banana trees
near the beach by the prison.

It was not all gloom. Sometimes a handful of us might be lucky enough to be detailed off for a smaller, more agreeable working party – to go to the beach to collect sea water for salt-making; to do repairs at the Japanese officers' club; or even to add a nuance to the villa of Saito, the great general himself, commander of all Southern Prison Camps. On these occasions we might stay a week or more under the same lone guard who would be about the same age as ourselves and just as bored and homesick – like Ikeda sketched above. Under these circumstances it became possible to develop a sort of non-commital relationship with him, based on mutual confidence.

Provided we did not take visible advantage of the situation, the guard would leave us to our own resources, hitting us only when it was necessary to keep face in front of a superior.

One day on the beach I took the chance of letting Ikeda see me making a sketch of some banana trees. Later, while we were having our rice break, he showed us photographs of his family and asked me to make a sketch of him on an army issue postcard to send to his mother. I made my first 'try' in my little sketchbook (above) and a second effort on the postcard, which he carefully put into his ammunition pouch until he could post it home to Japan. The likeness was good and he was

pleased. From then on he turned a blind eye when I slipped away on my own to sketch, for example, a stretch of the idyllic beach that looked vaguely across the South China Sea towards Borneo, or a native hut in a nearby kampong (pages 150–153). He would remain sitting under a convenient coconut palm, sighing for home. I hope he finally managed to see it again.

Sometimes we had a guard who was less forthcoming and simply wanted an opportunity to catch up on his sleep, like the one sketched below, who relied on us to wake him when it was time for us to march back to gaol . . .

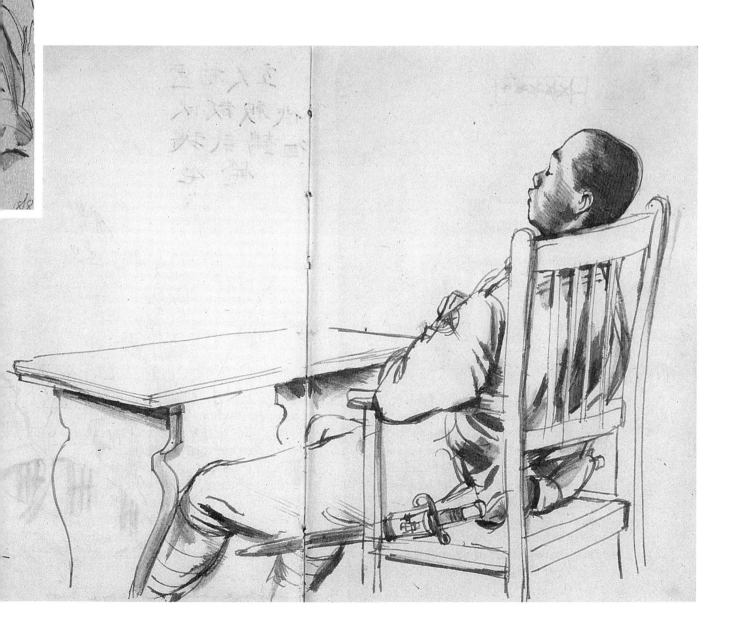

A beach near the prison, July 1944.

During those occasional and bizarre moments of artificial liberty, it was dreamlike to be so swiftly transported from the bedlam of the prison into a silence broken only by the breeze in the coconut palms and waves lapping over dazzling white sand. To be standing for a moment, unconfined, undisturbed, quietly sketching a chocolate-boxy, desert island shore instead of a never-ending Guignol of sick and skinny bodies; to have only an uninterested fisherman between me and the horizon, instead of a heaving, sweating mob in that steel and concrete labyrinth up the road, burnished the faculties a little and when the time came to return to prison, withdrawal was very hard. I clung to that therapeutic image so fiercely that even now, when I look at the sketches, I can smell the shore and almost count the grains of sand clinging to my feet.

Ronald Searle. July 1944. Singapore

Beach near the prison

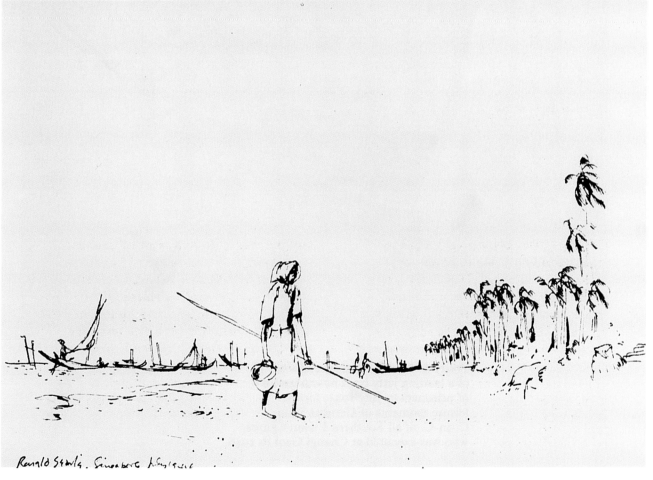

Ronald Searle. Singapore Malaysia

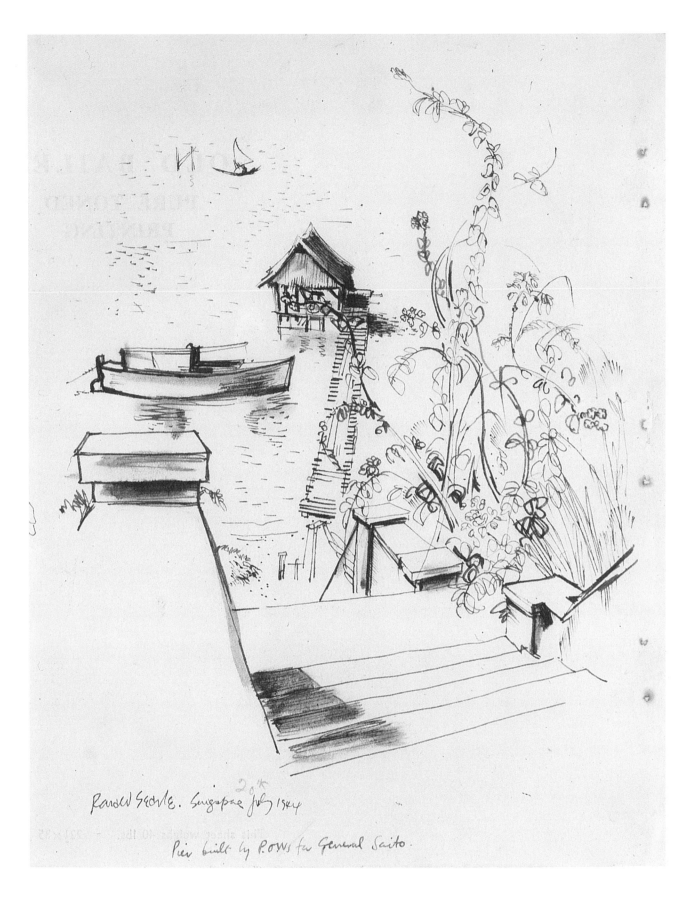

Ronald Searle. Singapore July 20th 1944

Pier built by P.O.Ws for General Saito.

Pretty (non-committal) sketch
of a boating jetty built by our group
of prisoners in July 1944, for the
leisure moments of General Saito,
C.-in-C. of all Southern Prison Camps,
who was executed at Changi Gaol in 1946.

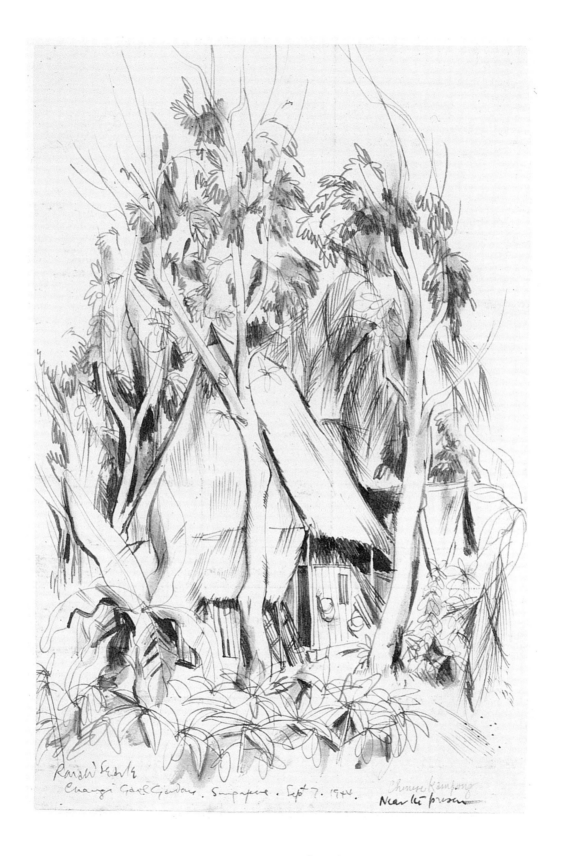

Chinese kampong by the prison,
September 1944

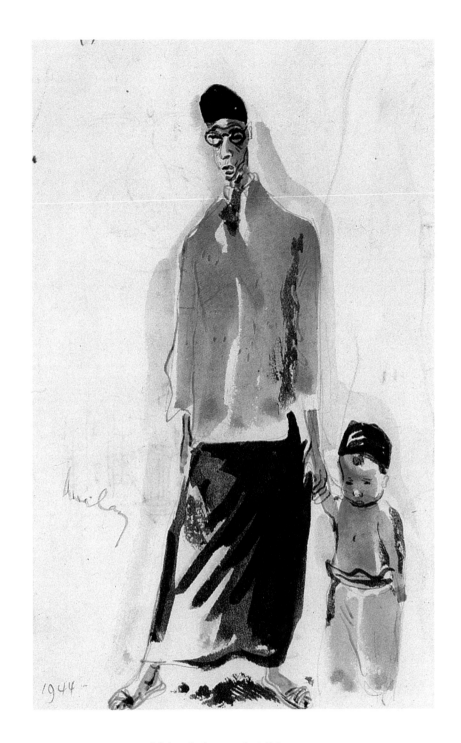

Malay father and child
from a nearby kampong

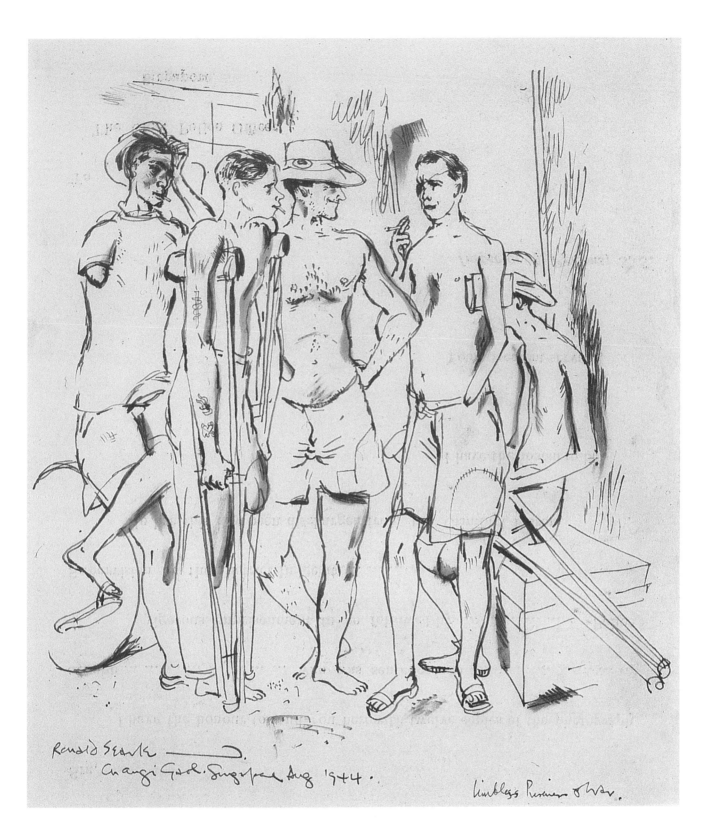

Back to reality: war wounds and
prison amputations. Limbless
prisoners in Changi Gaol, August 1944

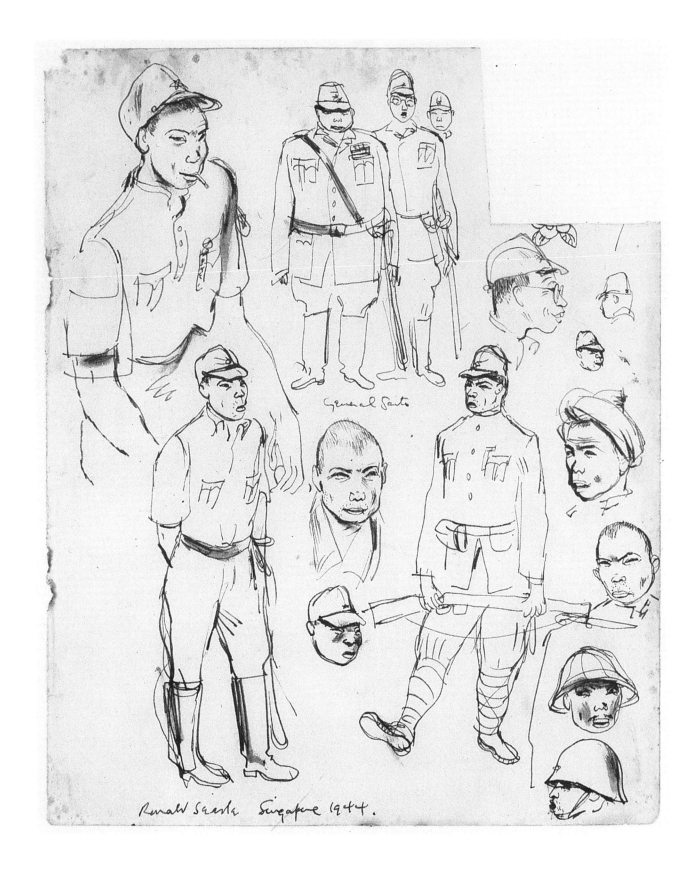

General Saito and assorted minions.
Page from a sketchbook, Changi Gaol,
August 1944

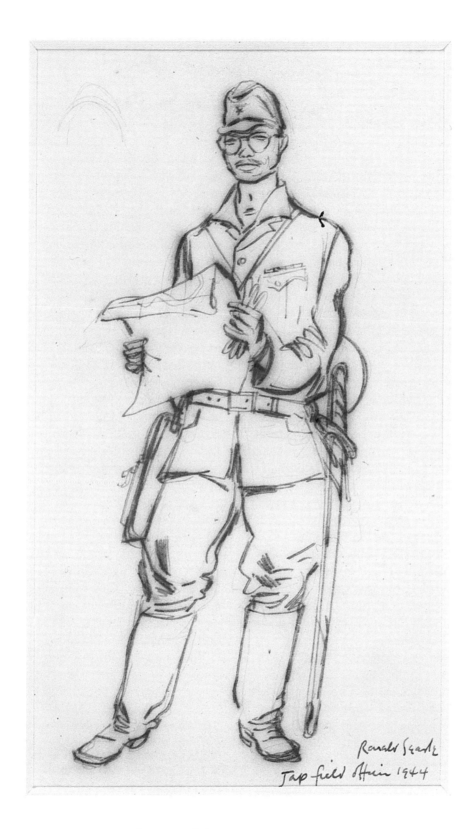

Japanese field officer surveying
the ground, Changi 1944.
After Allied reconnaissance planes
began to appear over the island,
Japanese combat troops were seen
more frequently.

By the end of 1944 we were being given so little to eat that it was almost impossible to think of anything else other than food and how to obtain it. The pangs of hunger were frequently more demoralizing than the combined miseries of beri-beri, dysentery and the clammy hand of malaria. We talked ceaselessly about food, we dreamed about food and, after we had eaten our miserable allowance for the day, tried to take our minds off it with any handy diversion: arguments, discussions, concerts, arts, crafts, musical moments, essential repairs, knocking together *Exile*, the prison magazine, and searching for something to smoke. And how we smoked. We inhaled any blade of grass or leaf that would smoulder when wrapped in any morsel of paper that would stay rolled. Thin paper was so rare that in desperation I smoked the spare corners of many of my drawings (see page 156 for example), half of *Pickwick Papers* after a fifth reading, and the whole of Rose Macaulay's *Minor Pleasures of Life*, which had been respectfully printed by Gollancz on something resembling prayer-book paper.* However foul and acrid the result, however like choking over an autumn bonfire, it helped to hold off the constant clamouring of the stomach to be sent down something – anything.

On Tuesday 14 November 1944, one of our immediate circle managed to catch, conceal and cook a cat that no one else had spotted. It was a remarkable achievement in the midst of ten thousand starving men – and a superb cat, especially when served with chillies, grated coconut and succulent seaweed, over our combined evening rice ration. Until then nothing more domestic than a pet rabbit had crossed my culinary

horizon. Now the animal kingdom opened up new and delicious prospects. We knew that the Dutch lines were toying with some foul-sounding variation of curried rat and that members of our own company groups were doing wonders with whelk-sized snails they had concealed in their hats whilst working in outside under-growth. But now that we had tasted big game we set our sights higher.

Whether it was on account of the cat, or something less interesting, I was ill for five weeks after with a spectacular dose of yellow jaundice. However, this paled into insignificance when, on 19 December, our lot pulled off a very delicate coup. One sunset they managed to approach, throttle, skin, cut up and conceal the meat of an extremely large and unfriendly guard dog that had separated itself from its Japanese master for a moment. The beast nourished a lot of men that night and fully justified its brief passage on earth.

Lastly, there were the three little kittens. They had been earmarked for our Christmas dinner and were put into our care for fattening up on 10 December. I drew them several times before, on Christmas Day, they were gently fried to give us a memorable meal. They tasted rather like baby rabbit, but more delicate and sweeter. Delectable.

So passed our third Merry *Kurissumassu* in captivity . . .

* By chance, many years later, I met Rose Macaulay at a party. I told her how I had been able to add a further minor pleasure to her anthology. Sad to say she was not amused, looked me up and down with distaste and turned her back to talk to someone more respectful. Dickens, I feel, would have been more understanding.

Kittens Dec 10–25 1944.
Changi Gaol. C Point. Ronald Searle.

Two-thirds of Christmas
dinner 1944

7

The Last Year

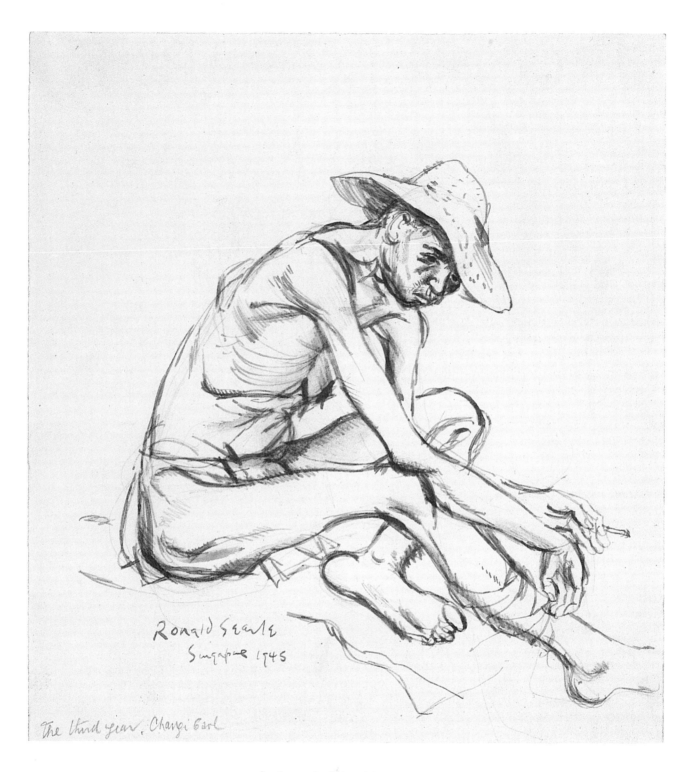

Ronald Searle
Singapore 1945

The third year, Changi Gaol

At the end of the third year
in captivity, 1945

1945 got off to a rather ironic start. About the time we were gloomily ticking off our third year in captivity, Allied planes, for some subtle reason known only to themselves, chose to bomb Singapore docks and warehouses instead of something more vitally military. Of course it was lovely to know that the Allies were around but, with that air-raid on 24 February, we said goodbye to the best part of the food stock of the island – food for the locals as well as for ourselves. Furthermore it was not a very heartening incident for prisoners who were, as usual, doing all the dirty work on the docks. Allied intelligence was either miserably ill-informed or totally incompetent, for we found it difficult to believe that at this stage in the war our own people would knowingly let many more prisoners die unnecessarily of malnutrition and its side-effects, or that they were aware that for three years the forced labour on the island was done by prisoners – especially on the docks. The odd bombing raid did not really affect Japanese morale one way or the other at that moment. However, had the Allies intended to further demoralize those locals who still remained their friends and to strike prisoners where it would hurt most, they could not have done better.

Whether it was done as a reprisal, or whether there was literally nothing much left to distribute, our almost invisible rations were immediately and drastically reduced by the Japanese. In one of my sketchbooks I noted quantities. We were now receiving only 310 grams (11 oz.) of food a day; 200 grams of it, rice. The remainder consisted of half a mug of seaweed soup with veg, plus, at the end of the day, one 'rissole' – a euphemism that veiled a multitude of sins. Anything else we needed we had to scrape up among ourselves. So one was torn between praying not to be detailed off on a working-party and the longing to get a chance of foraging for something edible outside.

Though it seemed impossible that there could be any increase in deficiency diseases, there was, and they appeared swiftly. The population of the Changi

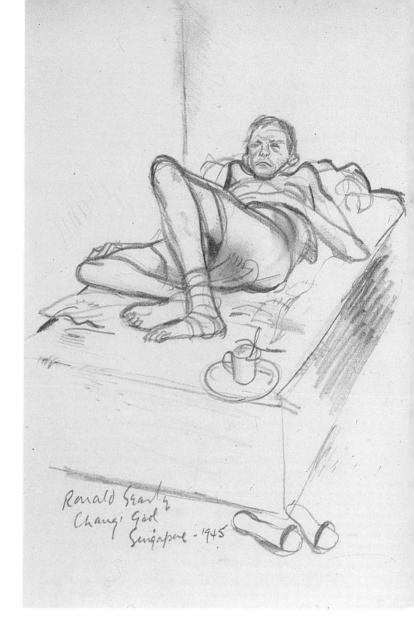

Ronald Searle
Changi Gaol
Singapore – 1945

Gaol area was then just over ten thousand. Three-quarters were ill. A steadily-increasing procession of undernourished malaria- and dysentery-ridden corpses made its way to the prison burial area, carried by their mates who were only marginally removed from the same fate.

There was light relief on All Fools' Day. The Japanese suddenly produced some Red Cross parcels and one 8 lb. parcel was divided between every twenty men. Then, on 29 April, the Emperor (bless him) had his birthday and we were invited to celebrate with an extra mug of rice.

The next day Hitler committed suicide. But we did not know it then, otherwise we would have been happy to save a little of the rice to celebrate the event.

In the midst of work, sleep and the hunt for something to eat or smoke I was trying to keep going with my task of recording our captivity, but not very enthusiastically. I was still a little unnerved by a curious incident involving my drawings and the Japanese.

Towards the end of the previous July Captain Takahashi, administrator of the prison for the highly inscrutable general, Masatochi Saito, had suddenly 'requested' that my drawings be sent to him. Despite the fact that Takahashi was known to be a tolerant man with a dry sense of humour, more intelligence and less arrogance than most of the military élite around Changi, I had been taken aback and very apprehensive at this unexpected, not to say unhealthy, attention shown me by the Japanese. True I had become slightly conspicuous through my decorations for the camp theatre and the poster and programmes for the variety shows that were always attended *en masse* by all ranks of the Japanese. I had also been seen to be working on the illustrations for the first issue of a prison magazine that had to be censored by the Japs before it could be circulated. But apart from this, I had been unable to guess what they might know about my drawing, or what Takahashi expected to see. I had always been extremely secretive about my project and careful to conceal any subject that might be considered even remotely compromising. So, taking a chance that the Japanese might know nothing about my 'eye-witness' drawings and noting that Takahashi had only sent a message and not guards to take me away with the drawings, I had prepared a mixed bag of inoffensive sketches such as the one opposite, some landscapes, fantasies and one or two uncontroversial portraits of prisoners, and sent them up the tower to Takahashi. But not without a rather chilly feeling wandering up and down my spine.

For three days I had heard nothing. Then, just as I was beginning to get really worried by the silence, Lieutenant Jusuke Terai, the creepy Jap interpreter, had suddenly materialized before me in his oh-so-impeccably-pressed uniform and understanding smile, bearing a beautifully tied-up package. My drawings were returned to me with many flowery remarks delivered in a very 'Oxford' English – and sixty sheets of superior paper, 'with the compliments of Captain Takahashi, for the continuation of your studies . . .'

This delicate attention had left me extremely uneasy. It paid to keep a low profile where the Japanese were concerned. It was not healthy to be even vaguely identifiable, above all not to the administration itself, so for the sake of security I changed the hiding places of the incriminating 'eye-witness' drawings around the prison – but not without pondering at length over the reason for having been pin-pointed like this.

Back to the present: April 1945. An order came from the tower bearing the *chop* of Captain Takahashi, Administrator of the Prison, 'requesting that, at first light, Mister Searle and three other Royal Engineers be ready to be taken under guard to the Beach Club of the Officers of the Imperial Japanese Army, where they are to await further instructions'.

We were ready and, at first light, were compared with the order sheet, counted several times and marched out of the prison by a sleepy guard who, once we were around the corner, made one of us carry his rifle so that he could smoke and shamble along the track to the beach more comfortably.

It was already hot by the time we got to the beach club. We were welcomed with many bows by Oba-san, the motherly Japanese housekeeper, who led us to the

Prison headgear, 1944.
Something for Takahashi
– among other things.

vast comfortable salon, sat us down, gave us a mug of tea and a sweet biscuit, then retreated, all smiles, followed by a little white dog. She had obviously been given detailed instructions. All very cosy, and the fact that our guard was shuffling about unhappily and uneasily at this close contact with an inner sanctum of the military hierarchy of the island confirmed that, even if this should prove to be our final tea and biscuit, it was certainly not he who was going to be dragging us kicking and screaming down to the beach to do us in. Anyway, by now he had disappeared into the kitchen where he could smoke without having to suffer our longing looks at his cigarette packet.

A young officer appeared, all sword and shiny boots, acknowledged our bows and scrapes and addressed us at length. Roughly disentangled, the gist of his remarks was that, from now on until further notice, we were to spend all day every day at the villa improving and beautifying anything we could find to improve and beautify inside and out by command of Captain Takahashi to whom alone we would be directly responsible for orders. Captain Takahashi would, in turn, answer for us and our behaviour to the officers of the club, including General Saito, who would be responsible to the Emperor. So we must work honourably and diligently. *OK ka?* and *arigato.*

So the carpenter was to nurture the woodwork, the plumber to restore confidence in the pipes and the electrician to seek a solution to the nuances of the Singapore electricity supply. Searlo-san was to decorate certain walls with what was known in the trade as 'muriels'. It was quickly apparent, however, that none of the work was vital. The villa was perfectly *OK ka* and it was clear that we had been specially chosen to mess about quietly. But why? It was bizarre – but who were we to question the convolutions of our captors' minds? Ours but to do or, er, die. So we diligently set to as requested.

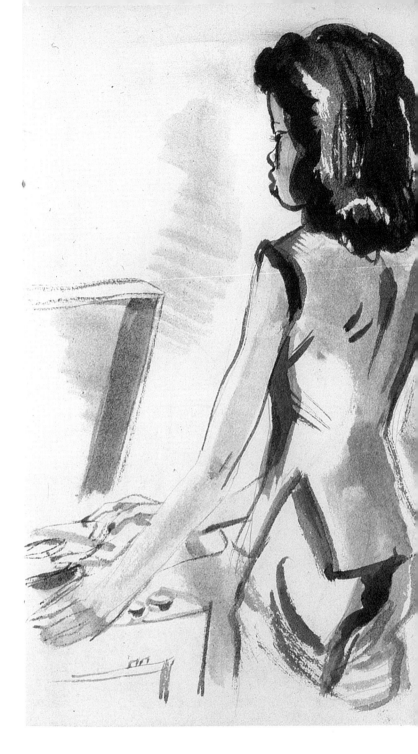

Other than our guard, who kept a low profile, there was rarely anyone at the club during the day except Oba-san, her doggie, and Hanaka, a teenage Chinese 'amah', who lurked around the saloon mooning over worn-out records to relieve her boredom until claimed by her evening duties. Outside there were two or three Javanese gardeners keeping the weeds down, mostly by sitting on them.

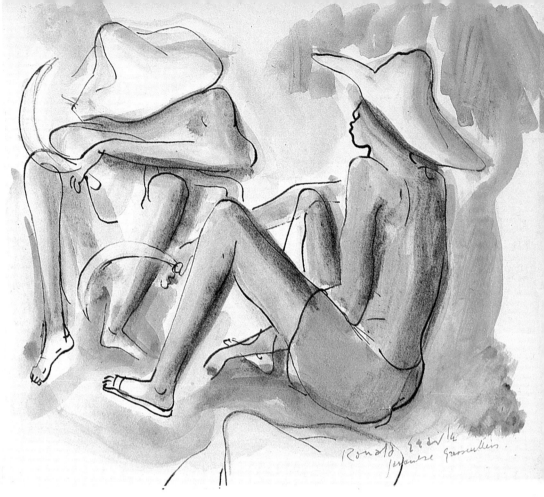

Ronald Searle
Javanese Grasscutters.

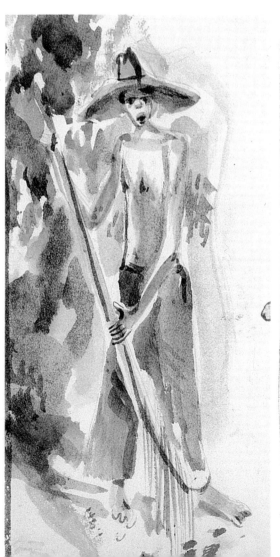

Hanaka
Chinese Amah
to Japanese

Ronald Searle
Jul 21 1945
Thirty-three
Singapore.

LEFT Hanaka,
the beach club 'amah',
mooning.
RIGHT Javanese
gardeners around
the villa.

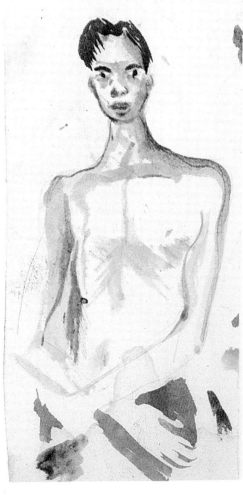

167

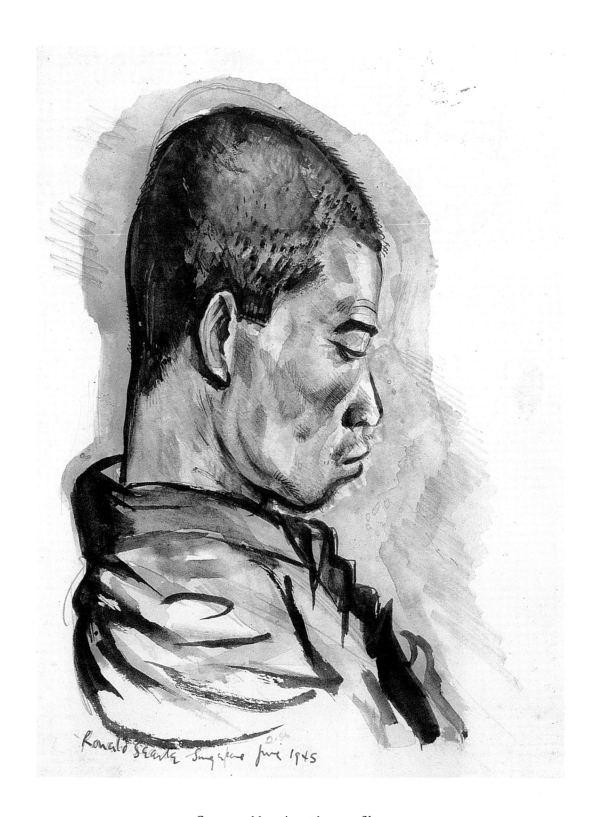

Our guard keeping a low profile
at the beach club, June 1945.

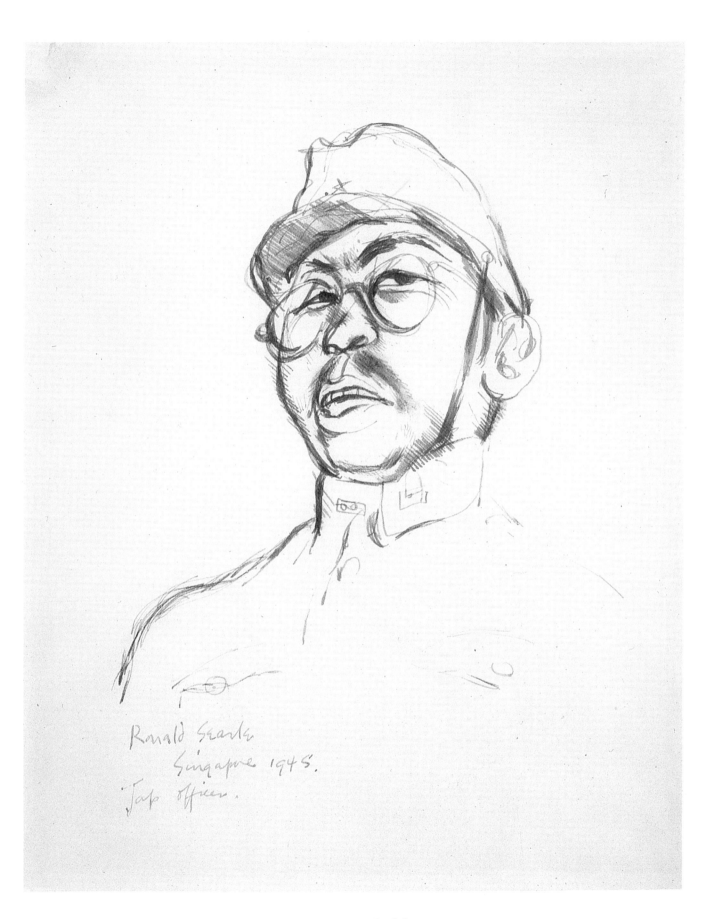

Ronald Searle
Singapore 1945.
Jap officer.

Officer at the beach club, 1945

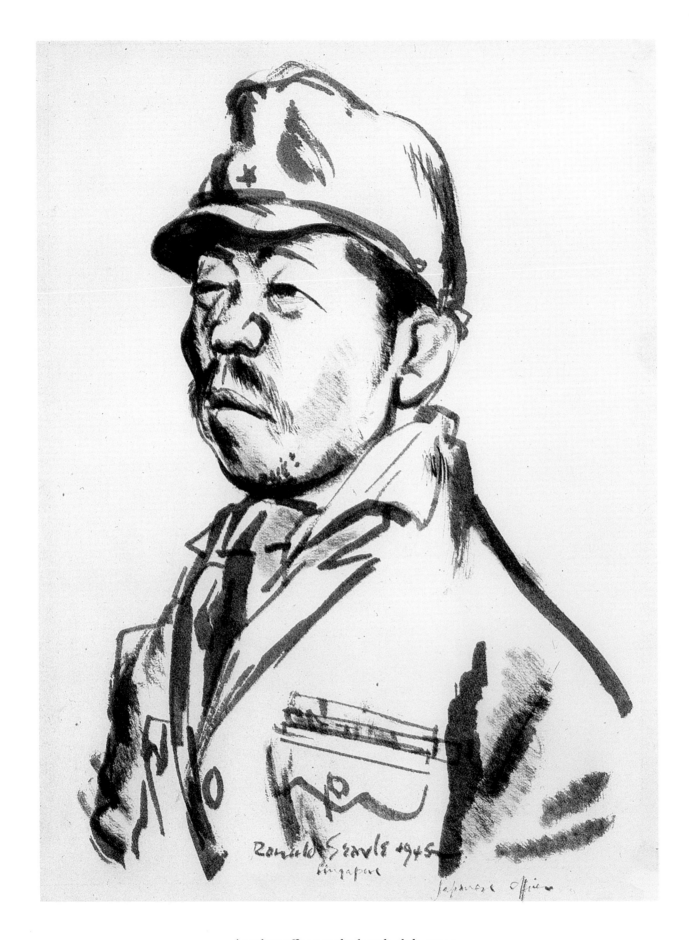

Another officer at the beach club, 1945

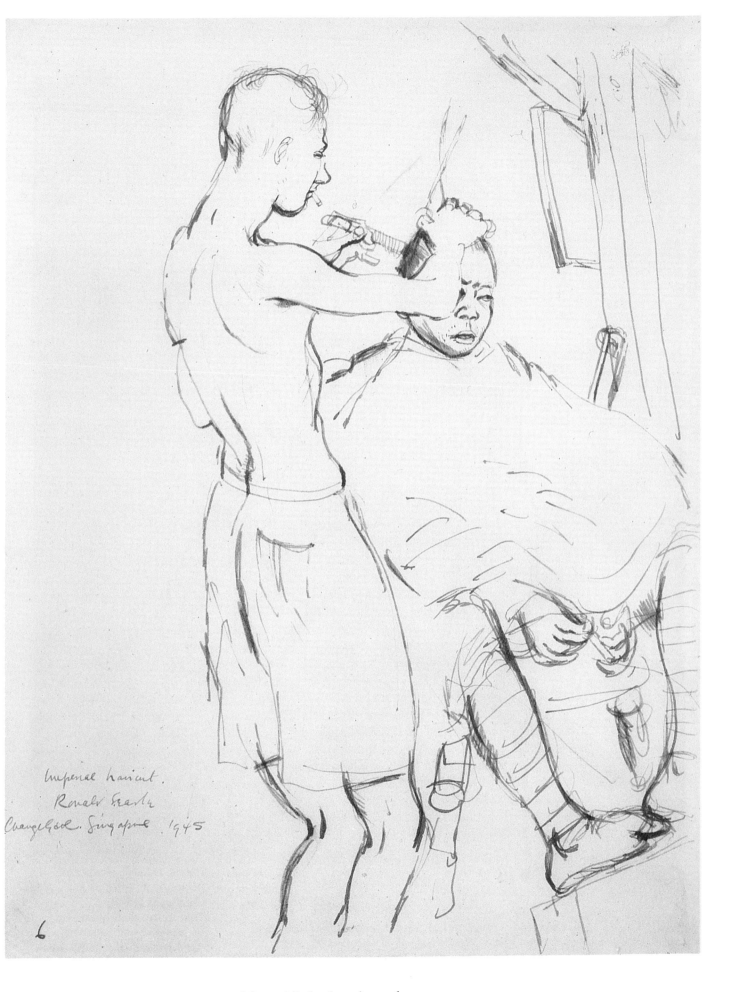

Imperial haircut.
Ronald Searle
Changi Gaol, Singapore. 1945

Meanwhile back at the gaol . . .
Prisoner giving our guard a haircut, 1945

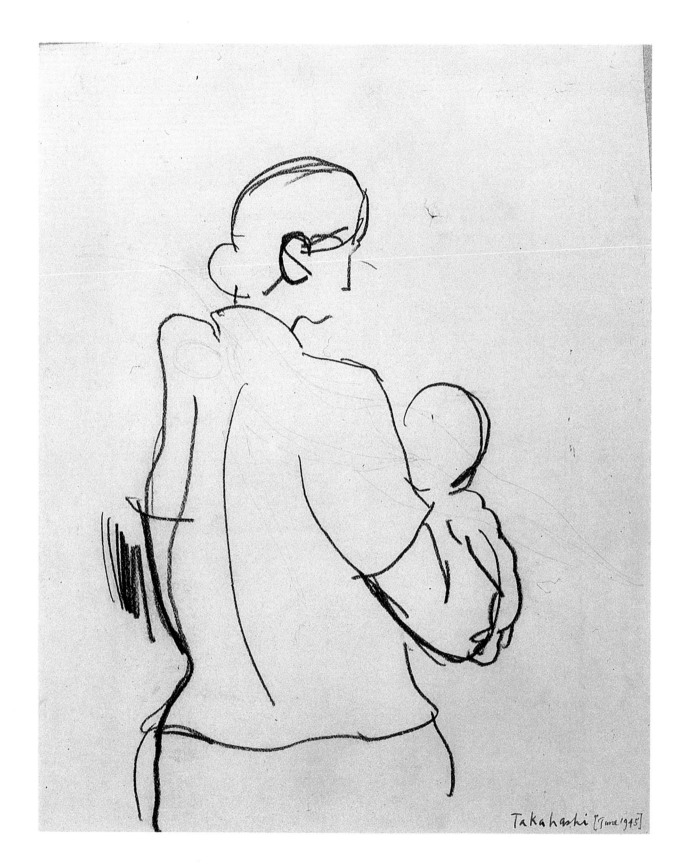

Takahashi [June 1945]

Takahashi did this.
Note in my sketchbook by
the last-but-one Japanese
administrator of Changi Gaol,
June 1945

From time to time Captain Takahashi would turn up at the club. Acknowledging our salutes and bows with a polite nod he would unbuckle his sword, sink into a chair and motion us to proceed with our fiddling about, He would look around with amusement as our ragged quartet went through the pretence of absorbing ourselves in something resembling work, always keeping our eyes away from his end of the room. Apart from the odd question to our overwhelmed guard in an attempt to divine what was actually going on and an occasional glance cast over my sketch-notes, Takahashi rarely paid us any attention. After sipping something that Oba-san had brought him, he would quietly efface himself, in contrast to the nerve-racking clatter that usually went with Japanese officers.

One day in June I was alone and 'muriel-ing' behind the bar when Takahashi wandered in. He handed his sword and cap to Hanaka and motioned her away. When she had closed the door he strolled over to the bar which I was, as usual, using as my drawing table, offered me a cigarette and lit one himself. His movements were, as always, unhurried and accompanied by a slightly cynical smile. But behind that bland, narrow-eyed, aristocratic reserve, he was a razor-sharp observer. Looking at me sideways for a moment with what little there was visible of his pupils, he took off his gloves, picked up my sketchbook and a pencil, said, 'May I?' and began to draw the outline of a mother and child on the first blank page. Then he stopped, looked wryly at the sketch and said in his careful English:

'You know, Mister Searle, I also am an artist – a painter. I was studying in Paris when I was called home to this – ah – to serve . . .'

He turned over a few pages of the sketchbook with a vaguely reflective air,

handed it back to me, put on his gloves again and, with his usual slight bow, left the room puffing his 'Tojo special'.

He returned at once. 'Oh, I forget. I intended to ask you whether you would care for these.' And he laid a handful of coloured pencils and wax crayons on the bar.

Finally the question was answered.

I had never for one moment imagined that Takahashi's 'request' to see my drawings would turn out to have been for reasons non-military, non-political, non-administrative, and non-suspicious. Or that – as in the case of the present order to idle about the beach club – he was making a quiet, unsoldierly gesture of solidarity between artists. Fortunately for the four of us, a sentimental fantasy had interposed itself between Takahashi the civilized, cultivated painter and the sordidly real circumstances in which Takahashi the prison administrator, lord of life and death, was now obliged to exercise his talents. Our paths crossed only briefly, but the resulting rare moments of peace that he had made possible for a few of us have been long remembered. For the first time as we were taken back to prison at night, we had something to look forward to next day.

Apart from the odd courtesy, Takahashi never spoke to me again; he gave no indication that our conversation had ever taken place. A few weeks later he was suddenly taken away from the gaol and we did not see or hear of him again.*
Not surprisingly our work at the club came to a halt and next day we were back on the docks with the others, unloading an ammunition ship.

* With the help of the Imperial War Museum I have tried to discover what became of him – but without success.

By July 1945 the end was approaching, but we did not know it.

In May we had heard rumours that the war in Europe had ended. Very nice. But all that seemed so remote from our own isolated existence that our level of optimism hardly fluttered at the thought. The prison was always rife with rumours of one sort or another, and one had learned not to give them too much credence or to be hopeful any more. In any case there was no positive indication that an end – apart from the one that was still carrying off too many diseased and hungry men – was in sight for us.

Quite apart from the ravages of malnutrition, malaria had now reached epidemic proportions and those of us who were not actually flat on our backs with fever were too feeble to cope with much in the way of physical effort. So much so that, to retain some semblance of working parties, the Japanese were forced to reduce the hours by half, as few men could now stand up to a twelve- or fourteen-hour day of hard labour. The occasional Red Cross parcel had become only a sweet memory and, by June, rations had sunk below subsistence level again. After three and a half years of confinement and hunger we were simply shrivelling and mouldering away. With the subsequent weakness came the inevitable cloud of depression and the sense of having been abandoned to our fate.

Prisoner, Changi Gaol, July 1945.
The closed door is symbolic.
Cell doors were always left open.

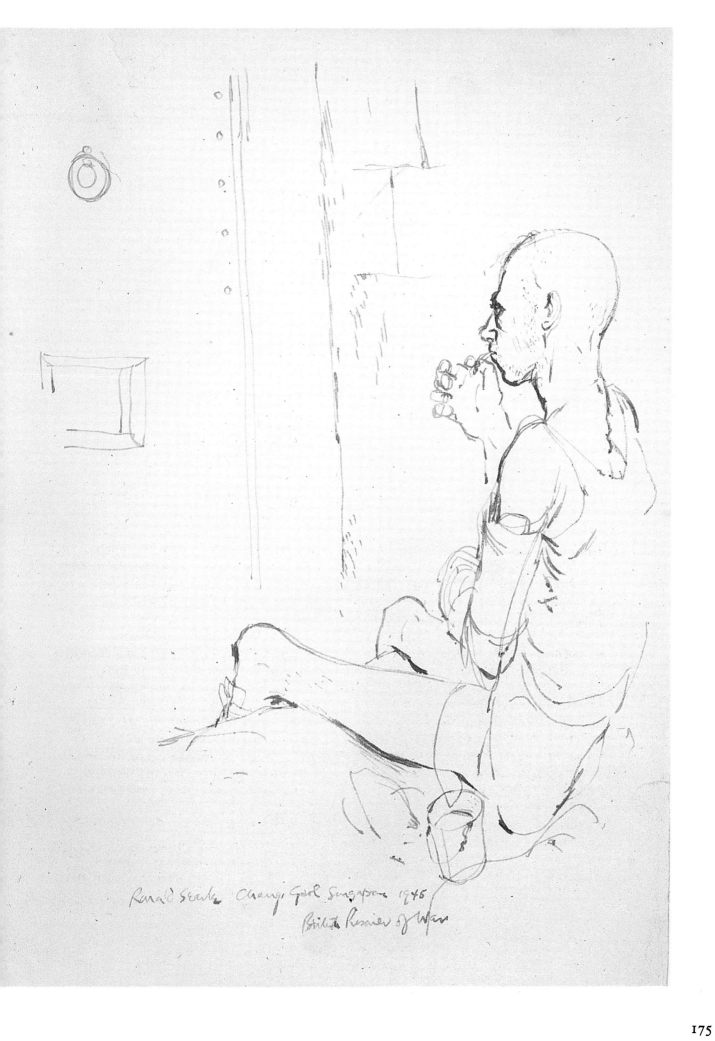

Ronald Searle Changi Gaol Singapore 1945
British Prisoner of War

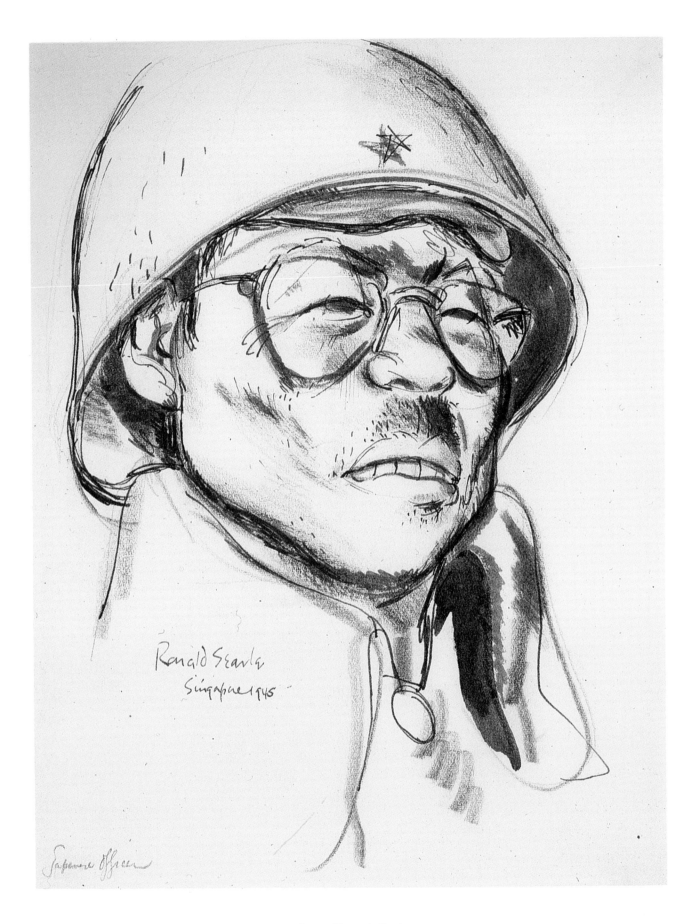

Japanese officer, Changi Gaol, 1945

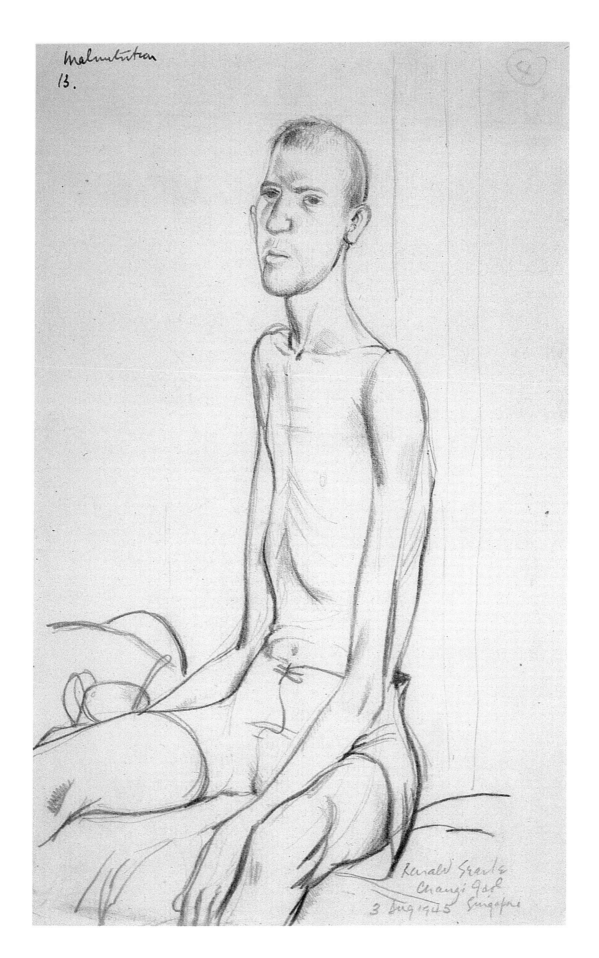

Hungry prisoner, Changi Gaol,
3 August 1945.

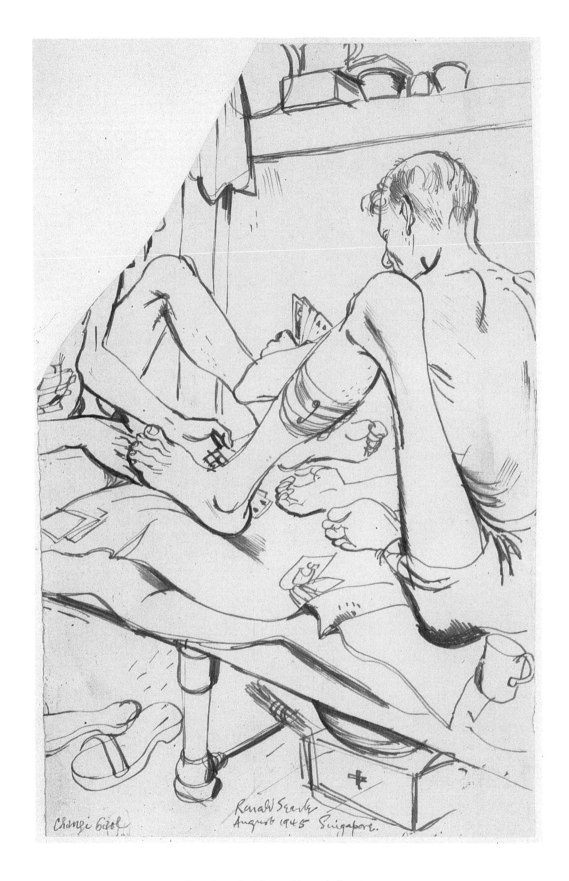

In a hospital hut, Changi Gaol,
August 1945

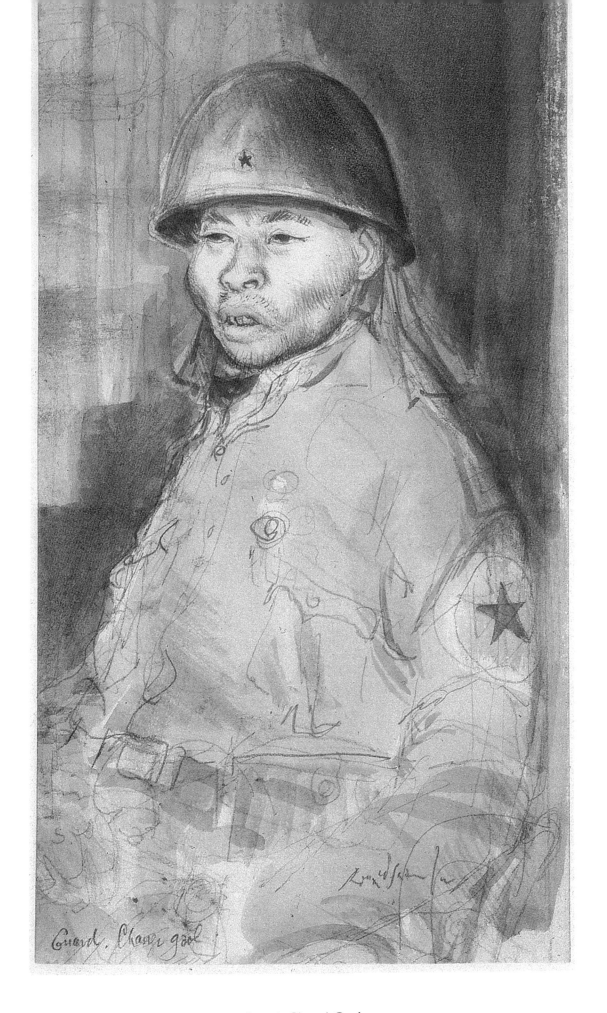

Guard, Changi Gaol, 1945

On 27 June I was carted off to one of the palm-thatched hospital huts in the shade of the prison walls for some surgical attention. I was unable to walk because of a disagreeable ulcerated hole in my left calf, that was now deep enough to conceal a medal. It was finally scraped out on 10 August and, early the next morning, while I was still feeling bitterly sorry for myself, the place was suddenly abuzz with news. Captain Mura, the new administrator of the prison, had told our commander at 07.00 hours that morning that Japan had started surrender negotiations and that it was probably only a matter of days before the war would be over.

I was stuck in that bug-ridden hospital hut for a further two and a half weeks. But although not in the cell blocks, all of us on our backs out there were able to follow the subsequent goings-on very closely. The Japanese began to take away every available prisoner for defence work around the island and on the coast of Johore. It was only then that we really believed a climax of some sort must be approaching and this time, we hoped, someone would tell the Allies where we were before they began blasting the Japs.

On 15 August the Japanese authorities announced that although Nippon had agreed to unconditional surrender, Field-Marshal Count Terauchi, Commander-in-Chief of the Southern Army, did not associate himself with it and intended to fight on. What we did not know then was that a plan existed at Count Terauchi's Saigon headquarters to execute all prisoners in case of invasion.

In his turn, General Itagaki, Commander of Singapore, refused to surrender the island. We were still being guarded by the Japanese, who were getting increasingly nervous and irritable. Rumours that we were going to be butchered looked as if they might have some substance in them now that all working parties and prisoners from other camps were being concentrated in the gaol. By 27 August there were over 17,000 prisoners in the cells and around the area; and there were no signs that anyone was

going to get us out. Rations were increased a little, but the comics said that was only to fatten us for the chop. Meanwhile it was now twelve days since the war with Japan had ended.

On the thirteenth day, 28 August, all the inmates of the gaol stopped what they were doing, listened, and ran into the courtyards. Even the patients in the hospital tottered out to look up at the sky. Two Liberators were making great circles over the prison, passing and repassing just above our heads, showering us with leaflets.

We all began to cry.

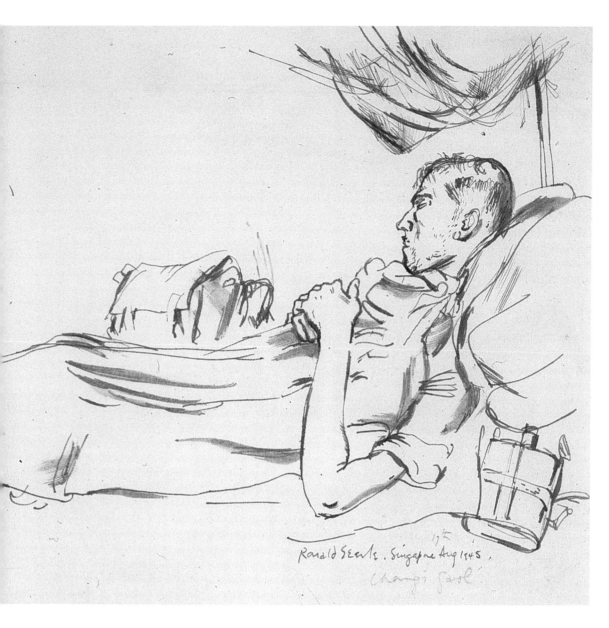

Sick prisoner (George Spurgin)
in the hospital hut, Changi Gaol,
17 August 1945.

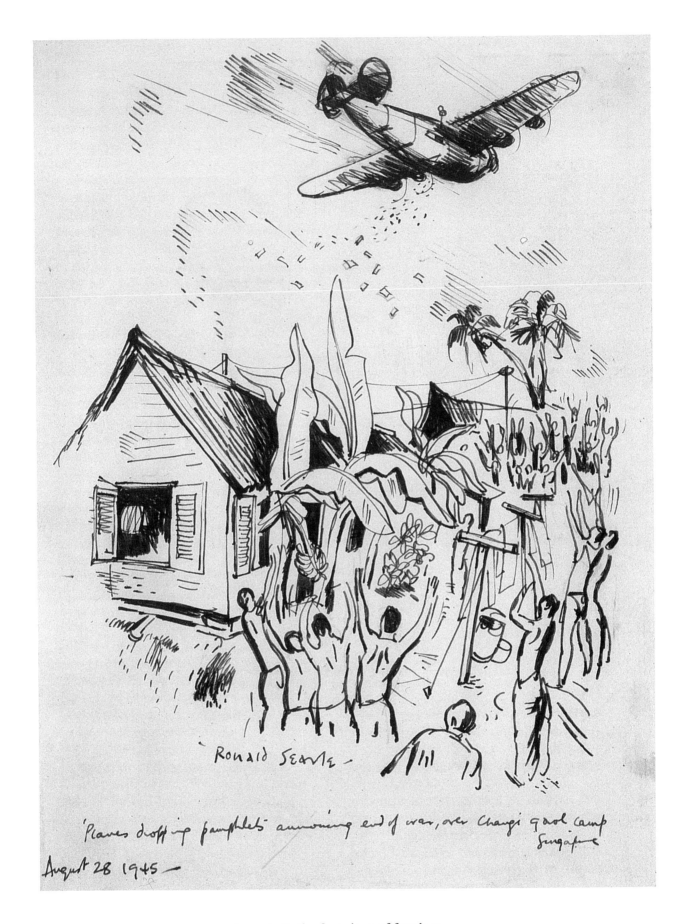

'Planes dropping pamphlets announcing end of war, over Changi gaol camp
Singapore
August 28 1945 —

Ronald Searle -

August 28, the first signs of freedom
seen from the hospital area.
Liberators flying low over the prison,
dropping leaflets announcing
the end of the war.

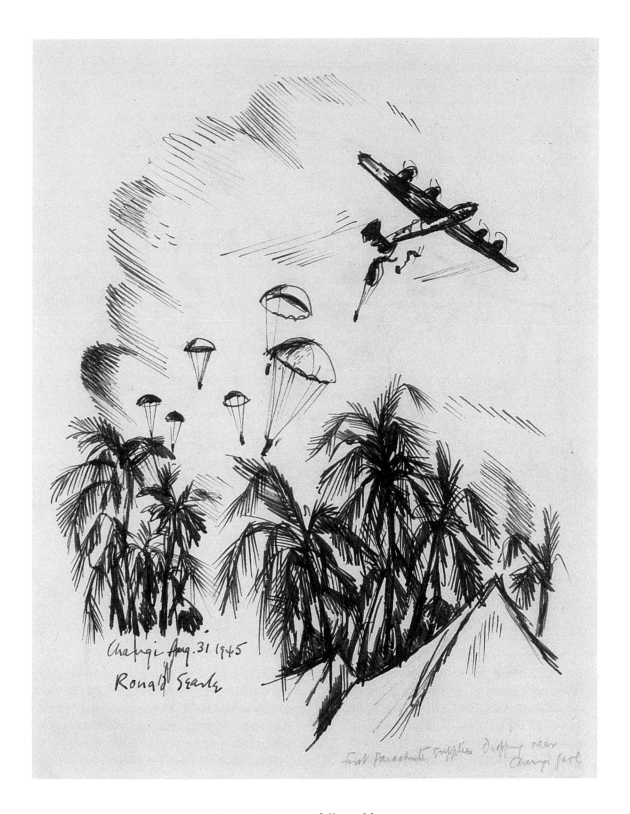

Changi Aug. 31 1945
Ronald Searle

First Parachute supplies dropping near Changi gaol

The leaflets were followed by
two staff officers and two doctors
on the 30th. Then, next day,
the first of several tons of food
began to float down onto us.
It was all very heady.

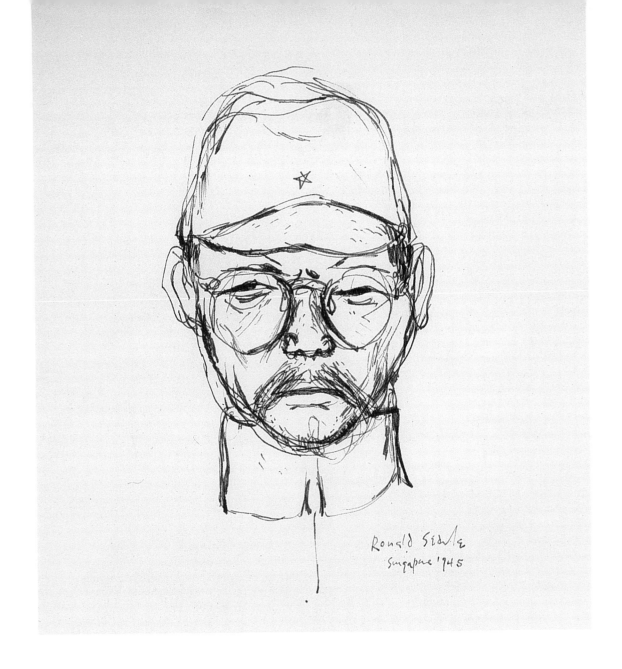

Ronald Searle
Singapore 1945

On the morning of 31 August our Japanese guards suddenly withdrew from the prison. Soon after, the Royal Navy anchored off the island and, on 4 September, it was all over. General Itagaki boarded the *Sussex* to sign the surrender of Singapore and we were free.

I was finally discharged from the hospital hut on 14 September and returned to my cell in the prison block. To my surprise almost everyone was still there, out of their minds with frustration and impatience. It was almost ten days since the Japanese had surrendered and we were still stuck in our lousy cells. But bureaucracy (no psychologist) was at work, so it was not until almost two weeks later that the overwhelmed and incompetent repatriation force finally got round to putting us on a boat for home.

On 28 September, after an agonizingly drawn-out extra three and a half weeks in prison, all that now remained of the 18th Division pulled out of Singapore harbour. By a curious coincidence we found ourselves on the same battered old Polish vessel that had taken some of us away from England in 1941 – the *Sobieski*.

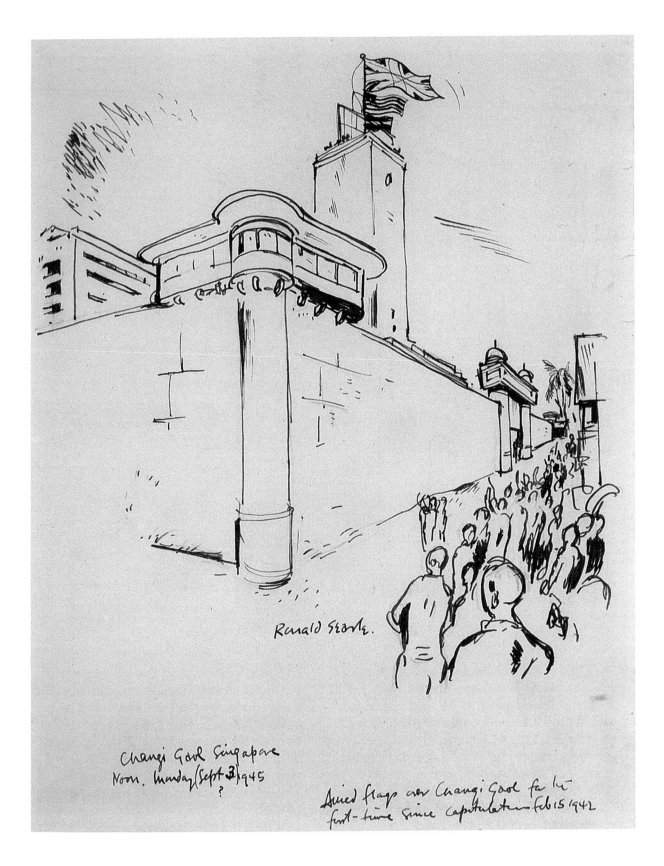

Ronald Searle.

Changi Gaol Singapore
Noon. Monday Sept 3 1945
?

Allied flags over Changi Gaol for the
first time since capitulation Feb 15 1942

We came out of our cells
to see Allied flags flying
over Changi Gaol again.

The voyage took another month. But the time passed somehow. The food was plentiful and good, so we were considerably less skeletal-looking by the time we disembarked at Liverpool on 25 October 1945, almost four years to the day since we had sailed away.

We soon found that during our absence we had been left behind. Life had changed, people had changed, the language had changed and it was going to take a long time to catch up with the nuances of the post-war world – not to mention four years of news. But mentally and physically marked though we were by our isolation and virtually incommunicable experiences, we were one small step in advance of those who had not been forced to make the journey to the Kwai and back. We now had in our grasp a thorny, but true, measuring-stick against which to place the things that did or did not matter in life.

Which is everything when one is twenty-five, starting from the bottom, hoping to shoot up like a rocket and not rise like a corpse, from the depths . . .

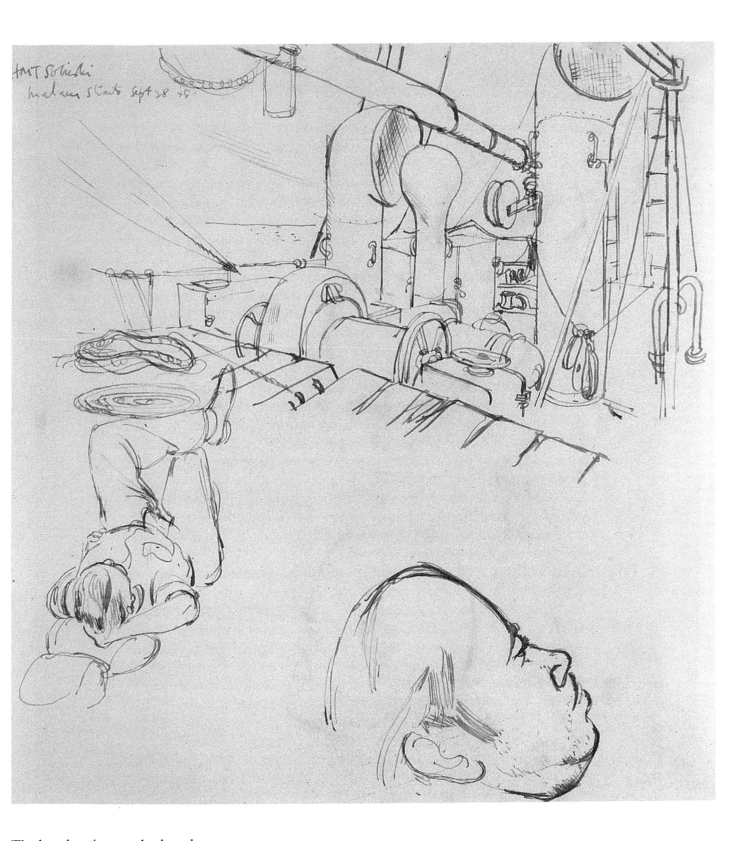

The last drawing, made aboard
the *Sobieski* as we moved into
the Malacca Straits on September 28
and headed for England.

Tailpiece

Like many of the drawings, the reflections and opinions lightly sprinkled about these pages retain some of the adolescent spirit that they had at the time of the events.

Global views of political and military strategy not being normally available to teenage rank and file, it is inevitable that personal adventures such as these can only be recounted as a self-dramatizing microcosm of the invisible whole, in which one is inevitably cast as the juvenile lead.

My own reactions fitted the norm. Only much later when war-lords regurgitated their experiences, politicians polished theirs and experts cut a path through this jungle of self-interest to align it all into something resembling critical and historical perspective, were we survivors able to step back and gaze in wonder at the tableau as a ghastly whole.

Now, forty years after, I have had the benefit of hindsight, and where my memory needed jogging, the labour of others has been there to jog it. I have listed in the bibliography a dozen books to which I have turned for confirmation and information. But they are only an indication of the yards of literature now available on the subject of the Japanese invasion of South-East Asia.

I had never intended to re-live those days in detail, either for myself or for the enlightenment of others. For those who returned, the flavour is still too bitter to wish to linger over it. Circumstances, however, decided otherwise.

In addition to the fact that a substantial proportion of my war drawings have now been reproduced for the first time in this book, after having remained tucked away since I carried them home in 1945, all the originals from which this selection was made are finally conserved for the public in the Imperial War Museum, London. Because of this, it became necessary for me to clarify much of the subject-matter and to place the drawings in some sort of historical context for those who do not know the story, rather than leave them as they were: a collection of vaguely related sketches, often obscure and open to misinterpretation by anyone reduced to guesswork.

I agreed to set down the facts as I recall them within the limits of my persisting 'Changi memory'. But in doing so I have been aware that, unnamed, living, or dead, my fellow prisoners have been vividly present throughout. Without them I would not have returned with these drawings. Without them I could not have returned at all.

R.S.

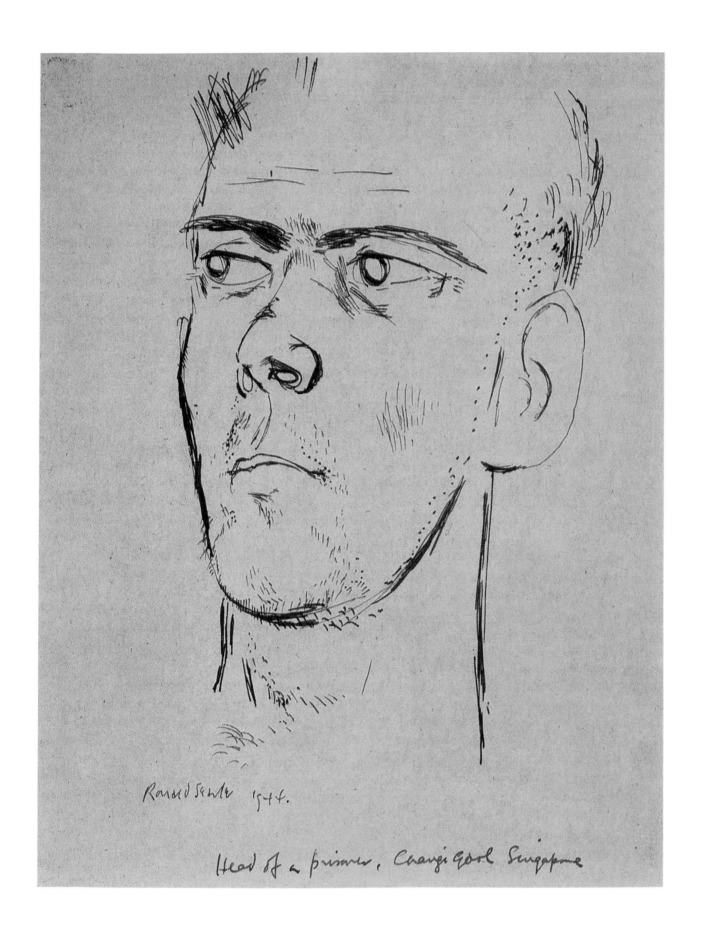

Ronald Searle 1944.

Head of a prisoner, Changi Gaol Singapore

Catalogue Reference Numbers

The original drawings are now in the collection of the Imperial War Museum, London. The catalogue reference numbers given below refer to Ronald Searle's own cataloguing system, WD denoting War Drawings, P denoting Prisoner-of-War Drawings. In the Imperial War Museum's system War Drawings have the prefix IWM:ART:15746, and Prisoner-of-War Drawings IWM:ART:15747.

P. 1: P171; p. 2: P173; p. 3: P130; p. 6: P73; p. 8: P76; p. 11: P101; p. 12: WD1; p. 14: WD8; p. 15: WD12 (above), WD2; p. 16: WD10 (above), WD11; p. 17: WD6; p. 18: WD3; p. 19: WD9; p. 20: WD4; p. 23: WD14 (above), WD16; p. 24: WD25 (left), WD29; p. 25: WD30 (above left), WD26 (above right), WD28; p. 26: WD42 (above), WD41; p. 27: WD44 (above), WD32 (below left), WD33; p. 28: WD57; p. 29: WD51; p. 30: WD60 (above), WD59; p. 31: WD70; p. 32: WD66 (above), WD75; p. 33: WD64; p. 34: WD63; p. 35: WD73; p. 36: WD68; p. 37: WD69; p. 38: WD80; p. 39: WD89; p. 40: WD90 (above), WD83; p. 41: WD78; p. 42: WD81; p. 43: WD103 (above), WD100; p. 44: WD107; p. 45: WD106; p. 46: WD98; p. 48: P8; p. 51: WDB; p. 52: WDG2 (above), WDG1; p. 53: P131; p. 54: WDC1 (above left), WDC2 (above right), WDC3; p. 55: WDD; p. 56: WDI; p. 57: P90; p. 58: P6; p. 59: P3; p. 60: P5; p. 61: P2; p. 62: P4; p. 63: P9; p. 64: P7; p. 66: P10; p. 67: P11; p. 68: P14; p. 69: P12; p. 70: P15; p. 73: P22; p. 74: P18; p. 75: P19; p. 76: P36; p. 77: P33; p. 78: P34; p. 79: P24; p. 81: P49; p. 82: P39; p. 83: P30; p. 84: P44; p. 85: P45; p. 86: P40; p. 87: P41; p. 88: P50a; p. 89: P42; p. 91: P43; p. 92: P55; p. 93: P63a (above), P63b; p. 94: P65; p. 97: P80; p. 98: P84a; p. 99: P66; p. 100: P67a; p. 101: 67b; p. 102: P68b (above), P68a; p. 103: P69; p. 105: P77; p. 106: P85; p. 107: P81; p. 108: P82a (above), P82b; p. 109: P83; p. 111: P79; p. 112: P87; p. 113: P89; p. 114: P91; p. 115: P84b; p. 116: P107a (above), P106a; p. 117: P78; p. 118: P72; p. 119: P75; p. 120: P74; p. 121: P70 (above), P71; p. 122: P94a (above), P94b; p. 123: P95 (above), P97a; p. 124: P102; p. 125: P103; p. 126: P100; p. 127: P99; p. 129: P108; p. 130: P126; p. 133: P110; p. 134: P112; p. 135: P113; p. 136: P115; p. 137: P114; p. 138: P124; p. 139: P128 (left), P127; p. 141: P134; p. 142: P119; p. 143: P118 (above), P122b; p. 144: P148c (above left), P148b (above right), P147 (lower left), P147a; p. 145: P148a; p. 146: P130; p. 147: P125; p. 148: P157/5–6; p. 149: P157/60; p. 150: P149a; p. 151: P152b (above), P152a; p. 152: P151; p. 153: P156; p. 154: P147a; p. 155: P120; p. 156: P116; p. 157: P117; p. 159: P144; p. 160: P143; p. 162: P173; p. 163: P168; p. 165: P142; p. 166: P192a, b; p. 167: P191a (above), P191c (below left), P191b; p. 168: P165; p. 169: P162; p. 170: P178; p. 171: P166; p. 175: P176; p. 176: P158; p. 177: P170; p. 178: P177; p. 179: P174; p. 181: P182; p. 182: P195; p. 183: P196; p. 184: P171; p. 185: P197; p. 187: P197; p. 189: P123.

Bibliography

Allen, Louis, *Politics and Strategy of the Second World War: Singapore 1941–1942* (London, 1977).

Backhouse, Sally, *Singapore* (Newton Abbot, 1972).

Braddon, Russell, *The Naked Island* (London, 1952).

Caffrey, Kate, *Out in the Midday Sun: Singapore 1941–1945* (London, 1974).

Hall, D. O. W., *War History Branch, Department of Internal Affairs, New Zealand: Prisoners of Japan* (Wellington, 1949).

Hardie, Dr Robert, *The Burma Siam Railway* (London, 1983).

Holmes, Richard and Kemp, Anthony, *The Bitter End: The Fall of Singapore 1941–1942* (Chichester, 1982).

Kinvig, Clifford, *Death Railway* (London, 1975).

Members of the Unit Association, *The Grim Glory of the 2/19 Battalion A.I.F.* (Sydney, 1975).

Nelson, David, *The Story of Changi, Singapore* (West Perth, 1974).

Probert, Squadron-leader H. A., *The History of Changi* (Singapore, 1965).

Searle, Ronald, *Forty Drawings* (Cambridge, 1946).

Swinson, Arthur, *Defeat in Malaya: The Fall of Singapore* (London, 1970).

Taylor, William, *With the Cambridgeshires at Singapore* (March, Cambs., 1971).

Acknowledgements

In wishing to thank those who have made this book possible, I must acknowledge my particular indebtedness to the following persons: Tessa Sayle of the Tessa Sayle Agency who, aside from spending two years co-ordinating the project, arranging the transfer of the pictures to the Imperial War Museum and their publication as a book, volunteered for services beyond the call of duty and physically dragged the boxes of drawings from France to England, to assure their safe delivery; Nobuko Albery for generously accepting the disagreeable task of combing the manuscript for any errors of Japanese spelling, translating the 1883 Precepts of the Emperor Meiji to the Imperial Army, and for giving me her invaluable reaction concerning the balance of the book from the Japanese point of view; also her uncle Tadao Yagi for his scholarly research on my behalf in Tokyo and equally valuable precisions regarding the translation of the Meiji Imperial Rescript; Monica Searle and Dan Franklin, my editor, who revised the manuscript; Dr Alan Borg, FSA, Director of the Imperial War Museum, Angela Weight, Keeper of the Department of Art, and Dr Christopher Dowling, Keeper of the Department of Education and Publications, for their unstinting co-operation; the photographic department of the Imperial War Museum and John R. Freeman & Co. (Photographers) Ltd, London, for copying the pictures and Graham Bush, London, André Chadefaux, Paris, and Rosmarie Nohr, Munich, for other photographs; finally John and Nonnie Locke of the John Locke Studios, New York, who, with Tessa Sayle in London, helped to keep everyone at bay during the six months it took to complete the documentation of these exceptionally murky years in the troubled history of South-East Asia.

R.S.